ART IN THE MAKING

DEGAS

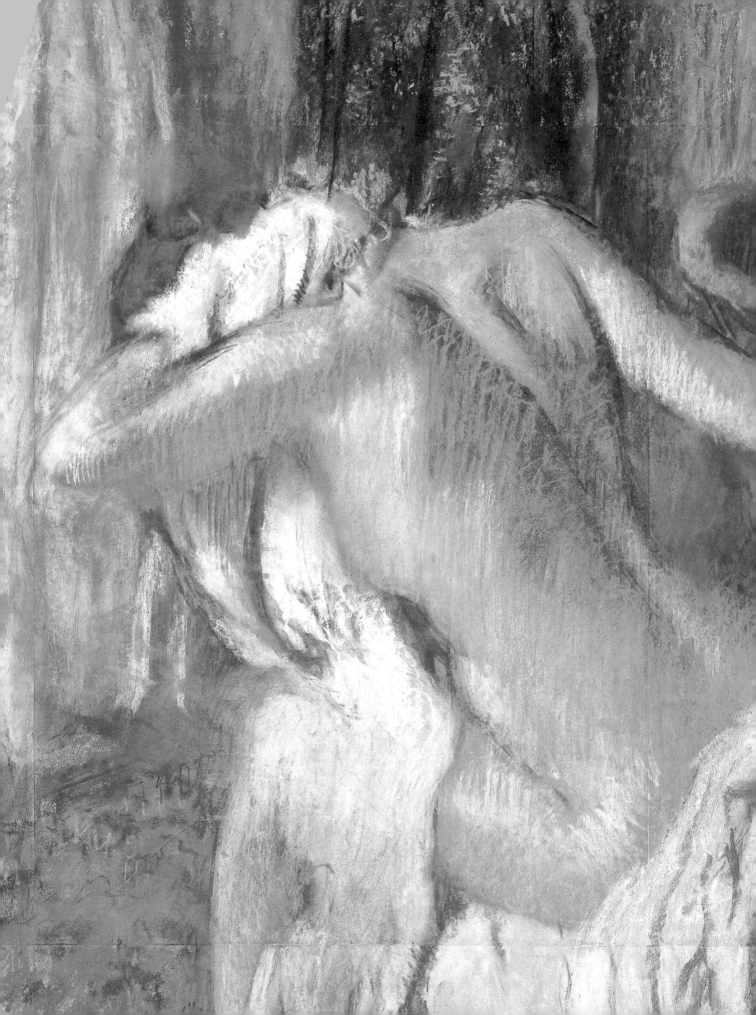

ART IN THE MAKING

DEGAS

David Bomford, Sarah Herring, Jo Kirby,
Christopher Riopelle and Ashok Roy

NATIONAL GALLERY COMPANY, LONDON

Distributed by Yale University Press

This book was published to accompany the exhibition *Art in the Making: Degas* held at The National Gallery, London, from 10 November 2004 to 30 January 2005.

Sponsored by ExxonMobil

ACKNOWLEDGEMENTS

We would like to thank the following for their help in many different ways: Peter Bower, James Cuno, Douglas Druick, Charlotte Gere, Rachel Grout, Ella Hendricks, Helen Howard, Richard Kendall, Kate Lowry, Heather Norville Day, Suzanne Penn, Harriet Stratis, Mark Tucker, Ernst Vegelin, Caroline Villers and Emma Wesley. Within the Gallery, the assistance of Caroline Campbell and the technical expertise of Rachel Billinge, Catherine Higgitt and Raymond White are gratefully acknowledged.

First published in Great Britain in 2004 by
National Gallery Company Limited
St Vincent House
30 Orange Street
London WC2H 7HH
www.nationalgallery.co.uk

ISBN 1 85709 969 9

525124

British Library Cataloguing-in-Publication Data
A catalogue record is available from the British Library

Library of Congress Catalog Card Number 2003106319

PUBLISHER Kate Bell
PROJECT MANAGER Jan Green
EDITOR Rowan Whimster
DESIGNER Libanus Press
PICTURE RESEARCHERS Xenia Corcoran and Kim Klehmet
PRODUCTION Jane Hyne and Penny Le Tissier

Printed and bound in Great Britain by Butler and Tanner,
Frome and London

FRONT COVER
Edgar Degas, *Ballet Dancers*, detail of cat. 13, about 1890–1900

FRONTISPIECE
Edgar Degas, *After the Bath*, detail of cat. 11, about 1890–5

pp. 8–9 Edgar Degas, *Young Spartans Exercising* (cat. 3), about 1860

pp. 56–7 Edgar Degas, *Beach Scene* (cat. 6), about 1869–70

BACK COVER
Edgar Degas, *Promenade beside the Sea*, detail of cat. 1, about 1860

Contents

Sponsor's Foreword

Back in 1988 when Esso UK first began its association with the National Gallery we chose to support an exhibition that delved into the thinking and skills of the artist. That was the first in a series of *Art in the Making* exhibitions, all of which proved extremely popular and successful.

We are very pleased, therefore, to be returning to the same theme this year. The exhibition has been put together after years of examination and analysis of the work of Edgar Degas. An experimental artist who painted to please himself, his work soon found fame and his paintings became among the most sought after and expensive works of contemporary art in the world.

Much research has been undertaken at the National Gallery and this is a fascinating exhibition. We are very proud to be associated with it. By understanding the thinking and craftsmanship behind these masterpieces, we hope you are encouraged to discover more of the magic contained within the National Gallery's collection.

ROBERT OLSEN
Chairman
ExxonMobil International Limited

Sponsored by
ExxonMobil
Esso Mobil

Director's Foreword

The National Gallery's first series of three *Art in the Making* exhibitions culminated in 1991 with *Art in the Making: Impressionism*, a groundbreaking investigation into the working methods and materials of the French Impressionists. Visitors to that exhibition might well have expected to find paintings by Edgar Degas included in it. He was long associated with the Impressionists and an enthusiastic participant in their early exhibitions. The National Gallery is rich in his works. However, Degas was not to be seen there. Early on in planning, the organisers realised that the sheer variety and complexity of Degas's working procedures, as yet little studied, set him apart from his colleagues. Much more research needed to be undertaken at the National Gallery, and assembled from museums and galleries around the world, before they would be ready to present their findings on this enigmatic master and his endlessly experimental approach to art.

A new series of *Art in the Making* exhibitions is now underway. The first of these, *Underdrawings in Renaissance Paintings*, was a highlight of London's 2002–3 exhibition season. Now, it is Degas's turn. The present exhibition is the result of years of examination and analysis of the artist's paintings by a team of National Gallery conservators, curators and scientists, including three scholars who also worked on *Impressionism* thirteen years ago, David Bomford, Jo Kirby and Ashok Roy. As usual, it focuses on the National Gallery's own paintings, including *Russian Dancers*, a dazzling pastel that entered the collection by gift as recently as 1998. These are supplemented by a handful of important loans for which we are grateful. Within the scope of a relatively small exhibition we see revealed here the protean inventiveness of Degas's art, while our understanding of his place in nineteenth-century French painting is enhanced by Christopher Riopelle's vivid biographical sketch. And as Sarah Herring reminds us in her essay, we also celebrate the debt we owe to Degas, as artist and collector, in the formation of the National Gallery's collection of modern paintings.

Finally, we gratefully acknowledge the generosity of our old friends at ExxonMobil in sponsoring this exhibition. It seems particularly appropriate that their long-standing and enthusiastic support of the National Gallery, dating from the very first *Art in the Making* exhibition in 1988, is once again expressed in this form.

CHARLES SAUMAREZ SMITH
Director of the National Gallery

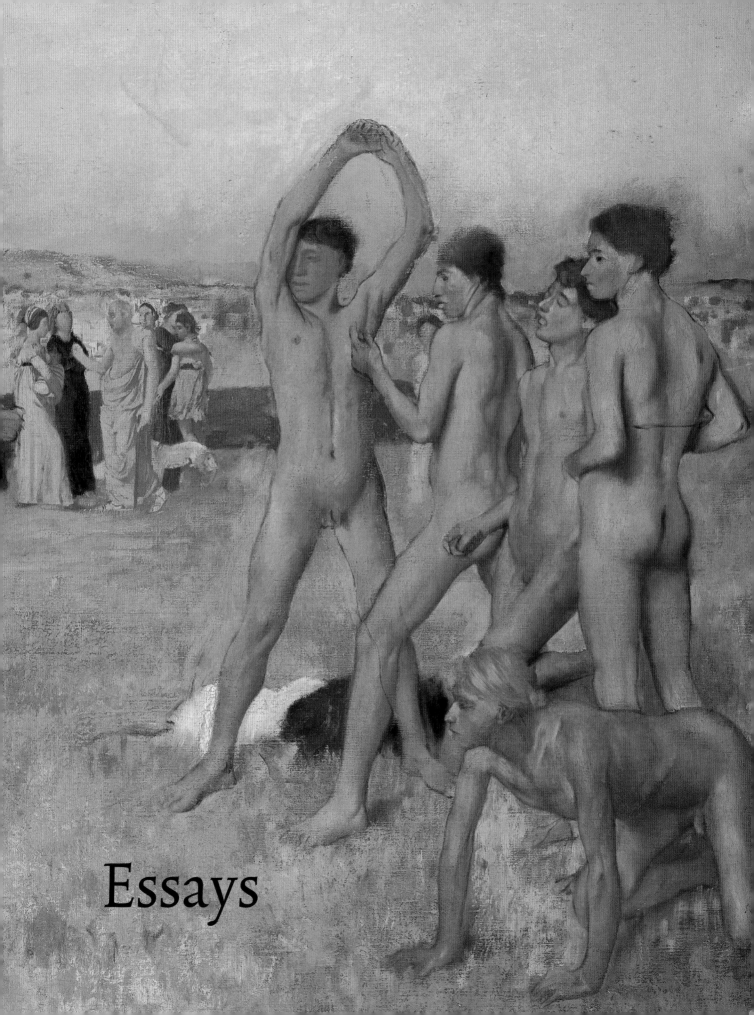

Essays

Edgar Degas: Illustrious and Unknown

Early in his career Edgar Degas painted or etched some twenty self portraits. An artist, especially a young one with few resources, is also his own most convenient model, always on call and charging no fee, and this may account for the early plethora of images. Nonetheless, the series of self portraits also constitutes an exercise in youthful self-analysis, as if Degas were determined to explore the contradictions already apparent in a psyche still in the process of formation. His distinctive features are instantly recognisable; a long, aquiline face and nose, full, somewhat petulant lips and a quizzical gaze from beneath hooded eyelids. In a portrait of 1857 (Fig. 1), the shadow that a flat hat throws across his face, light falling only on his right cheek, underscores a sense of personal detachment, if not also Romantic *ennui*. The sidelong glance the 23-year-old casts our way is tentative, but it also hints at steely determination. More than that, it echoes a famous early self portrait by Degas's artistic idol, the no-less-determined J.-A.-D. Ingres (Musée Condé, Chantilly), the allusion succinctly announcing the young man's intention to emulate his masters. The sketch-like brushstrokes and bare area of the canvas at the lower left also suggest that even early on Degas was unbothered by conventional notions of pictorial finish or 'proper' technique – that he painted to please himself, as would indeed prove to be the case.

Numerous witnesses corroborate what this self portrait begins to suggest, that Degas's was a charming if prickly personality, isolated, intensely self-aware and ambitious. In 1858 an older artist-friend spoke of his constant 'grumbling and growling' only to confess that he would miss it when the young painter was away.[1] The writer Paul Valéry, who dined frequently with Degas in the 1890s, appreciated the charm but also saw a streak of cruelty, calling him 'faithful, sparkling, unbearable . . . the guest whose comments, in their sovereign breach of fairness, in their selective truth, could prove lethal.'[2] Displeasure could lead him to ostracise even his oldest friends, while with others he would cavort like a merry child into his seventies. Degas said of himself that he would like to be 'illustrious and unknown,'[3] and he succeeded; by 1900 his paintings were among the most sought after and expensive works of contemporary art in the world, while he himself remained a life-long bachelor, living alone with a housekeeper and leaving behind no evidence that he ever enjoyed an amorous relationship. Very late in life, his

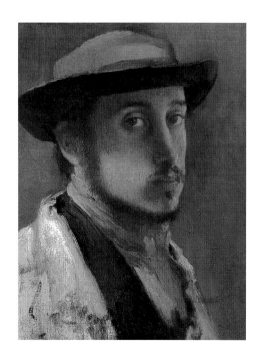

Fig. 1 *Self Portrait in a Soft Hat*, about 1857/8.
Oil on paper, mounted on canvas, 26 × 19 cm.
Williamstown, Massachusetts, Sterling and Francine Clark Art Institute, inv. 544

eyesight all but gone, less active as an artist but ever more intolerant in his convictions, Degas's proverbial charm seems to have abandoned him, a universal anger and disdain to have taken its place. The German diplomat, diarist and collector Harry Graf Kessler – a man of generous spirit – was thrilled to be invited to dine with him once in 1907, but came away from the meal calling Degas 'a fanatical, maniacal fool'.[4] Remarkable artistic accomplishments were to be expected of the highly-strung young man in the 1857 self portrait, and they began almost as soon as he took up his brush; that he would end his days in Lear-like fury and solitude was his tragedy.

Degas was born in Paris in 1834, the eldest son of the eldest son of a remarkable man. Hilaire Degas had fled France during the Revolution – narrowly escaping the guillotine, family lore had it – and established himself in business in Naples. He married well and prospered as a banker in the southern metropolis, lived in a vast *palazzo*, and in 1825 sent his son Auguste to Paris to found a branch of the family firm. There in 1832 Auguste, who intimated a spurious aristocratic lineage by spelling the name de Gas, married a neighbour, Célestine Musson, whose family was originally from New Orleans and who bore him five children. Young Edgar's mother died in 1847. His father, who had little aptitude for banking but a love for art and music, early on introduced the boy to the fine arts, and to important art collectors as well. (Late in life Degas in turn became one of the most discriminating collectors of his day.)[5] Almost immediately upon leaving school in spring 1853, the young man announced his intention to become an artist himself by registering to copy at the Louvre. Brief stints in the studio of the painter Louis Lamothe and at the Ecole des Beaux-Arts followed. (A briefer stint in law school was quickly forgotten.) He even sought the advice of the elderly Ingres who urged him either to 'draw lines, lots of lines,' or to copy from the old masters; accounts differ.[6] Numerous notebooks crammed with sketches after earlier artists' works, particularly by the Renaissance masters, establish that Degas did indeed copy voraciously and steeped himself in the art of the past; from the beginning of his career, it was a constant, informing presence in his art.[7] He drew lines too, brilliantly; the effortless linearity of his draftsmanship bears favourable comparison with the work even of the revered Ingres.

Degas travelled to Italy for the first time in 1856 and again in 1858–9, acquainting himself with the art of Antiquity and of the Renaissance, but also with his extended Neapolitan family. They became the models for many of his early portraits. His first masterpiece (Fig. 2), begun in Florence in 1858, shows his aunt, Laura, with her two daughters and husband, Gennaro Bellelli, living in disgruntled political exile. A grandly formal work in the tradition of aristocratic portraiture, it is at the same time an unsettling image of a family in emotional crisis, the father distanced from the women in his family, the mother aloof and prone to depression, one girl at least seemingly torn between the two. Preceded by numerous pencil and oil studies, the painting, which was not completed until 1867, establishes Degas as one of the most incisive portraitists of his age.[8] Like Ingres before him, however, he would

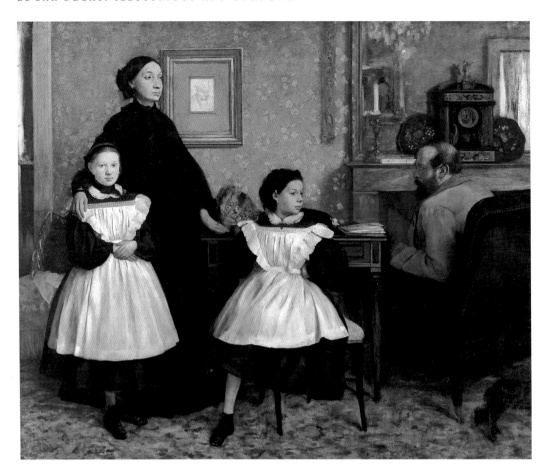

Fig. 2 *The Bellelli Family*, 1858–67.
Oil on canvas, 200 × 250 cm.
Paris, Musée d'Orsay, inv. RF 2210

often insist that he detested portrait painting as beneath his ambition. Unlike Ingres, he
rarely did it for the money; the vast majority of his portraits show family or friends. It was
in Italy as well, probably in 1859, that Degas began to explore the theme of the horse and
rider which would remain central to his art throughout much of his career (Cat. 1). This was
another distinguishing characteristic of his art: once he found a theme that intrigued him
Degas rarely put it down but returned to it tenaciously, teasing out its full range of expressive
possibilities over the years.

 Imbued with the ambition to emulate the old masters, Degas was determined to make
his mark as a history painter. During his early years, many of his most audacious works
were large, learned paintings set in the ancient or medieval past and teeming with figures
in historically accurate dress, the fruit of scrupulous research. The meanings of these works
are often obscure – surely by intention – and elicit conflicting interpretations to this day.
Nonetheless, they were dear to the artist; he kept the *Young Spartans Exercising* with him until
his death, probably continuing to work on it even late in life (Cat. 3). Gradually, however,
Degas's artistic attention began to turn to the modern world and contemporary life. No less

ambitious in scale and complexity than the history paintings that preceded it, nor any less enigmatic in meaning, is *Interior* of about 1868 (Fig. 3). The scene is set in a modern bedroom lit by the eerie glow of a gas lamp. The relationship between the standing man and the woman slumped on a chair is fraught, the mood one of desperation. One interpretation has it that Degas is illustrating a scene from Emile Zola's recently-published novel, *Thérèse Raquin*, where lovers meet for the first time following the murder of the woman's husband, and the enormity of their crime now drives them apart.[9] If so, such literalness is rare in the artist's oeuvre, nor does the melodramatic story exhaust the palpable psychological tension Degas imparts to the scene. More often, Degas preferred to play knowingly with our expectations of narrative and to mix and meld levels of reality on his canvases. In his *The Ballet from 'Robert le Diable'* (Fig. 4) we see the white-robed nuns of Giacomo Meyerbeer's famous opera, risen from their tombs and dancing ecstatically in a medieval cloister. In the foreground, wearing contemporary dress, are the musicians of the orchestra pit, and audience members some of whom pay little attention to the action on the stage. At the left, one gentleman, opera glasses raised, scans the boxes. Our eyes are pulled in opposing directions as well, as we try to interpret this strange jumble of motifs. Like *Interior*, this too is a kind of modern history painting, full of enigmatic incident, but transferred now to that privileged realm of artificiality and stylisation, the theatre, where the past is re-born each evening as the curtain rises.

One reason why Degas took up modern subjects was surely the example provided by new artist-friends of the 1860s such as Edouard Manet, whom he met in the Louvre in 1861, that provocative master's younger admirers Claude Monet and Auguste Renoir, and their fellow Impressionist painters – as they would come to be labelled – all of whom also sought painterly themes in the world around them. Indeed, modern life in Paris and its suburbs provided the quintessential themes of Impressionist painting. Massive expansion, reconstruction and improvement in those same years were transforming Paris into the first modern metropolis, 'the capital of the nineteenth century,' in Walter Benjamin's famous coinage. Life in the boulevards, cafés and theatres of the capital, and at the racecourses and

Fig. 3 *Interior*, about 1868–9. Oil on canvas, 32 × 45 cm. Philadelphia Museum of Art, The Henry P. McIlhenny Collection in memory of Frances P. McIlhenny, 1986, inv. 1986-26-10

Fig. 4 *The Ballet from 'Robert le Diable'*, 1876. Oil on canvas, 76.6 × 81.3 cm. London, Victoria and Albert Museum, inv. CAI.19, Lemoisne 391

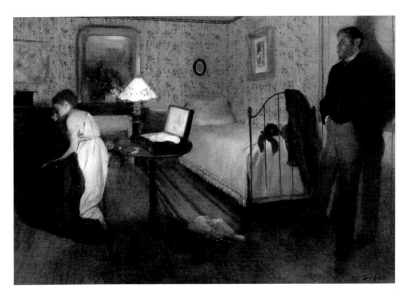

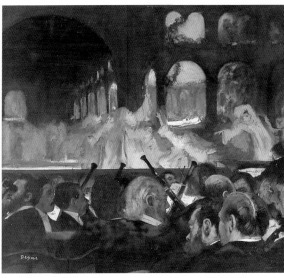

pleasure grounds on its outskirts, constituted an endless and fascinating spectacle of colour and light. What went on there took on an emblematic character for Parisian artists, poets and writers, as it did for foreigners casting envious eyes its way. Not to be in Paris was increasingly seen by cosmopolitan spirits, there and abroad, as a cruel deprivation – Henry James's novel *The Ambassadors* is all about imagining that you couldn't possibly live anywhere else – and a young generation of Paris artists, Degas among them, promulgated the myth by providing images of the city as a place of constant, beguiling flux.

Degas understood the allure of modern Paris as fully as any of his contemporaries. Moreover, he had spent time in Naples and Florence, and would later visit New Orleans, so he also knew the gulf that separated metropolitan sophistication from numbing provincial respectability. Yet he always positioned himself at a distance, stylistically, from his Impressionist colleagues with their fascination with the depiction of fleeting effects of atmosphere and light. He produced no views of the teeming boulevards from high vantage points, nor did he evince (at least until late in life) more than a passing interest in the suburban landscape. Form in his paintings does not dissolve into daubs of colour as we approach. Even the blur of paint that represents a dancer's tutu nonetheless manages to imply the sturdy little body beneath. The majority of Degas's paintings are set in interior spaces – his racecourse pictures being the most notable exception – often under extreme conditions of artificial light, including theatrical limelight. Interior spaces immediately begin to give an architectonic structure to an image while Degas's reliance on the drawn line, *le dessin* in academic parlance, accentuated that sense of structure in even the seemingly most random

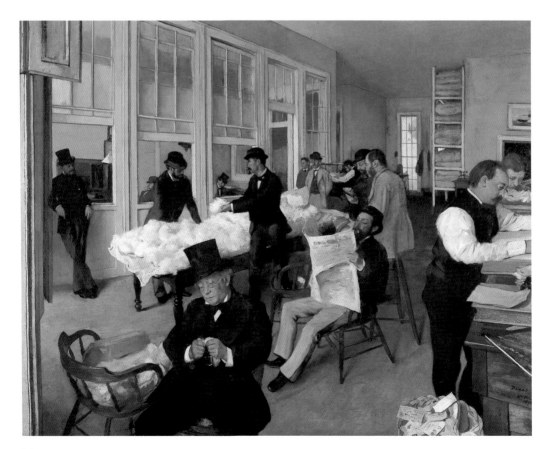

Fig. 5 *Portraits in an Office (New Orleans)*, 1873.
Oil on canvas, 73 × 92 cm.
Pau, Musée Nationale des Beaux-Arts. Acquired by the town of Pau thanks to the Noulibos bequest, inv. 878.12; Lemoisne 320

images. Degas's draftsmanship also provided a point of connection with a later generation of painters, as different as Paul Gauguin and Henri de Toulouse-Lautrec, for whom scintillating, decorative line playing across the picture surface would provide a way to move beyond the 'merely' ephemeral effects of Impressionism.

In 1872, Degas and his favourite younger brother René travelled together to New Orleans so that the artist could meet his mother's large, boisterous family, the Mussons, into which René by now had married. Restless, easily bored by provincial life – the lack of opera particularly distressed him – Degas was soon pining for Paris and announcing his imminent return. Nonetheless, he was open to the unique qualities of the Louisiana city, such as the fascinating mixture of black and white faces he saw on the streets, and the reliance of the local economy on the cotton trade. 'People do nothing here . . . except cotton,' he wrote. 'They live for cotton and from cotton.'[10] Moreover, it was the source of the Musson family fortune. By February 1873, Degas had begun work on a large-scale, multi-figure composition showing the family's busy cotton market (Fig. 5), an office populated in Degas's depiction by fourteen men efficiently going about their business. This included the examination of piles of snowy white raw cotton laid out on a tabletop. It is a masterpiece of observation on a subject almost entirely novel in painting, the world of commerce and the modern workplace.

For Degas, the cotton market was a theatre by any other name, and the businessmen, as expert in their field as any dancer or singer, had their own stylised rituals and gestures, communicating in a manner fully comprehensible only among themselves. Here again Degas expanded the scope of history painting by introducing modern professional life as a theme. This fascination with specific milieus, and the manners of professional comportment practised in them, would also inform his depictions of ballerinas, musicians, jockeys, shop assistants and milliners (Fig. 6), people earning a living by the practice of their craft. Even Miss La La hanging by her teeth from the ceiling of the Cirque Fernando is like a New Orleans cotton trader in that she too is a professional plying a specialised trade (Cat. 4). This is no less true of Degas's portraits of friends such as the Italian writer Diego Martelli (Fig. 7), depicted informally in his study: a still life of writerly paraphernalia, including books, leaflets and sheaves of paper, scattered about him, so many attributes of his calling. Similarly, Degas depicted his American friend Mary Cassatt in the Grande Galerie of the Louvre casting an appraising professional eye, as a painter might be expected to do, on the works of art among which she strolls (National Gallery of Art, Washington, DC).

Of all such milieus, the world of dance held the most intense fascination for Degas over the greatest number of years. Like many Frenchmen of the upper middle class, he spent much time at the Opera Ballet (the ballet company of the Paris opera house), not only at performances but also backstage between acts with the young ballerinas, and at daytime rehearsals as well. Unlike many gentlemen to be found there, he was not in search of sexual adventure. Rather, he was busy finding subject matter for some of his most formally

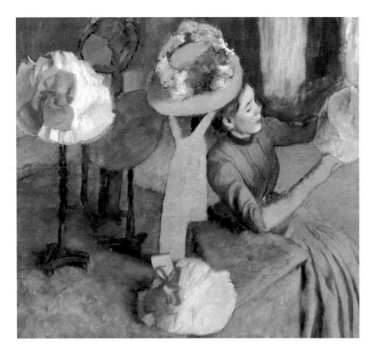

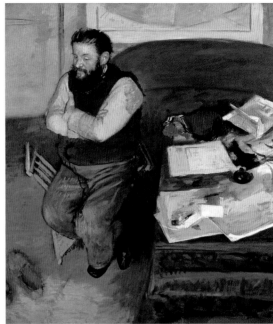

audacious works, and his images of the ballet as a whole – they number in the hundreds – constitute the most thorough pictorial analysis of that art form ever undertaken.[11] One suspects that, with time, the young dancers simply no longer took any notice of the bearded, ageing gentleman, pencil in hand, who paid such scrupulous attention to their activities. Degas was always economical with his formal inventions, however. In one depiction of a dance class (see Fig. 148), he included a grouping of three dancers at the rear of the rehearsal room. The poses of those dancers later reappeared, in a much more loosely painted manner, in other paintings, including Cat. 13, executed a decade or more later. Did Degas refer specifically to the earlier painting when he undertook the later work, or to preliminary drawings, or by that time had he perhaps made those poses and gestures so much a part of a mental repertoire of dance motifs that he was able to retrieve them at will?

A ballet dancer was also the subject of the only sculpture Degas ever exhibited in his lifetime (Fig. 8). The work he showed in 1881 was made of wax, a traditional sculptural medium. (He was an indefatigable modeller of wax figures, depicting dancers, bathers and horses; like the *Little Dancer aged Fourteen*, they were cast in bronze only posthumously.) More audacious was the artist's decision to dress his ballerina in a real tutu, a wig of human hair and a hair ribbon, thus traversing the line between sculptural fiction and physical reality in ways that opened new possibilities for sculptors for generations to come. Late in the nineteenth century Degas became fascinated with Russian dance as well, turning out numerous images in pastel of the colourfully garbed women (Cat. 12). Where he had seen them perform has never been ascertained. Here, however, as in many of his late works,

Fig. 6 *The Millinery Shop*, about 1884–90. Oil on canvas, 100 × 110.7 cm. Art Institute of Chicago, Mr and Mrs Lewis Larned Coburn Memorial Collection, 1933, inv. 1933.428

Fig. 7 *Diego Martelli*, 1879. Oil on canvas, 110 × 100 cm. Edinburgh, National Gallery of Scotland, inv. NG 1785; Lemoisne 519

tracing played an important role in the creative process as the same figures reappear in different works in novel configurations and sometimes in reverse – further evidence of the economy Degas exercised with his formal inventions, never discarding, constantly reassessing, reinterpreting and redeploying them.

Degas promoted his own work assiduously, as he later did those of the Impressionists, and he could be a fiercely loyal friend to fellow artists. For a time, sales were an economic necessity for him. Although he had been born rich and would die even richer, at one point his father's bank failed, saddling him with heavy debts. Degas originally intended to achieve success in the conventional manner by exhibiting large-scale paintings at the official Salon, perhaps winning a medal or critical recognition that then might lead to lucrative commissions. Manet hoped to do the same thing. Degas sent paintings to the Salon between 1865 and 1870, including *The Bellelli Family* in 1867. The works were largely ignored. (Gratifyingly, fellow artists expressed their appreciation.) Degas claimed that the pictures were badly hung and after 1870 determined to stop exhibiting at the Salon.[12] By 1867, on the other hand, he had seen an example of alternative exhibiting strategies when both Manet and Gustave Courbet erected private pavilions in which to show their works at that year's Universal Exposition. Moreover, that same year a group of young painters including Monet and Renoir were making plans to hold an entirely independent exhibition of their paintings, which, if it had taken place, would now be recognised as the first Impressionist exhibition.

That project was postponed until 1874, by which time Degas was fully convinced of the virtue of such independent exhibitions, became an enthusiastic participant, and would go on to show in seven of the eight Impressionist exhibitions. He also entered into business arrangements with the dealer, Paul Durand-Ruel, who exhibited Degas's works in London and later New York as well as Paris, which lasted until the late 1880s. Like Pablo Picasso after him, however, Degas right from the beginning of his career held back a surprisingly large number of works from the market. This may have been because he did not consider them finished, and any painting that remained in Degas's studio, no matter how heavily worked it already was, at any time might be taken up and re-worked anew. But it may also have been because he wished to retain them for his personal collection and for the museum he at one point intended to establish. The sight of his old friend Gustave Moreau's morgue-like private museum in Paris seems to have put him off that particular project and Degas's personal collection was dispersed in a series of posthumous auctions in 1918. (See pp. 48−52 for a discussion of the important role those auctions played in the history of the National Gallery.)

In later years, his fortune secure, Degas made a point of acquiring paintings by artists even more radical than the Impressionists, including Paul Gauguin and Vincent van Gogh, especially if he thought he might be able to quietly help by putting money their way. (Other equally radical manifestations of contemporary art seemingly left him cold; of Georges Seurat's monumental *Sunday Afternoon on the Ile de la Grande Jatte* of 1886 (Art Institute

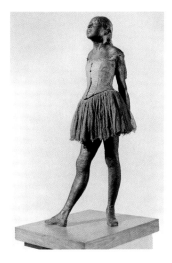

Fig. 8 *Little Dancer aged Fourteen*, 1881.
Later bronze cast, 95.2 cm high.
London, Tate, inv. NO 6076

of Chicago) he remarked, succinctly enough, that it was 'very big'.)[13] He was appalled when, after Manet's death in 1883, the artist's family allowed one of his most important historical compositions, *The Execution of Maximilian* of 1867–8 (see Fig. 39), to be cut into pieces and dispersed. Degas scoured the shops for the fragments, recovering four of them which he reassembled on a single canvas. Following the death of Berthe Morisot in 1895, he helped organise a retrospective exhibition of her work, though Morisot's daughter, Julie Manet, ruefully noted that Degas, increasingly curmudgeonly, would probably have preferred to keep the public out.[14] A definitive break with old artist-friends like Monet and Camille Pissarro came near the end of the century, not on artistic grounds but for political reasons, when in *l'affaire Dreyfus* Degas emerged as a relentless opponent of the army captain falsely accused of espionage, something of a xenophobe, and to the disappointment of Jewish friends among others, an anti-Semite as well.

Right from the beginning of his career, Degas was a richly experimental artist, not only in the complicated use he made of media and supports but also in his omnivorous curiosity about public and private life and their intersections, and in his endlessly inventive play with motifs. If anything, in his later years Degas's art became even more experimental. Of course, he had always been dexterous with a paintbrush. Late in the process of painting his Neapolitan cousin Elena Carafa in about 1875 (Cat. 9), for example, he simply repainted her head at a more confrontational angle, and adjusted her left shoulder accordingly; it is all to be seen in the X-ray (see Fig. 127), but a close look at the canvas itself also reveals the changes – note the chintz pattern of the chair covering that still shows through the altered left shoulder – as well as the supreme self-confidence with which they were executed. Far from slowing down, or resting on his laurels, while his eyesight lasted he continued to search for new ways to make art and new motifs to explore. His later works became larger, the

Fig. 9 *After the Bath*, 1896. Photograph. Bromide print, 16.5 × 12 cm. Los Angeles, J. Paul Getty Museum, inv. 84.XM.495.2; Terrass 25

Fig. 10 *After the Bath*, about 1896. Oil on canvas, 89 × 116 cm. Philadelphia Museum of Art. Purchased with funds from the estate of George D. Widener, 1980, inv. 1980-6-1

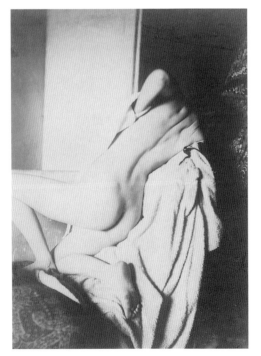

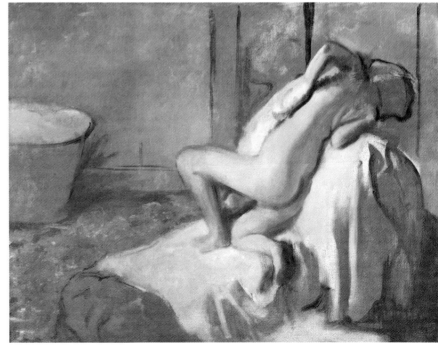

colours ever more intense. Indeed, *Combing the Hair* of the late 1890s (Cat. 14), almost monochromatic, is keyed to as high and vibrant a chromatic pitch as anything Gauguin was attempting in the South Seas during these same years. Pastel became ever more important to the artist. Not only was it capable of being worked and re-worked into dense matt surfaces but the paper surface to which Degas applied it could be expanded in all directions with the addition of further paper strips.

Thematically, Degas's gaze increasingly fell on women and the private interior world they inhabited. Large-scale pastels show female nudes in the intimacy of their baths (Cat. 11), often seen voyeuristically from the rear and seemingly unaware of the artist's presence. Sometimes, too, Degas's models were made to adopt contorted, even painful poses, and the artist was fascinated anew by the body *in extremis*. In other cases maidservants attend to the women in silent feminine rituals of ablution and grooming. Degas also took up the camera and made himself into an intriguingly original photographer, masterful in the sensual contrasts of light and shade his prints achieve (Fig. 9).[15] He also explored ways in which the camera could inform his painting in turn (Fig. 10). Surprisingly, late in life landscape painting emerged as an interest, but the rounded, pliant female body can often be sensed subsumed within the undulating roadways and hillsides he depicted (Fig. 11).[16] These are profoundly enigmatic images, flirting in some cases with pictorial abstraction. It may have been as late as the 1890s that Degas also returned to one of his most ambitious paintings of the 1860s, *Young Spartans Exercising,* in order to alter the background, effacing architectonic motifs and adding rolling, pastel-coloured hills as soft as female flesh. Thus he succeeded in intensifying the latent sensual tension between the two groups of naked youths as they themselves awaken to a consciousness of their own ripening bodies. Degas has come full circle here, the work of youth melding with the work of maturity, and it is all achieved entirely on Degas's own long-percolating, still-mysterious terms.

CR

Fig. 11 *At Saint-Valéry-sur-Somme,* 1896–8.
Oil on canvas, 67.5 × 81 cm.
Copenhagen, Ny Carlsberg Glyptotek, on deposit from the Statens Museum for Kunst, Copenhagen, since 1945, inv. 883C (IN (SMK) 4324); Lemoisne 1215

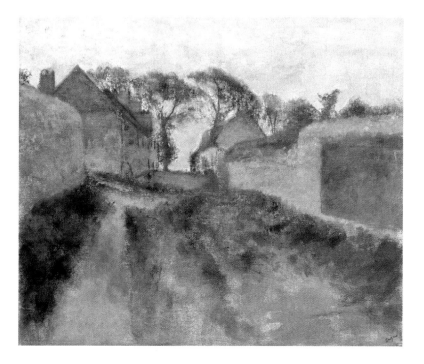

Degas at Work

From conventional beginnings, Degas became one of the most technically complex artists of the nineteenth century. Fascinated by materials and processes throughout his career, he developed a unique array of image-making methods that he used individually or in a seemingly limitless variety of combinations. His notebooks were full of jottings and recipes gleaned from fellow artists or experts in technological procedures. His technical fascination was not just with artistic practice, but with the minutiae of the routines he was depicting, whether they were laundresses ironing, dancers at the ballet or jockeys riding. In his art, he constantly experimented with visual effects and once remarked that he would never 'find' his method: 'I'd be bored to death.'[1] A number of Degas scholars – beginning with Denis Rouart in his *Degas: à la recherche de sa technique* – have attempted to throw light on his methods.[2] However, in many of his works it is difficult to be sure of the precise techniques that have been used, and some of his ways of manipulating materials remain uncertain. The sections that follow are intended as a summary of what is known about his techniques and how they have been combined, but the sheer unpredictability of Degas's choices of material or method in any given work necessarily makes any account incomplete. Certain patterns, habits and preoccupations can be discerned, however, and Degas's restless experimentation is the key to many of the unusual and incomplete surfaces that we encounter in his oeuvre.

Oil painting

In his earlier career, oil paint on prepared canvas was Degas's principal mode of expression, but its use diminished in the 1870s and 1880s in favour of pastel, and only revived briefly with a flurry of late paintings and reworkings in the 1890s. During the period of using oil, his style and handling changed greatly. He admitted to Vollard that it was an increasingly difficult technique for him:

> 'What a cursed medium oil is anyway! How is one to know the best canvas to use – rough, medium or fine? And as for the preparation, is white lead better, or glue? Should there be one layer, two or three?' . . . He would struggle with canvas for a while and then go back to pastel. 'I will never touch a brush again,' he would declare. Then, as if lured by its very difficulties, he would return to oil once more.[3]

Fig. 12 *Giulia Bellelli*, study for
The Bellelli Family, 1858–9.
Essence on buff wove paper
mounted on panel, 35.5 × 26.7 cm.
Washington, DC, Dumbarton Oaks,
House Collection, inv. H.C.P.
1937.12(E)

Fig. 13 *Nude Woman drying herself*,
about 1884–6.
Oil on canvas, 150 × 214.3 cm.
New York, Brooklyn Museum of Art,
Carll H. de Silver Fund, 1931,
inv. 31.813

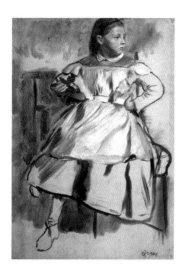

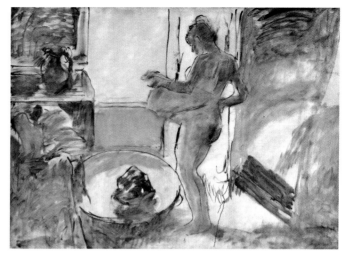

The development of his style in oil moved between flawlessly smooth representation to the roughest and sketchiest of images. The painting of an early work such as *The Bellelli Family* (1858–67, see Fig. 2) followed entirely conventional pathways: drawings on paper (Fig. 12) – done when Degas visited the family in Florence – followed by oil sketches of detailed parts, a pastel study of the whole scene and then the final large canvas. The carefully modulated brushwork, covering the pale ground with even thickness, is very much in the manner of Ingres, Degas's mentor, or even Van Dyck – whose painting of Marchesa Brignole-Sale Degas much admired in Genoa and sketched in a notebook as an inspiration for the Bellelli portrait.[4] The novelty of the painting lies in its famous psychological tension, not its technique.

Later oil paintings such as *The Absinthe Drinker* (Musée d'Orsay, Paris; see Fig 41) or *Vicomte Lepic and his Daughters, Place de la Concorde* (Hermitage, St Petersburg), both of around 1876, experimented with dramatic foreshortening and truncation of figures by the edge of the canvas; his use of materials in these works remained conventional, however. Some idea of the broadly traditional way in which he built up forms in his oil paintings may be deduced from the large and monumental canvas, *Nude Woman drying herself* (Fig. 13), begun in about 1884–6 and left unfinished.[5] All the preparatory stages are visible, including distinct traces of a grid for the process of squaring-up from a preliminary drawing. As usual with Degas, outlines were drawn and redrawn several times, altering and refining the pose of the figure and the positions of objects as the work took shape. There are faint indications that the bathtub and the woman were in quite different positions originally. Pencil and charcoal sketching underlies the fluidly painted black lines that map out the design. The forms were then filled in with underpaint in tones of brown, painted quickly with broad scrubbing movements of the brush. Although the subject matter here is unique to Degas, his way of achieving it in paint follows the conventional path of the drawn composition followed by the

ébauche, even to the extent of using the traditional brown 'sauce' of the academic painter for shading. This distinguishes him profoundly from Impressionist contemporaries who essentially worked in colour directly on the prepared canvas. Why Degas left his painting unfinished is unclear: perhaps he could not resolve the difficulties of positioning the various elements within the picture; perhaps he was satisfied with it as a daring and dramatic monochromatic image. In any event, it remained in this state in the studio and was sold in the posthumous sale of 1918.

Another example of a painting left in an *ébauche*-like state – but presumably declared finished, since it is signed – is the 1869 portrait of Mme Théodore Gobillard, née Yves Morisot, the elder sister of Berthe (Fig. 14).[6] Preceded by drawings (e.g. Fig. 15) and a pastel, the portrait is the result of several careful studies and yet it is contrived to look like a rapid sketch of a sitter caught unawares. Very little about Degas's art is as spontaneous as it appears: Degas firmly believed that 'nothing in art should be accidental'. The picture is almost entirely monochromatic: the only touches of colour are the green of the garden glimpsed behind the sitter and red on the mirror frame at the right.

As late as 1893, Degas told his young pupil Ernest Rouart: 'You paint a monochrome ground, something absolutely unified: you put a little colour on it, a touch here, a touch there, and you will see how little it takes to make it come to life.'[7] Degas's persistence in building his oil paintings up in the academic manner of the earlier nineteenth century is notable in the context of his otherwise radical and experimental methods. His use of colour on top of the *ébauche* looks back to an even earlier tradition – to Titian and the sixteenth-century Venetian painters whom he so admired. Titian's habit, in his later years, of dashing in colours, setting the painting aside and then returning to it to change, correct and adjust the forms, perfectly describes Degas's practice as his style developed and became more varied through the 1860s and 70s. His paintings often contain pentimenti, which can be completely visible – almost as if he is offering a choice of poses. The *Woman ironing* of about 1869 (Fig. 16) – which depicts the model Emma Dobigny rather than a real ironer – shows both arms in alternative positions. Her right hand seems to move the iron across the cloth from one place to another, and her left is both smoothing the cloth and hidden behind it. Ever the

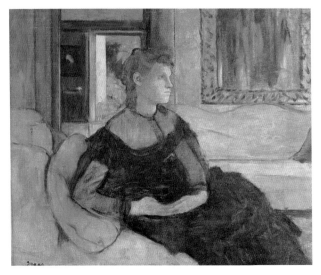

Fig. 14 *Mme Théodore Gobillard (Yves Morisot),* 1869.
Oil on canvas, 55.3 × 65.1 cm.
New York, Metropolitan Museum of Art. Bequest of H.O. Havemeyer; the H.O. Havemeyer Collection, 1929, inv. 29.100.45

Fig. 15 *Study for Mme Théodore Gobillard,* about 1869.
Crayon and pencil, heightened with white on paper, 48 × 32.5 cm.
Paris, Cabinet des Dessins, Louvre (Musée d'Orsay), inv. RF 29881

draughtsman, Degas outlined the forms with repeated lines of bold, dark paint; this was his habitual practice throughout the painting process – in the *ébauche*, at intermediate stages in trying out different positions, and in the final stage when fixing a preferred pose. These multiple outlines are visible in drawings, pastels and paintings alike: they are quite apparent, for example, around the figure of Hélène Rouart in Cat. 7.

The *Woman ironing* is, by convention, considered unfinished – although notions of finish in Degas paintings are notoriously difficult to define.[8] Certainly it remained in his studio and bears the executor's stamp instead of a signature. Whatever its state, it is notable for the highly characteristic range of textures that Degas contrived and employed on the surfaces of his paintings – from the smooth, meticulously worked flesh paint, through the solid regular brushwork of the foreground cloth, to the broken, almost random strokes of the washing hanging behind. The background is a mixture of thick, rough brushwork applied with great freedom, of paint that has been scraped away in places and of bare ground that was never painted. Like Rembrandt, whom he also admired, Degas used texture to focus the viewer's attention: the central points of interest were often highly finished, while the peripheral parts might be merely indicated with the most cursory of brushstrokes. He achieved textural effects with dragged and dabbed brushwork, by scraping down and sometimes using his fingers.

Degas's interest in shape and texture dominated his painting technique. He often chose unusual square-format canvases and, as his comments to Vollard suggest, he always considered the fineness or coarseness of the weave. He was also increasingly fascinated by dry, matt paint textures and developed particular techniques that exploited such effects – principally *peinture à l'essence* (see below) and, occasionally, painting on unprimed canvases, such as in *Ballet Dancers* (Cat. 13) and *Women ironing* of around 1884–6 (Fig. 17). Using oil paint directly on the fabric was an unconventional technique, used sometimes by Berthe Morisot, but rarely by other Impressionist contemporaries. For Degas, its appeal was the dry, broken appearance of the paint that resulted; as the loaded brush touched the canvas, the oil was quickly absorbed by the bare fabric and long, fluid strokes were impossible. In the background of *Women ironing*, the brush has dragged over the coarse weave, catching the tops of the threads and skipping over the hollows, accentuating the texture beneath.

Fig. 16 *Woman ironing*, about 1869. Oil on canvas, 92.5 × 74 cm. Munich, Neue Pinakothek, Bayerische Staatsgemäldesammlungen, inv. 14310

Fig. 17 *Women ironing*, about 1884–6. Oil on unprimed canvas, 76 × 81.5 cm. Paris, Musée d'Orsay. Bequest of Count Isaac de Camondo, 1911, inv. RF 1985; Lemoisne 785

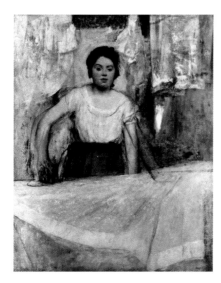
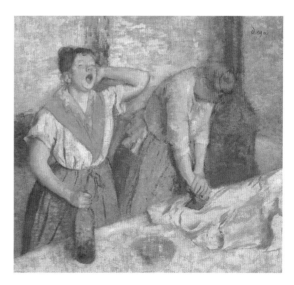

The figures are more layered, more solidly constructed, making them stand out. In addition, the contrast between the light, irregular passages of paint and the darker tones of the canvas visible through it perfectly imitate the flickering movement and play of light in the steamy, dim interior that Degas was trying to capture.

As well as revising and correcting his paintings as he initially developed them, Degas would also habitually return to paintings made years before and rework them – sometimes so obsessively that, with his failing eyesight in later life, he would spoil them irretrievably. Or, at least, that is what his contemporaries thought: Vollard recounts how Henri Rouart:

> . . . knew the artist's mania for adding final touches to his pictures, no matter how finished they were. And so to protect himself, he fastened the famous *Danseuses* to the wall with chains. Degas would say to him: 'Now that foot, Rouart, needs just one more touch . . .' But Rouart had no fear of losing his picture; he had confidence in the strength of his chains.[9]

Degas explained to Vollard, 'the fact is that I never feel really satisfied in letting any of my work go out of the studio . . .'

Notable paintings were reworked later by Degas. *Young Spartans Exercising* (Cat. 3), for example, was altered intermittently over a twenty-year period before he stopped work on it and kept it in his studio for the rest of his life. One of the most complex of his reworked paintings is *Scene from the Steeplechase: the Fallen Jockey* (Fig. 18), submitted in its original form to the Salon of 1866 and then substantially altered twice, in the early 1880s and around 1897. It is difficult to be sure how the original composition was arranged, but it appears that there was a single leaping horse poised above the fallen rider: the outline of its rump and tail can be seen against the trees and sky just above the present horses. Degas then scraped down and repainted large areas, changing the position of the riderless horse, introducing a second one and an additional rider in the background. His last alterations to the painting, around 1897 coincide with the painting of a wholly new version of *The Fallen Jockey* (Kunstmuseum, Basel) depicting a single horse and fallen rider against a simple landscape. Both large canvases remained in Degas's studio until his death.[10] Degas's habit of reworking his canvases, sometimes with layers of thick, muddy overpaint, has led to ethical dilemmas for later owners and restorers: in *The Cleaning of Paintings*, the restorer Helmut Ruhemann describes the removal of heavy repaintings done by the artist in old age that were concealing an early racecourse scene. In this case, the repainting was so crude and the painting beneath so fine that its recovery was considered justified.[11]

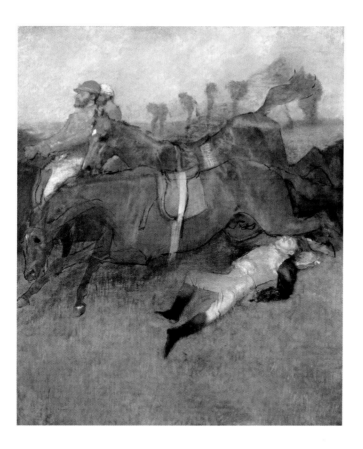

Fig. 18 *Scene from the Steeplechase: the Fallen Jockey*, 1866 (reworked 1880–1 and about 1897). Oil on canvas, 180 × 152 cm. Washington, DC, National Gallery of Art, collection of Mr and Mrs Paul Mellon, 1999, inv. 1999.79.10/PA

Peinture à l'essence

Degas's preference for matt, velvety surfaces found its ideal method in the technique of *peinture à l'essence*, in which oil paint is drained of its oil (often on blotting paper) and then diluted with turpentine. Used on paper, the effect is very like that of watercolour – thin, liquid, easily brushed out and relatively transparent. The resulting surface may be quite dry and chalky, or may have a slight sheen depending on how far the oil is extended. Identification of works done in *essence* can be difficult, as it often resembles watercolour or gouache: accurate analysis of the paint medium is limited by the very small amounts of binder present. However, a practised eye can distinguish the different drying properties of solvent-based or water-based paints. Solvents sink into the paper more and evaporate faster and tend to produce a succession of drying fronts in a large area of wash, whereas the slower evaporating water allows greater time for blending.[12]

Degas was used to painting conventionally in oil on paper from the 1850s, as the 1857 self portrait shows (see Fig. 1). He also employed the *essence* technique for adding colour to drawings on paper as early as the late 1850s, in his studies for *The Bellelli Family* (see Fig. 12). In the 1860s he used it to sketch such striking drawings as the *Young Woman with Field*

Glasses on pink paper (Fig. 19). Some of his finished paintings from this period are in the same medium: the ambitious and complex *Scene of War in the Middle Ages* of 1863–65 (now in the Musée d'Orsay, Paris) is painted largely in *essence* on several pieces of paper mounted on canvas. Four works in the present catalogue – *Beach Scene* (Cat. 6), *At the Café Châteaudun* (Cat. 5), *Carlo Pellegrini* (Cat. 10) and *Woman at a Window* (Cat. 8) – are in *essence* on unprimed paper, Degas's preferred support for this type of painting, usually mounted on canvas. He seems to have had a number of paper-on-canvas supports specially prepared around or just before 1870: three have been identified of exactly the same size – *Woman at a Window* (Cat. 8), *Racehorses before the Stands* (Fig. 20) and *The Pedicure* (Fig. 21).

The effects that could be achieved with *essence* were highly versatile, depending on the way it was manipulated and the nature of the paper. In *Racehorses before the Stands*, the preparatory drawing was reworked in pen and ink and shows through the paint almost everywhere. The *essence* colour is high-key and crisp with a dry linear brilliance that perfectly conjures up a dazzling day in high

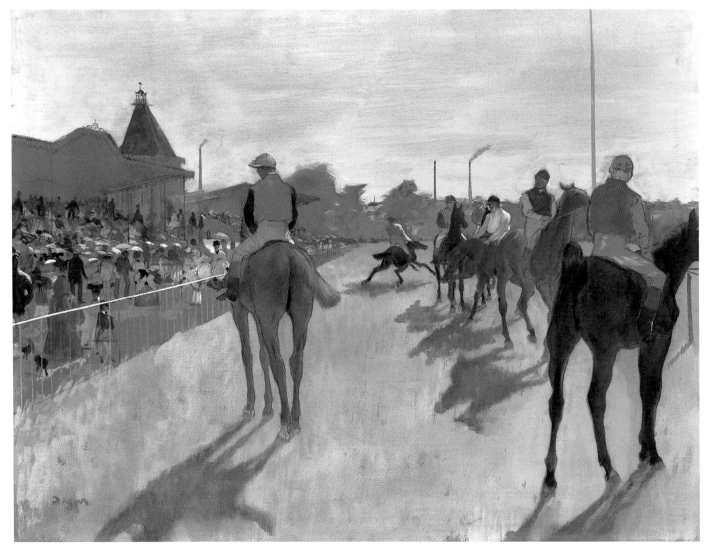

summer. *The Pedicure* is quite different – an interior scene full of luminous clarity, but also the subtle gradation of shadow and the interplay between transparent and opaque. Here, the handling of the *essence* medium is used to point up these contrasts, precise and hard-edged at the front of the composition, becoming soft and blended towards the back.

The number of paintings completed purely in *essence* is relatively small and dates from the late 1860s and 1870s, although Degas continued to use the medium in his repertoire of methods for adding colour to drawings. He also used *essence* combined with other materials in some of the highly experimental mixed-media works of his mid-career (see below).

Pastel

Degas's gradual and ultimately definitive switch from oil to pastel has been ascribed to several factors.[13] Its immediacy and speed of execution were undoubtedly appealing to an artist who admitted finding oil painting more and more laborious, and the direct, bright tonalities would be easier for someone of failing eyesight. Pastel allowed initial ideas to be set down,

Fig. 19 *Young Woman with Field Glasses*, 1866. *Essence* on pink paper, 28 × 22 cm. London, British Museum, inv. P&D 1958-2-10-26

Fig. 20 *Racehorses before the Stands*, 1866–72. *Essence* on paper, mounted on canvas, 46 × 61 cm. Paris, Musée d'Orsay. Bequest of Count Isaac de Camondo, 1911, inv. RF 1981

Fig. 21 *The Pedicure*, 1873. *Essence* on paper, mounted on canvas, 61 × 46cm. Paris, Musée d'Orsay. Bequest of Count Isaac de Camondo, 1911, inv. RF 1986

developed and altered with the minimum of complication: no paint had to dry and the work could be left and picked up again at any time. Works in pastel could be produced quickly and sold more readily – a significant factor for Degas in the 1870s when he was in financial difficulties. For the older Degas, the whole notion of repeated designs produced by tracing and colouring was also important, and pastel was the ideal vehicle for these sequences. Most persuasively, as several authors have suggested, the spontaneous fusion of drawing and colour that Degas sought and found so difficult in oil, was perfectly realised in the medium of pastel.[14]

Degas first used pastel around or just after 1860, for elaborating drawings and for compositional sketches such as that for *The Bellelli Family*.[15] In the summer of 1869 on a visit to Normandy, in rare moments of working *en plein-air*, he did a number of landscapes and seascapes in pastel on the buff pages of a large notebook. Dating from around the same time is the celebrated full-length portrait of his sister Thérèse, *Mme Edmondo Morbilli* (Fig. 22), one of his first significant achievements in the pastel medium. Highly finished, with few individual strokes showing, it is clearly the work of a painter using pastel to create an effect similar to that of an oil painting. The pale features, the striking yellow dress, the sumptuous red upholstery and the gold of the picture frames and candelabrum are all rendered in densely worked passages of colour, rubbed and blended ('sweetened') to create a continuous, illusionistic surface.

In the mid 1870s, Degas began to use pastel much more extensively than before. One of the triggers for this new direction was his discovery of the monotype (see below), a form of printmaking that he virtually invented and which he often used as a base for colouring with pastel. Indeed, his first recorded monotype of 1876, *The Ballet Master* (carried out with his friend Ludovic Lepic, whose signature appears with Degas's at the upper left) was produced in two impressions – a darker first print (Fig. 23) and a paler second print that Degas worked up in colour with pastel and gouache (Fig. 24).[16] An extraordinary number of Degas's pastels have monotypes beneath them: of the nearly 700 works in pastel that he produced, around 100 are based on monotypes.[17]

In the third Impressionist Exhibition of 1877, Degas showed several of these pastelised monotypes, including *Women on the Terrace of a Café in the Evening* (Fig. 25), which aroused great interest (including that of Emile Zola) and overshadowed the now more famous *The Absinthe Drinker* (see Fig. 41), a late arrival in the same room of the exhibition. As well as the appeal of the monotype process itself, the advantage to Degas of working over such prints was that they provided the essential monochromatic structure of the composition – analogous to the *ébauche* in a painting – and could be allowed to show through for the darker

Fig. 22 *Mme Edmondo Morbilli*, 1869. Pastel on wove paper with added strips at top and bottom, 51 × 34 cm. New York, Private collection

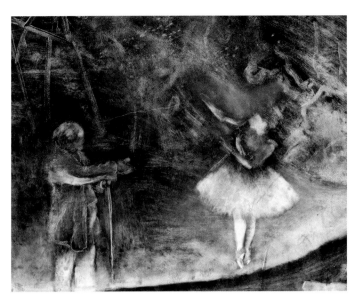
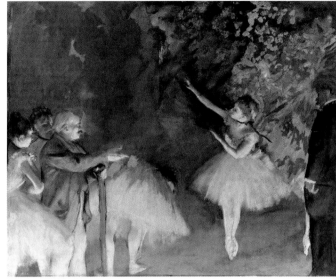

Fig. 23 *The Ballet Master*,
1874 or 1876.
Monotype heightened and corrected
with white chalk or wash,
56.5 × 70 cm.
Washington, DC, National Gallery
of Art, Rosenwald Collection, 1964,
inv. 1964.8.1782 (B24.260)

Fig. 24 *The Ballet Rehearsal*,
about 1876.
Gouache and pastel over monotype
on paper, 55.7 × 68 cm.
Kansas City, Missouri, Nelson-Atkins
Museum of Art. Acquired through
the Kenneth A. and Helen F. Spencer
Foundation Acquisition Fund,
inv. 73-30

Fig. 25 *Women on the Terrace
of a Café in the Evening*, 1877.
Pastel over monotype,
66.7 × 47.3 cm.
Paris, Musée d'Orsay. Bequest
of Gustave Caillebotte, 1894,
inv. RF 12257

passages. This effect is particularly striking in *Women on the Terrace*, in which dark areas in the foreground and much of the shadowed street beyond the terrace consist of the unmodified monotype. Simple touches of white and coloured pastel for the streetlights, the pillars of the café and the clothes and skin of the four women, render a beautifully convincing night scene, illuminated by pools of light from within the buildings.

Degas continued to use pastel over monotype intermittently, but most of his pastels after the 1870s were done over drawing, usually charcoal. The nature of his developing pastel technique was based firmly on the paper supports he chose to work on.[18] He used conventional 'Ingres' laid – and also wove – drawing papers, exploiting their texture and

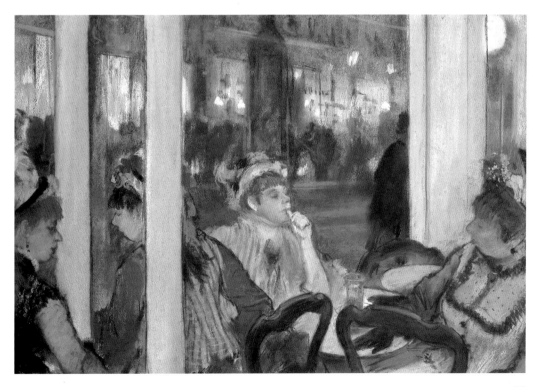

opacity. They might be coloured, or veined or mottled with colour, but it is often difficult to be sure of their original tonality as many would have faded within a relatively short time.

In a highly unconventional way, he also used tracing paper for large numbers of his late pastels. Tracing paper (*papier calque* or *végétal*) is, at first glance, a quite unsuitable support for pastel: it has no texture for catching and holding the dry colour, and it presents a bland, slightly yellowed surface that is without character in itself. Why, then, did Degas use it so frequently? The answer lies in Degas's use of motifs repeated constantly throughout his work and across the years. The same figure of, say, a resting dancer would reappear in different guises in numerous drawings, pastels and paintings, and tracing was the easiest method of reproducing subjects over and over again. Richard Kendall has described in detail the sheer extent of Degas's practice of producing such serial images in his later years, and how unsuspected connections between figures in different works are still being discovered.[19]

Degas was quite open about his method of replicating images: he advised fellow artists to 'make a drawing, begin it again, trace it; begin it again, and re-trace it.'[20] In a letter to his friend Bartholomé in 1886, he wrote, 'it is essential to do the same subject over again, ten times, a hundred times.'[21] According to Vollard:

> Because of the many tracings that Degas did of his drawings, the public accused him of repeating himself. But his passion for perfection was responsible for his continual research. Tracing paper proved to be one of the best means of correcting himself. [. . .] He took great pains with the composition of the paper he used for pastel; however, by his very method of work (tracing after tracing) most of his pastels were of necessity done on tracing paper.[22]

Degas's later pastels – often, repeated variants on the same themes – depended on such copying processes. One of his models described how he would:

> . . . retrace his drawing and copy the same tracing on to many sheets of pastel paper. Then he painted his subject in many different hues, endlessly varying the colours until one of the pastels satisfied him enough to complete it, leaving the others more or less finished.[23]

Usually, a tracing would be direct, but sometimes he would trace an image in reverse by flipping the semi-transparent paper: some of the figures in the *Russian Dancers* series (see Cat. 12) are mirror images of others.

Degas is known to have used tracing paper for small ink drawings in the 1850s and 60s – and, indeed, his mentor Ingres also used *papier végétal* for transferring designs – but his revival of interest in the method is credited to his fellow artist Luigi Chialiva, in whose studio he saw traced architectural drawings of Chialiva's son.[24] Equally important for Degas's pastel technique was the secret fixative that Chialiva, an authority on art materials (described

by Vollard as 'an Italian painter of sheep'[25]), is reported to have given him (see below).

Large rolls of tracing paper were seen in Degas's studio and some of his pastels were on single large sheets cut from the roll.[26] However, another puzzling feature of his technique was the complex assembly of pieces and strips of paper that sometimes made up his supports. *After the Bath, Woman drying herself* (Cat. 11), for example, is made up of seven pieces of paper (see p. 126) mounted on a large sheet of paper and card. *Dancers in the Wings* (about 1878, Fig. 26) consists of ten pieces of paper, some only a few millimetres wide. Degas built up compositions by pinning tracings and partially completed pastels to a board and then extending them with other pieces of paper. When he had decided how much more space he required, he would take his work in progress to his *colleur* Père Lézin for mounting. Vollard simply records that 'Lézin, the framer, would glue them onto bristol board.'[27] It is known that Lézin would often first mount tracing paper on pure white paper in order to give it brightness and counteract its natural yellowness and its tendency to become even yellower – a phenomenon now apparent in many Degas pastels.

A well-known account by the collector Etienne Moreau-Nélaton describes a visit with Degas to Lézin's shop on the rue Guénégaud, in which Degas discussed adjustments to the size of a pastel on tracing paper before it was mounted: 'I gathered from his comments that the drawing spread out before me was just a preliminary study. Once mounted, it would be more convenient to work it into something finished.' One important factor was that the mounting process would disturb the existing pastel unless it was fixed first, and Degas demonstrated to Moreau-Nélaton that the work in question was indeed fixed: 'The fixative caused the coloured powder to bond securely to the underlying paper. To convince myself, a brisk rub of the fingertips against the pastel. It stood up to the test.'[28] The process of sticking down these partially worked sections and aligning all the joins would have required great skill: sometimes the paper wrinkled in the process. Richard Kendall has described one case where this happened and how Degas turned it to his advantage: unintended paper creases at the lower right of *Woman at her Toilette* (Art Institute of Chicago) were wittily adapted as folds in drapery apparently inserted into the composition for this very reason.[29]

If the structure of these pastels on composite supports – whether tracing paper or a more opaque wove paper – is examined, it is apparent that, at the heart of each, is one of Degas's repertoire of drawn motifs. If the composition was to be expanded beyond the basic motif, strips of paper would then be added piecemeal until the field was large enough for Degas to develop it. At the centre of *Dancers in the Wings* (Fig. 26), for example, the figure of the dancer adjusting her slipper exactly fills the central piece of paper, and is derived directly from a drawing of around seven years earlier (Fig. 27). Degas began with the idea of this single figure and then built the rest of the composition around it, adding strips of paper accordingly. Interestingly, precisely the same figure appears in a painting of *Dancers resting*

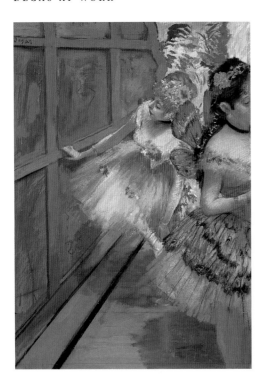
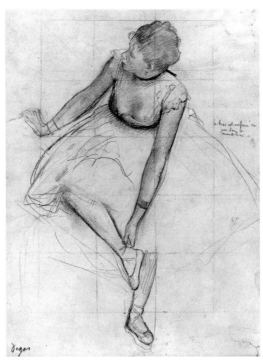

Fig. 26 *Dancers in the Wings*,
1880.
Pastel and tempera on paper,
mounted on paperboard,
69.2 × 50.2 cm.
Pasadena, California, Norton Simon
Art Foundation, inv. M1977.06.P

Fig. 27 *Dancer adjusting her
Slipper*, about 1873.
Graphite and charcoal heightened
with white chalk on faded pink paper,
33 × 24.4 cm.
New York, Metropolitan Museum of
Art. Bequest of H.O. Havemeyer,
the H.O. Havemeyer Collection,
1929, inv. 29.100.941

of 1874 (private collection) and beneath the Musée d'Orsay version of *The Dance Class* in which she has been painted out.[30]

A particularly informative example of the expansion of a composition from a single figure is *The Dance Lesson* (about 1879, Fig. 28). The dancer is positioned towards the left of the main piece of paper and strips have been added at the top and at the right – the latter apparently to accommodate the violinist, who certainly could not have been present originally since the join passes through his face. Fascinatingly, there is a partly legible inscription in pencil at the upper right, in Degas's writing: '9c à droite / 3c en haut / . . . coté pour . . . / refaire . . .' Since these measurements correspond to those of the added strips of paper, this appears to be an instruction to the *colleur*, possibly Lézin, to make the additions according to Degas's wishes.[31]

Many of the pastel colours that Degas used are likely to have been supplied by Henri Roché, whose range of brilliant colours in the later nineteenth century certainly corresponded with those used by the artist.[32] Ernest Rouart also maintained that Degas used bright and lightfast colours given to him by Chialiva. Vollard implies that Degas was concerned about fading and tried to remove fugitive colours before using pastels: 'What a devil of a job it is to bleach the colour out of pastel crayons! I soak them over and over again and even put them in the sun . . .'[33]

The evolution of Degas's style in handling pastel is complex. The dense, high finish of early works such as the portrait of *Mme Edmondo Morbilli* soon gave way to a more open way of

working, in which the structure of individual strokes and the colour and texture of the paper played a significant role. As with his oil painting and his work based on monotypes, Degas almost always set down a monochromatic framework before applying colour: this would usually be a charcoal drawing, stumped and blended to give shape and form. His subsequent manipulation of the pastel was brilliant, innovative and highly variable. At the simplest level, his repertoire of coloured strokes was remarkable: using the point or the side of a pastel stick, he achieved a remarkable variety of solid blocking, open patterns and latticed textures, each carefully weighted to suggest shape, form and surface within the composition. Superimposed networks of parallel strokes (*zebrures*), cross-hatching (*hachures*), and fluent or broken squiggles gave both notional and real depth and animation to his work. A pastel of the 1890s such as *Seated Woman in a Yellow Dress* (Fig. 29) uses such techniques vividly to suggest characteristic textures. The woman's skin is a fine, partly directional mesh of delicate yellow, pink and white, partly blended in the shadows; her hair is blocked in with close strokes of red over a solid dark base. Her silk dress is a shimmering tracery of yellow and white over the hint of a dark undermodelling; and the upholstery and wall consist of a bold grid of verticals and horizontals, suggesting harder, coarser materials. A different but equally varied range of fluid strokes and serpentine lines of colour make up *After the Bath, Woman drying herself* (Cat. 11).

But, as well as making direct marks with the dry pastel, he would also manipulate it with moisture and brushes or rags to create different effects. Various processes, including dry and wet brushing are evident in a number of works. Rouart also describes ways of moistening the surface by spraying or steaming and then brushing out the resulting paste into smoother, more blended passages: 'Naturally he took care not to spray the water vapour over the entire picture, reserving in some places the original pastel, so as to give him a different detail for the various elements making up the composition. He would not treat the flesh of a dancer in exactly the same way as her tutu, or the scenery might be given a different quality from the stage floor.'[34]

.Fig. 28 *Portrait of a Dancer at her Lesson* (*The Dance Lesson*), about 1879.
Black chalk and pastel on three pieces of wove paper joined together, 64.5 × 56.2 cm.
New York, Metropolitan Museum of Art. Gift of Adaline Havemeyer Perkins, in memory of her father, Horace Havemeyer, 1971, inv. 1971.185

Fig. 29 *Seated Woman in a Yellow Dress*, early 1890s.
Pastel on buff paper mounted on board, 71 × 58 cm.
New York, collection of Andrea Woodner and Dian Woodner, inv. W0-6

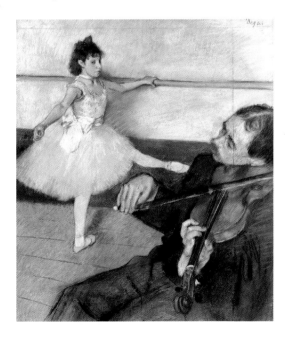

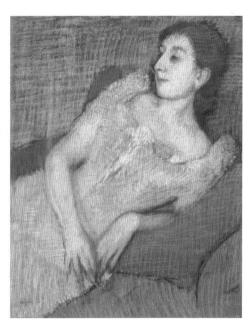

Something of the extraordinary diversity of technique that Degas might employ within a single composition is evident in a work such as *Woman at her Toilette* (Fig. 30).[35] Materials, surfaces and textures are represented with different modes of handling. Dry patterns of white, yellow and orange over a greenish background imitate the wallpaper; smoothly blended dark tones depict the frame and glass of the mirror. The thick towel at the left consists of a grey under-colour with coarse white zigzag strokes on top that project over the outlines and suggest the roughness of the cloth. The white gown and the bedclothes have been wetted with moisture or steam, scratched with a point in the shadows and worked and blended with a wet brush in the lights to convey the fineness of linen. The red-orange bed hanging at the upper right has a gritty texture that indicates successive layers of dried fixative and reworking with pastel on top. Degas's brilliant calculation of texture extends to colour effects also – in the repeated contrast of red-orange against blue-green, the multicoloured reflections in the china bowl and the toned shadows in the depths of the white fabrics.

The probable use of intermediate layers of fixative in parts of *Woman at her Toilette* raises the whole question of how – and how much – Degas fixed his pastels. The precise nature of the secret formula supplied by Chialiva is not known, but it may have been based on casein, which has been detected by analysis on some pastels. Denis Rouart wrote of Degas's admiration for the casein medium as used by the painter John Lewis Brown, and it has been shown that casein alters the surface of a pastel less than other glues or resins.[36] However, other likely fixatives have been detected, and it is probable that, as usual, Degas experimented with different materials.[37] It should be noted that such analyses are extremely difficult to

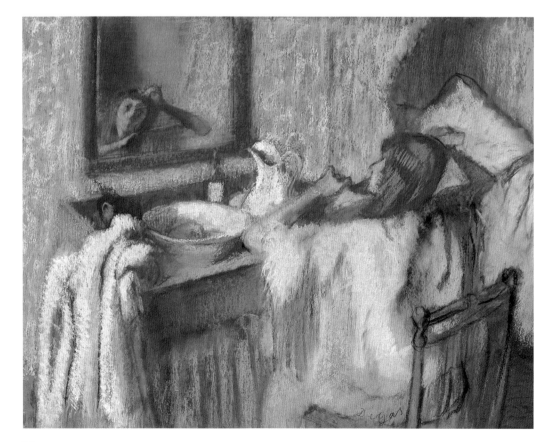

Fig. 30 *Woman at her Toilette,*
1895–1900.
Pastel on paper, 53 × 69 cm.
Copenhagen, Ordupgaard

carry out since the amounts of material are so small. What is certain is that fixing was a fundamental part of Degas's pastel technique, both for stabilising surfaces prior to the mounting process and to allow superimposition of colours without smudging or picking up the layer beneath. The slightly crystalline nature of dried fixative gave the grainy texture mentioned above which Degas exploited, often perhaps to counteract the uniform smoothness of the tracing paper support.

The late pastels are notable for their thick impasto-like structures, with alternating layers of pastel and fixative. Use of wetted pastel could cause clumping together and muddying of the lower layers that led to a dense, uneven build-up of colour and a pitted, almost cratered surface – accentuated, it is said, by burnishing the fixed colour. This is especially notable in the *Russian Dancers* series (Cat. 12), in which the surfaces are layered, pockmarked and blurred in a way quite unlike anything that had gone before. Repeated wetting and fixing also lowered the tonality and Degas would finish these works by applying brilliant passages of unfixed pastel that heightened the colour and supplied the final dazzling details.

Mixed media: oil, pastel, tempera and casein

Dating from the 1870s, technically the most experimental period of his career, there are a number of works by Degas in which it is difficult to be sure precisely what media – or combinations of media – he has used. As well as oil (used both conventionally and in the *essence* technique) and pastel (with or without a monotype base), Denis Rouart claimed Degas also used gouache, tempera and pastels ground up in water.[38] However, Rouart was relying on visual inspection for his conclusions and this, in general, can be unreliable. As an example, the technique of the portrait of Carlo Pellegrini in this book (Cat. 10) has been described in previous scholarly catalogues as a combination of oil, gouache and pastel – whereas close examination reveals it to be purely *essence* on laid paper. Similarly, *At the Café Châteaudun* (Cat. 5), long thought to be coloured with watercolour and gouache, has been shown by microchemical analysis to be in *essence*.

Recipes for unconventional paint media can be found in Degas's notebooks. For example, an entry in notebook 33 refers to a 'pastel-soap' (*pastel-savon*), in which ground-up pastel colours are mixed with water, glycerine and soda (or potash instead of soda) – although no evidence has emerged to suggest that Degas ever used such a mixture.[39] An important study by Fletcher and Desantis[40] has thrown light on some of the complex mixed media pictures of Degas's mid-career. Taking Rouart's observations as their starting point, the authors applied sophisticated analytical procedures to check his accuracy. They found no trace of animal glue tempera in any of the works they studied, but they did find egg tempera and also casein – used both as a pastel fixative and as a medium for turning crushed pastels into a thick aqueous paint. One of the paintings they examined closely was the famous *Dancers practising*

at the Bar, a painting on canvas originally owned by Henri Rouart, grandfather of Denis (Fig. 31). Denis Rouart had confidently asserted that the painting was executed solely in glue tempera – 'the well-known method of mixing hide glue and pigments . . . he did not bring any novelty to this method of painting'.[41] Theodore Reff, in his *Degas: The Artist's Mind*, stated that Rouart was 'incorrect', because he thought the painting was done entirely in *essence*.[42] In fact, Fletcher and Desantis showed that *Dancers practising at the Bar* was more complex than either Rouart or Reff realised. The basis of the painting is a fine *essence* paint, seen unmodified in the dark floor. Above the diagonal junction between floor and wall, however, the *essence* becomes progressively covered by a thicker, coarser and more cracked layer and the authors characterised the medium in these parts as egg-yolk tempera. They concluded that this was a home-made paint concocted by Degas from ground-up pastels and egg.

Etchings, Lithographs and Monotypes

For Degas, printmaking, like sculpture, was an essentially private activity. His first etchings, dating from 1856 when he was 22, were tentative and derivative landscapes, but his technique developed rapidly and he produced a striking self portrait in the following year that

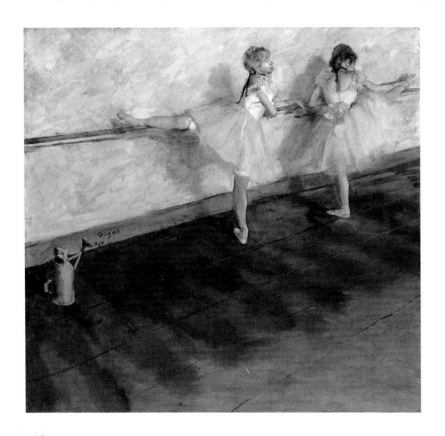

Fig. 31 *Dancers practising at the Bar*, about 1876–7.
Essence and egg yolk tempera on canvas, 74 × 80 cm.
New York, Metropolitan Museum of Art. Bequest of H.O. Havemeyer, the H.O. Havemeyer Collection, 1929, inv. 29.100.34

Fig. 32 *Self Portrait*, 1857.
Etching, 1st state.
New York, Metropolitan Museum of Art. Gift of Mr and Mrs Richard J. Bernhard, 1972, inv. 1972.625

Fig. 33 *Nude Woman at her Toilet, standing*, about 1891.
Lithograph, 31 × 20 cm.
London, British Museum, inv. P&D 1949-4-1131-93

developed through five states (Fig. 32). He began making lithographs around 1876, continuing into the 1890s and culminating in the monumental series of variations of a standing bather towelling herself after her bath (Fig. 33). Lithography was, Degas maintained, the perfect printmaking technique for a painter: 'If Rembrandt had known about lithography', Denis Rouart reported him as saying, 'God knows what he would have done with it.'[43] In all, he produced almost seventy etchings, drypoints, aquatints and lithographs. Despite this prolific activity, his prints were seldom seen in public; just four were published during his lifetime, and only a few were exhibited. The scale and experimental ambition of his printmaking only became apparent at his death, when nearly four hundred impressions of etchings and lithographs were found in the studio. The 1918 sale resulted in this extraordinary treasure trove of working proofs, trial impressions and unique states being dispersed to collections all round the world and it has been difficult to reconstruct precise sequences in some cases.[44]

The sheer novelty of Degas's approach to printmaking is conveyed by one of the most complex of his prints, *Mary Cassatt at the Louvre: the Paintings Gallery* of 1879–80, made during an intensely experimental period. Combining the techniques of etching, aquatint, drypoint and 'electric crayon', it proceeded through at least twenty states, with some impressions that were retouched in pastel (Fig. 34). The electric crayon, possibly the same as the 'voltaic pencil' mentioned in a notebook entry of 1878, seems to have been made from the carbon filament of an electric light bulb and became a favourite etching instrument. Notebook pages for the late 1870s and early 1880s are full of detailed technical jottings about printmaking methods, and a letter from Degas to Pissarro in 1880 discusses aquatint and soft-ground etching techniques at considerable length.[45]

It is widely agreed that Degas's most remarkable and original achievements in printmaking were his monotypes. Indeed, he can be said to have invented the modern monotype: he claimed the process as his own and was certainly unaware of any precedents.[46] It is, of course, debatable whether a monotype should be classified as a print at all since it is a technique that falls somewhere between a print and an original drawing. Degas himself disliked the word and, according to Lemoisne, preferred to refer to such works as 'drawings done with greasy ink and printed'.[47] As this description implies, monotypes were produced by drawing in an oily ink or paint on a metal plate or other smooth surface. By pressing a damp sheet of paper to the surface, a proof was pulled; this would generally use up most of the ink, but sometimes another, much paler, proof

could be made – and it was these pale second proofs that Degas frequently used as the basis for pastels (see p. 28).

There are two principal strategies of monotype production: in the first, the plate is uniformly inked, and then wiped away with rags or brushes or fingers to create lighter areas. In these 'dark field' monotypes, pale forms emerge from darkness. The first monotype that Degas made – with the help of his friend Count Ludovic Lepic in the summer of 1876 – *The Ballet Master*, was of the dark field type, and a second, paler impression was used for a coloured pastel (see Figs 23 and 24). In the second technique, the 'light field' method, the clean plate is used for a straightforward drawing and the proof has the more conventional look of dark outlines on white paper. An example of this way of working is the brilliant little double portrait of a man and a woman of around 1880, now in the British Museum (Fig. 35). A third, hybrid technique combines the dark and light field manners, partly inking and wiping the plate and partly drawing with line. What links all three methods and gives any monotype its unique character is the physical manipulation of the ink on the plate – the scoring of a stylus, the drag and roll of a rag, the tracks of a brush and, everywhere in Degas's monotypes, the dabbing of fingerprints and palm prints.

The definitive, monumental catalogue of Degas's monotypes by Eugenia Parry Janis published in 1968 listed a total of 321 extant or lost works, including those that were in their original black and white state, second and third proofs, and those that had been subsequently coloured with paint or pastel.[48] Janis plausibly suggested that the initial function of many of the dark field monotypes was to serve as the basis for coloured images – as we have seen, around 100 of Degas's 700 pastels were built on monotype foundations. But it is also clear that Degas became more and more interested in the possibilities of tone and texture that uncoloured monotypes provided and in the suitability of the technique for capturing the intimate and private worlds in which he moved. The range of subject matter that he explored in the monotypes has become well known in recent years, particularly the witty and explicit brothel scenes. On a strictly practical level, however, we should be cautious about assuming that such depictions were direct transcriptions from the subject. As Kendall has pointed out, the monotype process is very much a studio-based activity, depending as it does on the preparation of plates, the manipulation of inks and the use of some sort of printing press to make the impression.[49] Since very few of the monotypes can be linked to specific drawings, the conclusion must be drawn, therefore, that Degas was relying on his prodigious memory for nearly all of these extraordinary images.

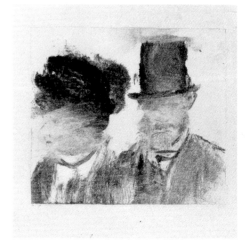

In the autumn of 1890, Degas began a completely novel series of monotype landscapes in colour, using thinned oil paint on his plates. He was visiting the country house in Burgundy of his friend Pierre-Georges Jeanniot, and said that the highly abstract images that he produced were inspired by the landscapes that he saw on the way there.[50] Jeanniot wrote a vivid account of Degas at work, 'in raptures' producing three or four monotypes each morning:

> With his strong but well-shaped fingers he grasped hold of each object, each tool of his genius, wielding it with surprising dexterity so that little by little there appeared on the metal surface a valley, a sky, white houses, fruit trees with black branches, birches and oaks, ruts full of water after the recent shower, orange tinted clouds scudding across a turbulent sky above the red and green earth. [...] When everything was ready, the plate placed on the press and the paper laid on the plate, Degas said: 'What a terrifying moment! Go ahead! Start turning!' Once the proof was obtained it was hung up to dry.[51]

Some of the landscape monotypes were further elaborated with pastel, but others, such as *A Lake in the Pyrenees* (Fig. 36), were left just as they came off the press.

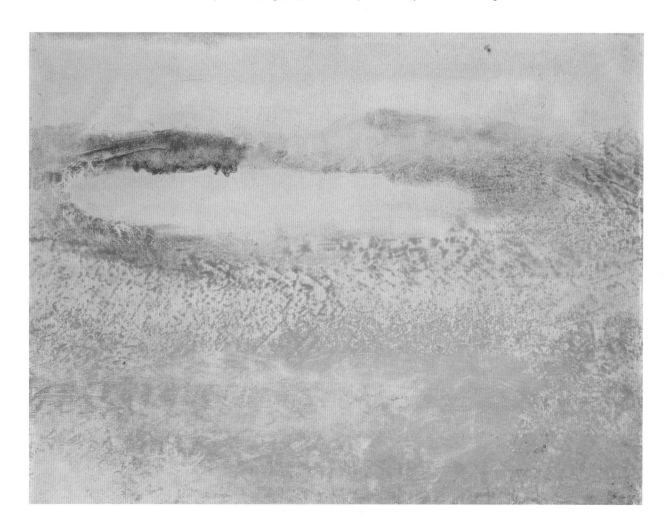

Sculpture

Degas's work as a sculptor was hardly seen by the world at large during his lifetime. He publicly exhibited only one sculpture, the *Little Dancer aged Fourteen*, in the sixth Impressionist Exhibition of 1881 (see Fig. 8). It had been announced for the 1880 exhibition but it did not appear, and rumours circulated about Degas's difficulties in finishing it. Even at the start of the 1881 show, the glass case intended for it remained empty and it was finally installed just three weeks before the exhibition closed. The critics' reaction to *Little Dancer aged Fourteen* was almost unanimously hostile, but a perceptive minority view was supplied by Joris-Karl Huysmans who described its 'terrible realism' and commented: 'At once refined and barbaric, with her costume and coloured flesh, palpitating, lined with the work of its muscles, this statuette is the only truly modern attempt I know in sculpture.'[52] It was indeed a work of extraordinary realism, made of coloured wax and real hair, and dressed with silk and satin clothes, ribbons and canvas shoes. The hair, bodice and shoes were thinly coated with tinted wax to unify the structure and introduce teasing ambiguities into the material novelty of its construction.[53] Modern X-ray studies have shown that the wax figure was built up around an elaborate armature of metal and wire.[54]

Vollard described Degas at work on his sculptures, claiming that when his eyesight became too bad, he gave up painting for sculpture: he is famously supposed to have said, 'I must learn a blind man's trade now.' One day, he showed Vollard a little dancer that he had remade for the twentieth time:

> 'I believe I have got it at last,' he announced, 'One or two days more work and it will be ready for the caster.' The next day, however, all that remained of the little dancing girl was the original lump of wax from which she had sprung. Seeing my disappointment, Degas said: 'All you think of, Vollard, is what it was worth. But I wouldn't take a bucket of gold for the pleasure I had in destroying it and beginning over again.'[55]

Although this anecdote implies that sending works to the caster was a routine procedure for Degas, the extent of his replicating sculptures by casting remains unclear and was probably quite limited. A close study of mould lines on the wax *Nude Study for the Little Dancer aged Fourteen* (Fig. 37) concluded that it was largely cast and not modelled as had previously been assumed – the arms, in a different wax, were modelled and attached later.[56] The *Nude Study* may have been cast around 1900 from an earlier version of 1878–9, now lost.[57] This was when he had three of his other sculptures cast in plaster – but these are the only instances we know about. None of the many bronze casts of Degas's sculptures now seen in collections around the world existed in his lifetime.

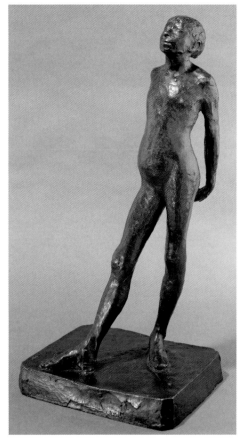

Fig. 37 *Nude Study for the Little Dancer aged Fourteen*, about 1890. Wax, 72.4 × 33.7 × 30.5 cm. Washington, DC, National Gallery of Art, collection of Mr and Mrs Paul Mellon, 1985, inv. 1985.64.67/SC

When he died, around a hundred and fifty pieces of sculpture were found in his house, made variously of wax, clay, wood, cork, and plasteline (a modelling material), many of them on crude armatures, all of them fragile. Joseph Durand-Ruel, who drew up the inventory of Degas's studio wrote afterwards:

> Most of them were in pieces, some reduced to dust. We put apart those that we thought might be seen, which was about one hundred … Out of these, thirty are about valueless, thirty badly broken up and very sketchy; the remaining thirty quite fine … They have all been entrusted to the sculptor Bartholomé, who was an intimate friend of Degas, and in the near future, work will be started by the founder Hébrard …[58]

After much careful repair,[59] seventy-two sculptures were cast in bronze and exhibited by Hébrard in 1921. Two others, *Little Dancer aged Fourteen* and *The Schoolgirl* were cast later. The procedure for each of the seventy-two was to make moulds directly from the fragile sculpture and then to cast a 'master bronze' or *modèle*. An edition of twenty further casts (lettered A to T), plus two for the foundry, was made for each sculpture, but using the *modèle* for the gelatin mould rather than the original. Although this sequence of operations is well documented, it is also possible to check technically. The *modèles* are about two per cent smaller than the original sculptures and the subsequent casts are about two per cent smaller than the *modèles*, as a result of the bronze contracting as it cooled inside the mould. There is also an appreciable loss of precision and surface detail in moving from the original wax to the *modèle*, and then to the edition of twenty-two. The original wax sculptures remained with Hébrard until 1955 when they were bought by Paul Mellon. The *modèles*, the master bronzes, were sold in 1976 and are now in the Norton Simon Museum, Pasadena.

Little Dancer aged Fourteen was not one of the seventy-two editioned by Hébrard, and the precise sequence of producing the numerous bronze casts of the figure remained obscure for many years. In particular, the *modèle* for the series was not identified – until important and enthralling research led to the conclusion that it was not a bronze at all, but a plaster cast now owned by the Joslyn Art Museum, Omaha.[60] The cast was made by the Hébrard foundry, and plaster was probably preferred to bronze because of the size and complexity of the sculpture: it would be lighter, would not contract on setting and would preserve surface detail more precisely. On the other hand, it would be more fragile and less able to withstand the repeated taking of moulds for the subsequent bronzes. For this reason, a second plaster *modèle* was made that is now in the National Gallery of Art in Washington. Both plasters were later coloured and adorned with hair ribbons and skirts, so they are now difficult to distinguish visually from the bronze casts that they preceded.

Frames

The conception of the painting being a fragment of continuous space, captured as if viewed through a window, was a notion that had first seen expression in the time of the Italian Renaissance. Nineteenth-century painters extended this idea, making the picture an imitation of the world and the frame thus took the role of a window frame: 'corners of nature seen by a quick glance, as if through a porthole briskly opened and closed', as Félix Fénéon once described the work of the Impressionists.[61] The frame could be a real extension of the pictorial space and some painters made use of this 'window' to have the subject of their painting encroach dramatically into the real world of the spectator, as, indeed, other artists had done in earlier times. However, for artists such as Degas, Camille Pissarro, James McNeill Whistler, across the English Channel in London, and many of their contemporaries, the frame was part of a continuum from wall to painting; it was a decorative border for the painting, but should be a harmonious one. This is demonstrated by the use of first white, then coloured, frames by painters such as Pissarro, Mary Cassatt and, later, Georges Seurat and his friends.[62] From this point of view, the traditional heavy gold frame was not appropriate: as Degas once told the collector Louisine Havemeyer, such frames crushed his pictures.[63]

Degas's interest in the framing of pictures continued throughout his career.[64] He saw the design of a picture as a whole – frame and painting – and his notebooks include examples of studies for paintings, and of paintings, within their frames. His painting of *The Bellelli Family* was sketched with its frame in about 1858; a detail of the frame with its outer border of restrained moulding with a classical motif and a relatively uncomplicated profile, shown against the wallpaper, was also drawn. A tiny sketch of *The Daughter of Jephthah* (Smith College, Northampton, Massachusetts) in a similar carved frame appears in another notebook.[65] Degas wanted the frame to harmonise with and to support a painting. In the depictions of framed pictures within his paintings, as much attention is paid to the design of the frame against the wall covering as to the picture portrayed.[66] Some of the details sketched in his notebooks are clearly of traditional ornate gold frames, with intricately carved mouldings, very different to those he designed for his own use. An example is the elaborate corner moulding of the frame of Rubens's *Birth of Louis XIII* (Musée du Louvre, Paris), which was then displayed in the Grande Galerie. The detail was used in a pastel of Mary Cassatt at the Louvre, a theme he revisited many times.[67]

The deep profile of many traditional gold frames threw a shadow across the painting, and the wall, spoiling any illusion of blending between painting, frame and the space around. A flatter profile to the frame gave a more harmonious result. Degas's design's for frame profiles all have a very low relief and are flat where they meet the picture plane, minimising effects of shadow. They are softly rounded, sometimes with shallow parallel grooves, giving a very

elegant frame which the artist particularly liked. Another moulding type had a more serrated edge: his 'cockscomb' frame, as Ambroise Vollard described it.[68] These designs would be presented to the framers he used at various times. In the 1860s and 70s he ordered frames from Poultier, whose workshop was near his studio at that time, while in the following decades he patronised the same framer as Pissarro, Pierre Cluzel, and occasionally used other framers as well.[69]

The frames could be coloured, or white; some of the profile designs have annotations describing them as 'coloured' (Fig. 38). According to Vollard he liked frames to have the bright colours used for painting garden furniture, but when Louisine Havemayer bought *The Rehearsal Onstage* (Metropolitan Museum of Art, New York), one of her earliest purchases made on the advice of Mary Cassatt, Degas had framed it in a soft dull grey and green frame, which harmonised with the scenery and soft dresses of the dancers.[70] Certainly the frames that still survive are subtly coloured and in no way garish. If the circumstances called for it, and the colour of gold would harmonise with the painting and with the surroundings, then he would use an appropriate gold frame.[71] His concern over the colour of the frames extended to that of the mount for his works on paper and he is recorded as liking a blue, sugar-paper mount for drawings, rather than bevel-edged mounts, which he described as detracting from the subject. The emphasis is thus on the flatness of the picture plane and its continuity with its surroundings.[72]

DB, JK, AR

Fig. 38 Studies of frame profiles, 1878–9.
16.7 × 11.1 cm.
Paris, Bibliothèque Nationale, Département des Estampes, carnet 23, p. 9

Two drawings on the right are annotated 'or ou couleur' [gold or colour] and 'couleur'; in the latter case Degas has indicated the part of the frame closest to the picture, although this may be a coincidence. This part of the profile (on the right of each study) is flat, its plane barely higher than the picture surface, allowing picture and frame to blend into one another.

Degas and the National Gallery

The National Gallery owns eleven paintings by Degas, covering the length and breadth of his career, from the early history painting, *Young Spartans Exercising*, to the late explorations of dancers and women at their toilette. There is also a group of French nineteenth-century paintings formerly in the artist's own collection that was purchased by the Gallery at the auction in 1918 after his death in 1917. Not only can the Gallery's active acquisition of foreign nineteenth-century paintings be said to begin with this sale, but also the realisation that Degas himself was an artist whose works should be acquired for the national collections. However, the process of collecting was a slow one, and at times controversial; indeed, one of Degas's paintings, *Combing the Hair* (*La Coiffure*), which the Gallery considered acquiring at the sale, ultimately came into the collection only in 1937. That some debate surrounded its possible acquisition in both 1918 and 1937 demonstrates the Gallery's sometimes hesitant approach.

The Degas Sales

For the last five years of his life Degas had lived as a recluse in rooms at 6 boulevard de Clichy in Montmartre. In these last rooms much of his own work was simply piled against the walls, although some of his collection was unpacked and displayed. After his death the contents were dispersed in two sales, the first in March 1918 being devoted to his collection and the second in May to his own paintings, drawings and prints.[1] Prior to his death his collection was not widely known outside his own circle of fellow-artists, dealers and collectors, and the sale was a revelation. There were a few old masters, including two El Grecos and a painting then attributed to Aelbert Cuyp, but for the most part it was devoted to French artists of the nineteenth century, and dominated by Degas's idols, Ingres, who had been his teacher, and Delacroix. Degas owned twenty paintings and 88 drawings by Ingres and thirteen paintings and 129 drawings by Delacroix. Representing Degas's own contemporaries were paintings by Corot, Manet, Van Gogh, Cézanne and Gauguin, but practically no landscapes by his fellow Impressionists, nothing by Monet and only a few works by Sisley and Pissarro. He had also collected a large body of graphic work, including lithographs by Daumier and Paul Gavarni, graphic work by Manet and prints by Pissarro,

Mary Cassatt, Gauguin and Whistler.[2] In the 1890s Degas started to record and document his collection, preoccupied with a scheme to preserve it intact as a privately run museum. The scheme was never realised, and it is probable that he was put off by his visit in 1903 to the newly opened Gustave Moreau Museum, which he found had the air of a mausoleum.[3]

The National Gallery bid at both the sales, although it fared a great deal better at the first.[4] The art critic Roger Fry appeared to be the only person in England to receive a copy of the catalogue of the collection sale, and he relayed its contents to the Gallery's director Sir Charles Holmes. At the same time he published a note on the sale in the *Burlington Magazine* in which he concluded: 'It seems a pity that the French nation is not able to keep together in the Louvre this magnificent collection, a collection chosen with a discrimination that no board of museum directors can ever hope to rival.'[5] Despite this published opinion he was keen for the National Gallery to acquire works from the sale. But funding had to be sought before any purchases could be contemplated. The National Gallery's purchase grant had been withdrawn at the beginning of the First World War and the Government would not have deemed it politic to give money for such a venture. It was the economist Maynard Keynes, who had a temporary position in the Treasury during the war, who stepped in to help, approaching Sir Charles Holmes and asking him to see Lord Curzon, then both a Trustee of the National Gallery and a member of the cabinet, and gain his support for Keynes's plan regarding the sale.[6] The result was that the equivalent of £20,000 in francs was placed at the British Embassy Account in Paris, and Keynes arranged for Holmes to join the International Financial Mission which was travelling to Paris to take part in an Inter Ally Conference.[7]

At this sale the National Gallery bought thirteen paintings, including pictures by Ingres, Delacroix, Corot, Gauguin, Manet (Fig. 39) and others.[8] It was an immensely significant purchase which increased immeasurably the Gallery's holdings of nineteenth-century painting, and added works by artists hitherto unrepresented in the collection, including Gauguin.

Fig. 39 Edouard Manet,
The Execution of Maximilian,
about 1867–8.
Oil on canvas, 193 × 284 cm.
London, National Gallery,
inv. NG 3294

The Gallery of Modern Foreign Painting

The purchase also marked the end of a period of indecision and confusion regarding the collection of modern foreign artists – although it remained unclear where responsibility for this lay. Since around the turn of the century the National Gallery had been singled out for criticism for its lack of interest in modern European painting.[9] In fact, its constitution meant that it could not buy or accept works by living artists and according to the critic Frank Rutter, the National Gallery Trustees had refused the offer of a painting by Degas in 1905.[10] But on the other hand, it had not attempted to acquire works even by dead artists such as Manet, as these were felt to be too advanced in style and not appropriate for a collection which was perceived to be of established old masters. The National Gallery's sister institution, the Tate, had been founded in 1897 as a collection of contemporary British art, and during the 1900s housed all the Gallery's nineteenth-century paintings, including works by Paul Delaroche, Rosa Bonheur, Henri Fantin-Latour and François Bonvin, as they were closer to the Tate's collection in date. Although no attempt was made to add to them, there was a growing awareness that Britain lacked a clear policy regarding the acquisition of modern foreign art. In 1914 an official report on this issue by Lord Curzon recommended that the formation of a collection of foreign paintings was 'not merely a duty imposed on us by the wise example of foreign countries, but is also essential to the artistic development of the nation'.[11] As a result, in 1917 the Tate was given its own Board of Trustees, and its remit was extended to modern foreign painting, for which a new gallery was to be built. Astonishingly it had no purchase fund with which to make acquisitions for the new gallery, and it was with difficulty that the Tate attempted to extend its collections of modern French painting over the next few years[12] – a fact which might help to explain the continuing confusion about who should take the initiative over acquisition of modern foreign paintings.[13]

Degas and Britain

If Degas was among those artists caught by the vagaries of acquisition policies, this was not a reflection of the esteem in which he was held in Britain.[14] Since the 1870s Degas's work had been shown regularly in London and was the subject of a number of articles, the earliest by Sidney Colvin in the *Pall Mall Gazette*, 28 November 1872.[15] He was one of the first modern French artists to find favour in England, and the first to be bought by private collectors, among them the artist Walter Sickert, Henry Hill (who by 1876 owned the finest collection of his works in Europe), and wealthy industrialists, philanthropists and the gentry, such as Sir William Eden, Constantine Ionides, William Burrell, founder of the great Glasgow collection, and James Staats Forbes.[16] By 1918 a few works by Degas had also entered national collections. In 1900 Ionides bequeathed his collection to the Victoria and Albert Museum;

it included the *Ballet Scene* from Meyerbeer's opera *Robert le Diable* (see Fig. 4), making this the first Degas to enter a public collection in this country. In 1905 Degas's *Young Girl with a White Scarf* (Fig. 40) was one of 43 works bought for the Gallery of Modern Art in Dublin by subscribers from the Staats Forbes estate. And in 1916 his portrait of the celebrated caricaturist Carlo Pellegrini (Cat. 10) was presented to the Tate by the National Art Collections Fund, the purchase money being provided by Lord Duveen.

The critical reaction to Degas's work was generally very favourable, with the notable exception of the storm surrounding *The Absinthe Drinker* (Fig. 41).[17] This picture, formerly in the collection of Henry Hill, was later lent to the inaugural exhibition of the Grafton Gallery in 1893. Entitled *L'Absinthe* in the catalogue and eulogised by D. S. MacColl in *The Spectator*, a battle ensued around its controversial subject matter.[18] In later years MacColl recalled the row: 'I rashly ventured to prophesy five years ago, that within that space of time Degas would hang in the National Gallery. The present administration has seen to it that the prophecy should be falsified.'[19] In the same article MacColl described Degas as 'the greatest living virtuoso of drawing'. This statement echoed a widely held view among British critics. George Moore wrote of the importance of Ingres in the work of Degas, arguing that this emphasis on drawing held him apart from Impressionism.[20] It was perhaps Degas's supreme ability as a draughtsman which brought him into such favour in this country. At the sale of his collection the predominance of pictures by other noted draughtsmen gave authority to his own skill and awakened in the authorities the realisation that this artist was vital to the national collections.

Fig. 40 *Young Girl with a White Scarf* (*Jeune Fille au Fichu Blanc*), 1871–2. Oil on canvas, 40 × 32 cm. Dublin, Hugh Lane Municipal Gallery of Modern Art, inv. 547

Fig. 41 *The Absinthe Drinker* (*L'Absinthe*), about 1875–6. Oil on canvas, 92 × 68 cm. Paris, Musée d'Orsay. Bequest of Count Isaac de Camondo, 1911, inv. RF 1984

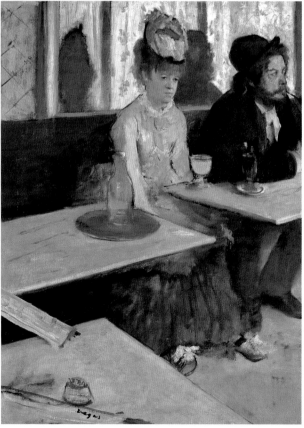

The Degas atelier sales

Nevertheless, when the artist's own studio work was put up for sale in May 1918, the Director Sir Charles Holmes and the Trustees of the National Gallery did not anticipate fierce competition, despite the fact that only a few months earlier, in March 1918, pictures by Degas in the London sale of the British collector Sir William Eden – in which the Gallery had not even bid – had fetched substantial prices. When Holmes heard of the sale he decided to act, and again enlisted the help of Maynard Keynes. He admitted in his letter to Keynes that Degas fell into the sphere of the new Gallery of Modern Foreign Art at the Tate, but wanted to know whether the generosity shown for the collection sale could be extended for this sale, 'and a part, or all, of the unexpended balance of our Grant be placed at their disposal for the Degas sale'.[21] He more specifically suggested the amount of £3,000 to £5,000 to Lord Curzon, stating that such a modest grant would suffice 'in the circumstances', while acknowledging that in any other circumstances £15,000 or £20,000 would be needed.[22] Holmes was confident that the continuing war would dampen interest in the sale, and the Gallery's success at the collection sale would be repeated. In fact, a total of £11,780 had been spent at the collection sale, which left more than £8,000 to be returned to the Exchequer, but the grant allocated was only £3,000, as Holmes had suggested. In the same letter to Lord Curzon, Holmes suggested four paintings (numbers 4, *Portrait de Famille*, 8, *Mlle Fiocre*, 44, *La Coiffure* (*Combing the Hair*) and 46, *Au Foyer*), stating that he would be drawing up a fuller list with Charles Aitken, the Director of the Tate Gallery. At the same time Roger Fry wrote a letter giving his preferences, all late works, and advising that they should go for one of the *Sortie de bain* series. As an example, he referred to a pastel, *Woman at her Toilet* (about 1894, Fig. 42), which at that time belonged to the collector Frank Stoop:

> As the sum is a small one I shd. be inclined to go for one fine example of the later work. I think we agree that the Stoop picture wh. was at the Burlington is the greatest type of Degas. I mean much finer that the thin tight early work (*And a propos of this remember that such thin work looks better in reproduction than in the original) I suppose there might be objection to a pastel tho' I think it wld. be quite safe in a public gallery.[23]

It is certainly true that there was a large amount of the late work in the sale. What was left in Degas's studio was not a representative body of work, but corresponded in some part with what he wanted for his museum: copies after Old Masters and early compositions from the 1860s, portraits, unfinished works from the end of his career, drawings and prints.[24] Also included was a series of large canvases, executed with the museum in mind in the second half of the 1890s, perhaps to counterbalance the large numbers of unfinished works. These were big, ambitious pictures, revisiting subjects central to his oeuvre – dancers on the stage, in the rehearsal room, a woman after the bath, a racing scene, and combing the hair (see

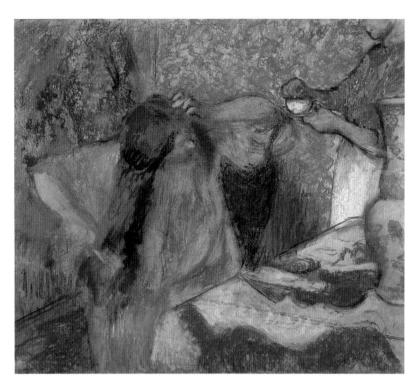

Fig. 42 *Woman at her Toilet*, about 1894.
Charcoal and pastel on paper, 95.5 × 110 cm.
London, Tate, inv. TO 4711

Fig. 43 *Head of a Woman*, about 1874.
Oil on canvas, 32.1 × 26.7 cm.
London, Tate, on loan to the National Gallery. Presented by Viscount d'Abernon and Lord Duveen, 1919, inv. L700 (TO 3390)

La Coiffure, Cat. 14). But absent were Degas's finished paintings of the 1870s and 1880s, ballet scenes, scenes at the races and of laundresses, pictures which he had sold at this period. There were also some works, presumably unfinished, that Degas did not even want to be seen, and having abandoned his idea of a museum, had requested to be destroyed after his death. Ernest Rouart had been entrusted with this task but had not carried it out.

On this occasion Holmes was unable to get across to Paris to the sale, and it was decided that Eric Maclagan of the Victoria and Albert Museum, who was already in Paris, should bid on the Gallery's behalf. A typed memorandum, repeating Holmes's four choices, stated that the Treasury did not wish to have its grant spent on pastels or sketches.[25] The National Art Collections Fund had therefore decided to ask Maclagan to spend up to £600 acquiring what he could on a separate list of such works, not expending more than £300 on any one picture. The memorandum ended:

> With due regard to the intrinsic merits of the pictures themselves and as far as the exigencies of bidding allow it is desirable that one or a fair proportion of each class – Portraits, Racing Subjects, Ballet and Nude – should be purchased.[26]

But in the event not a single picture was bought with the Treasury Grant, and the National Art Collections Fund was only able to buy *Princess Pauline de Metternich* (Cat. 2), which it presented to the Tate.[27] A further painting, *Head of a Woman* (Fig. 43) was bought by Stettiner

on behalf of Lord d'Abernon who, with Sir Joseph Duveen, presented it to the Tate in 1919. In a letter of 14 May 1918 to Lord Curzon following the sale, Holmes explained that Maclagan was not able to acquire any of the paintings because of high prices:

> The prices fetched at the Sale were a surprise, as, in spite of the very large number of pictures in the Sale and the moment at which it was held, everything at all good fetched quite a fair price, though if the Grant had been free from limitations to certain pictures, there might have been more chance of securing bargains.[28]

In this letter the four pictures listed in the previous memorandum were given, with the prices fetched (a total of around £16,000), except that No. 44, *La Coiffure* was replaced by no. 48, *Portrait of Edmond Duranty* (Fig. 44).[29] In another letter of 13 May 1918 from Holmes to Curzon five paintings are mentioned, the fifth being No. 13, *Les Malheurs d'Orléans* (*Scene of War in the Middle Ages*), which was bid for by the Musée du Luxembourg in Paris.[30] So it appears that only five paintings were considered of paramount importance, although a number of other pictures were also bid for and Maclagan received yet further instructions during the sale.[31] *La Coiffure* was subsequently bought by the Gallery from Pierre Matisse, the son of Henri, in 1937, the first Degas to be acquired since the 1918 studio sale. In the discussions regarding its purchase the Director reminded the Trustees that:

> ... the picture was one selected by Sir Charles Holmes for purchase at the Degas Sale in 1918, the selection being approved by the Board at the time. At the last minute the picture

Fig. 44 *Portrait of Edmond Duranty*, 1879.
Tempera, watercolour and pastel on linen, 100 × 100 cm.
Glasgow Museums, Burrell Collection, inv. 35/2332

had been crossed off the list by the Chairman, Lord Curzon, as being too coarse. It sold for the equivalent of about £1,000, so that as the Gallery limit for any individual picture was £600 it could not in any event have been acquired.[32]

There followed a flurry of criticism of the Gallery's performance at the sales in the *New Statesman*, which published two articles in October 1918 by a writer signing himself as Sardonyx or Onyx, and identified by Holmes as Arnold Bennett. The author claimed that not more than £1,000 could be spent on any one painting, and that no nudes or ballet subjects were to be bought, for which he laid responsibility at Lord Curzon's door.[33] Holmes's response was printed on 9 November, in which he explained that he was the person who had suggested the amount of £3,000. He also printed his original list of four pictures, including *La Coiffure*:

> Not a bad list I think you must admit. It was afterwards, of course, greatly extended. Our aim was the perfectly legitimate one of getting an important work in oil with the Government grant, and for that reason the slighter studies, including pastels and sketches from the nude, were left to the National Art-Collections Fund, who had very generously raised a fund for the purpose.

It is possible that the *New Statesman* got some of the detail wrong, but equally likely that Curzon's poor opinion of *La Coiffure* was leaked, and his influence over the choice of pictures exaggerated.

There is also a draft letter from Holmes in response to this criticism, explaining that because the prices at the collection sale had been so low, it was thought that the prices at the next sales would follow suit. It is likely that he put this down to the war and would not have taken into account the prices fetched at the earlier sale of Sir William Eden's collection, if indeed he knew them. He thought at first that the Gallery might be able to get such pictures for £1,200 or so – which would explain this amount being marked against two of the pictures – but when he was informed that efforts were being made to keep prices up, he changed the programme so that the whole of the grant could if necessary be devoted to a single picture.[34]

Reports in *The Times* give an indication of the prices. For example No. 8, *Mlle Fiocre in the Ballet 'La Source'*, (Fig. 45) sold for £3,200,[35] while the bidding for No. 46, *Dance Exercises*, started at £400, but eventually reached £4,008.[36] The paper also commented on the popularity of the sale:

> The Degas Sale is quite the most talked about event of the moment. At the exhibition of the collection before the sale the crowd of visitors was so great that it was almost impossible to see any of the pictures on the line. Buyers of all categories are there, and lovers of art from many classes.[37]

In fact, the prices are not substantially higher than those fetched for Degas's works in the Eden sale. In this a gouache and pastel, *Dancer* (now Norton Simon Art Foundation, Pasadena) sold for 2,000 guineas, and *Laundresses carrying Linen in Town* (now private collection), painted in *essence* on paper mounted on canvas, went for 2,800 guineas.[38] A third drawing, a fan design in gouache of dancers (Fig. 46), was bought by Mr Ernest Hill for presentation to the nation.[39] It was legally made over to the Tate, but he decided to wait for a more fitting time to present it.[40] In the end the painting never entered the Tate's collection, and is now in the Tacoma Art Museum, USA.

The Lane Bequest

Even in Degas's lifetime, the National Gallery Trustees had to consider the place of this and other modern artists in the collection. In the early years of the twentieth century the possibility of the loan and potential acquisition of another important group of modern European paintings was in the offing. In 1904 Hugh Lane, the Irish-born art dealer and museum director, mounted an exhibition in Dublin with a view to establishing a gallery of modern art in the city.[41] He borrowed 164 works from the executors of James Staats Forbes, an influential railway manager and art connoisseur, and inspired by the collection also went to Paris with William Orpen, the portrait painter and a fellow-Irishman, to borrow works from the dealer Durand-Ruel. A number of these paintings were purchased by subscribers for the gallery, including Degas's *Young Girl in a White Scarf*. At the same time Lane was acquiring a number of paintings for his own private collection, which was added to in subsequent years. The collection as it stood had been offered on loan to the National Gallery in 1907 but this offer was not taken up.[42] It was then placed on loan to the newly founded Dublin Gallery of Modern Art in January 1908, where it was housed in a temporary building. When in 1913 the Dublin Corporation rejected Lane's plans for a permanent home, he wrote again to the National Gallery in London to offer his collection of paintings on loan. In September of that year the pictures were moved to London and in October, unknown to the Trustees, Lane drew up a new will bequeathing them to the permanent ownership of the Gallery.

Included in the group was Degas's *Beach Scene* (Cat. 6), a painting much admired by Orpen, which was bought by Lane from the sale in 1912 of the great collector and friend of Degas's, Henri Rouart. When writing of the 1904 Paris trip with Lane, Orpen noted:

> . . . he knew nothing at all about modern French painters. I was with him at Durand-Ruel's, and he would say to me, behind his back, 'What is that? A Manet?' – he had never

Fig. 45 *Mademoiselle Fiocre in the Ballet 'La Source'.* 1867–8. Oil on canvas, 130.8 × 145 cm. New York, Brooklyn Museum of Art. Gift of A. Augustus Healy, James H. Post and John T. Underwood, 1921, inv. 21.111

seen Manet before – and 'What is that other? Is it one I should ask for to bring to Dublin?' But in a very short time he had made that great collection you are fighting for. He trusted his own taste. That 'Seashore' of Degas's he bought was a discovery.[43]

The National Gallery now had a chance of acquiring the Lane collection on loan. At the Board Meeting of 13 January 1914, and even though the collection had already been accepted, the Trustees chose to make a selection of fifteen of the paintings which they considered worthy of hanging in the Gallery. It was acknowledged, however, that this group of fifteen paintings was not necessarily the final choice, and the Director, Sir Charles Holroyd, was authorised to obtain outside opinion on the collection from the painter John Singer Sargent and D. S. MacColl, a former Keeper of the Tate Gallery and at that time Keeper of the Wallace Collection. Not knowing about the existence of Lane's new will, and without waiting for either Sargent's or MacColl's reports, the Director wrote to Lane on 15 January 1914 stating that only fifteen of the paintings could be accepted, asking him what his final intentions were regarding the pictures, and reminding him that paintings were only exhibited at the National Gallery in cases where there was a reasonable chance they would later be acquired.[44] Despite Degas still being alive, his painting was one of the fifteen chosen, although only after some debate.[45] Both MacColl's and Sargent's reports agree on its importance. MacColl divided the pictures into three groups, the first group being the best pictures, including the Degas, of which he wrote: 'The Degas is also of the rare early types. The Dutch exactitude of the foreground figures, the suggestion of the distant, and the originality of composition make it a fascinating work.' Sargent starred a few paintings on his list, which, in his opinion, should be specially recommended for reconsideration, including the Degas, of which is noted, 'Very good: So positively mapped out.'[46]

But the reaction of one of the Trustees, Lord Redesdale, shows that even at this period feeling about modern foreign painting still ran very high. He was not at the meeting on 13 January, and took great exception at the two outsiders being asked to give their opinion,

Fig. 46 *Dancers*, about 1879 (design for a fan). Gouache, oil pastel and *essence* on silk, 30.5 × 59.7 cm. Tacoma Art Museum, Washington. Gift of Mr and Mrs W. Hilding Linberg, 1983, inv. 1983.1.8

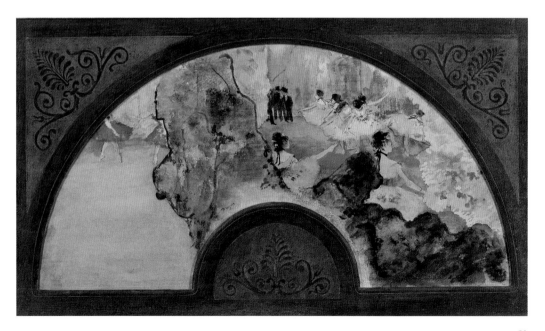

feeling that it was not right for the Trustees to delegate their responsibility in that way. In a memo of February 1914 written to the Director, Redesdale set out his objections. He was intensely critical of the quality of the Lane pictures, of which he specifically singled out the Degas:

> I accept without reserve, as far as I am concerned, Sir Hugh Lane's stricture that I have no expert knowledge of the class of pictures concerned. Neither have I any expert knowledge of the work of the pavement artist, the only school with which some of his paintings can be compared – notably the picture of the woman hunting in the hair of a young girl upon what is presumably intended to be a sand-heap by the sea-shore . . . [47]

Lane died unexpectedly with the sinking of the *Lusitania* on 7 May 1915, after which an unwitnessed codicil to his will was found among his papers, leaving the paintings to Dublin. Because the unwitnessed codicil had no legal standing, the pictures remained in London, and were transferred to the Tate Gallery in 1920, where they formed a very important nucleus to the new gallery which opened in 1926.

The Courtauld Fund

In the early 1920s all the works bought at the Degas sales were transferred to the Tate, alongside the Lane collection. Work on the construction of the Tate's new modern foreign galleries began in 1923, but by the time these were completed in 1926 it had become obvious that there was not going to be enough to fill them.

At this point the industrialist Samuel Courtauld gave £50,000 for the purchase of Impressionist and Post-Impressionist paintings for the English national collections.[48] A Board of Trustees was appointed to oversee the allocation of money, consisting of Courtauld himself as Chairman, the directors of the National Gallery and the Tate, Sir Charles Holmes and Charles Aitken; Lord Henry Bentinck, chosen by Courtauld as a representative of the Tate Board, and the educational pioneer and collector Michael Sadler. It was understood that pictures could be resold if better examples came along. Like Lane, Courtauld was also building his own private collection, some of which he gave to the Courtauld Institute of Art in 1931, bequeathing more on his death in 1947. Degas's *Young Spartans Exercising* (Cat. 3) was bought from the Fund in 1924, for £1,200 – an inexpensive purchase, and seen as an uncharacteristic work. It had actually been in the Degas studio sale but had never appeared on any of the lists as a desirable acquisition. *Miss La La* (Cat. 4) was bought in 1925. The two other Courtauld purchases of his work were *Elena Carafa* (Cat. 9) and *Ballet Dancers* (Cat. 13). Together with Van Gogh's *Long Grass with Butterflies*, these used up the remainder of the original fund in 1926 and entailed a gift of extra money from Courtauld. All the Courtauld purchases were displayed at the Tate in January 1926, to an extremely favourable response.[49]

By the 1920s these could no longer be described as radical acquisitions, but Courtauld's generosity meant that artists such as Degas, Manet, Renoir, Cézanne, Monet, Van Gogh and Gauguin were now well represented in the national collection, some for the first time. Courtauld himself specified the list of artists whose work could be bought, and he gave Impressionist landscape a central place in the modern movement, unlike many English critics such as Roger Fry (and indeed Degas himself). Frank Rutter had even gone so far as to say that Impressionism, with its sketch-like qualities and concern with surface appearances, had never been popular in England.[50] But for many others, Degas's rigorous draughtsmanship and sense of design held him apart from Impressionism. In his case the Courtauld purchases can really be said to have put the official stamp of approval on his art.[51]

Degas acquisitions after the 1920s

Paintings by Degas, along with other modern foreign works, were hung at the Tate from the early 1920s, where they were included in the Gallery of Modern Foreign Art. In the 1940s and 1950s the division of paintings between the National Gallery and the Tate was discussed with increasing frequency, but the ambiguity regarding their respective acquisition areas persisted. The National Gallery and Tate Gallery Act, passed on 14 February 1955, defined the former's collection as 'of pictures or established work of significance'. French nineteenth-century painting now fell very much into this sphere, and during the 1950s and 1960s pictures were regularly transferred from the Tate to the National Gallery in a way that would have pleased Courtauld, who had always intended that the pictures bought from his fund should rest ultimately in the National Gallery.[52] Of the works by Degas, *Princess Pauline de Metternich* was transferred in 1934, *Beach Scene, Young Spartans Exercising* and *Miss La La* in 1950, and *Portrait of Elena Carafa* and *Ballet Dancers* in 1961. The collection has also been increased through a steady flow of purchases and generous gifts from private donors, starting with the buying of *After the Bath: Woman drying herself* (Cat. 11) from Harry Walston in 1959. Two decades later, the haunting portrait of *Hélène Rouart in her Father's Study* (Cat. 7) was bought by private treaty from Peter Gimpel in 1981, while in 1991 Mr and Mrs Charles Wilmers presented the Gallery with one of the artist's earliest café scenes, *At the Café Châteaudun* (Cat. 5). The story of the National Gallery's Degas collection concludes with the gift of the exuberant pastel drawing of *Russian Dancers* (Cat. 12) by the Sara Lee Corporation in 1999, 81 years after the first purchase of *Princess Pauline de Metternich* from the 1918 atelier sale.

SH

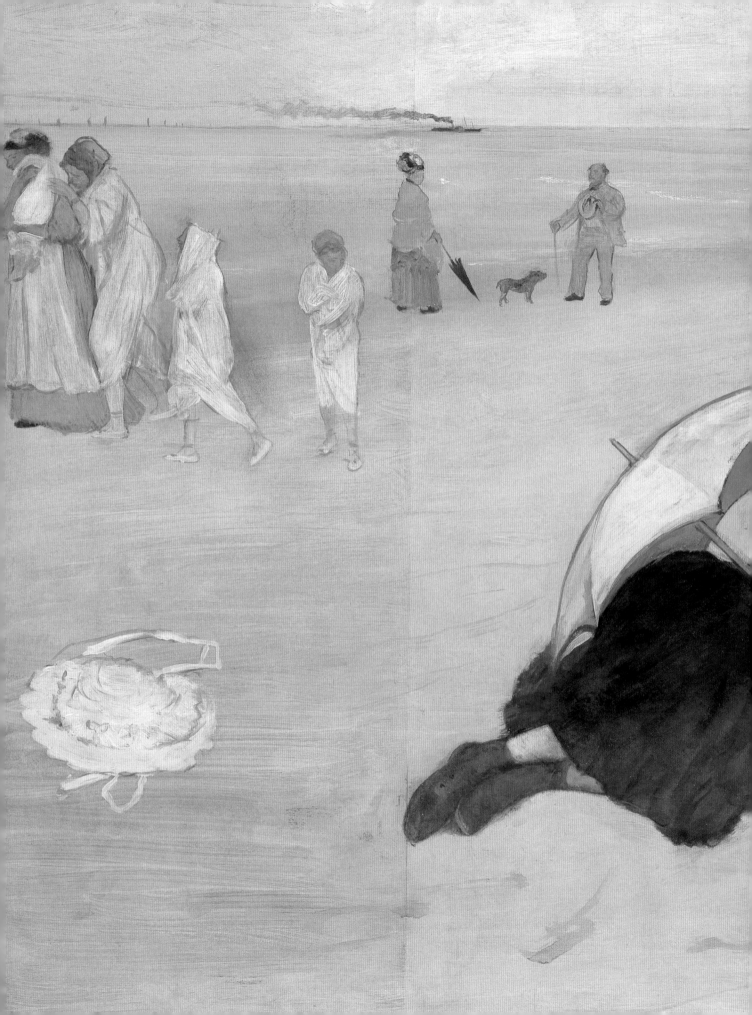

Catalogue

1 Promenade beside the Sea, about 1860

Oil on canvas
22.5 x 32.5 cm
L819

The young Degas first visited his Neapolitan relations in 1856. He returned
to the southern Italian city, briefly, in early 1860 when, among many sketches
executed there, he drew a panoramic view in pencil of the Bay of Naples,
showing distinctive local landmarks such as the Castel Sant'Elmo and the
Castello dell' Ovo, with Vesuvius in the distance (Fig. 48). At about the same
time he sketched an equestrian couple in ink and white gouache, one male and
one female, seen from the rear as they ride along a path elevated above a body
of water which may be the Bay of Naples (Fig. 49). It is one of the earliest
depictions of equestrian figures in Degas's oeuvre.

 The same view of the bay, and the same couple, reappear in combination in
the present work. The landscape is somewhat truncated, however; only a corner
of the Castel Sant'Elmo can be seen at the upper left while, as Richard Kendall
has noted, other details, such as Vesuvius, which would allow the viewer to
recognise Naples more easily, have been muted or suppressed.[1] Conversely, the
use of colour reveals details of the figures more clearly. Both riders sport
black top hats silhouetted against a grey sky. The *amazone*, riding side-saddle
to the right of her companion, wears a long skirt and fitted jacket, both in
brown, while a green scarf tied jauntily around her hat blows ahead of her in
the breeze. Quick touches of paint between the horses' legs suggest the dust
they kick up, reinforcing the sense of movement. Indeed, the vigour of the
brushstroke right across the canvas would seem to suggest that this is an oil
sketch, painted out of doors in front of the motif. However, as the painting
combines motifs from the two works on paper, and as Degas was in Naples only
briefly, it seems more likely that he executed it at a later date, perhaps upon his
return to Paris, basing it on the twin sketchbook sources. As Kendall has also
noted, Degas used the same female rider in a quite different pictorial context
in *On the Racecourse* (Fig. 50), set in Normandy and painted about a year later,
probably in 1861.[2] Such borrowing and adaptation of his own motifs was a
frequent characteristic of Degas's art throughout his career.

 Promenade beside the Sea is painted on a commercially prepared canvas,

Fig. 47 *Promenade beside the Sea*, about 1860.
London, National Gallery, inv. L819 (on long-term
loan from the Gere Collection)

58

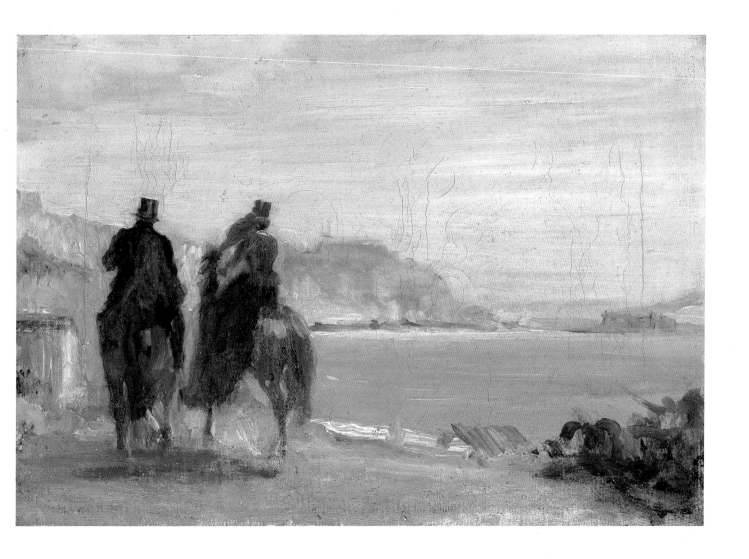

probably supplied as a standard No. 4 *paysage* size – with which its dimensions almost exactly correspond. The ground is a creamy off-white colour and its pale warmth shows through the paint in many parts. The technique is simple and, if anything, appears more sketch-like and less detailed than the notebook study that precedes it. Infrared examination reveals a rapid and summary pencil sketch beneath the paint, marking out the positions of the riders and the line of the hillside in the centre – somewhat lower than its final position, corresponding more closely with its shape in the notebook study. In the foreground, the edge of the path above the sea and the foliage at the right are also quickly drawn in. The painting is ambiguous in this area: the demarcation between the path and shore below is unclear, marked only by a few wooden planks, whereas in the notebook sketch they are separated by a continuous low wall with the foliage behind it.

The order of painting is straightforward and logical. The riders and horses were painted first and the landscape filled in around and between them. The water was added next and the sky painted last: brushstrokes of grey sky paint

Fig. 48 *View of the Bay of Naples*, 1860.
12.5 × 21.5 cm.
Paris, Bibliothèque Nationale, inv. Degas carnet 19,
pp. 6–7

Fig. 49 *Two Figures on Horseback*, 1860.
Ink and white gouache, 25.4 × 19.2 cm.
Paris, Bibliothèque Nationale, inv. Degas carnet I, p. 55

Fig. 50 *On the Racecourse*, 1860–2, detail.
Oil on canvas, 43 × 65.5 cm.
Basel, Oeffentliche Kunstsammlung. Gift of Martha and
Robert von Hirsch, 1977, inv. G 1977.26

clearly follow the outlines of the figures and landscape. In his painting of the
sky, and in reverting to a more conventional horizontal format, Degas utterly
transformed the mood of the notebook study. The billowing clouds threatening
rain and the tightly compressed landscape have given way to a calm grey sky
and an expansive, simplified vista of the great bay with its sweep of white surf
stretching away to the Castello dell'Ovo beside the water at the right.

REFERENCES
Boggs in Washington 1998, p. 38; Brame and Reff 1984, no. 38;
Kendall, in New York and Houston 1993–4, pp. 61, 64–5, 67, 74;
Riopelle et al., 2003, pp. 72–3.

NOTES
1 Kendall, in New York and Houston 1993–4, p. 63.
2 Ibid, p. 65.

2 Princess Pauline de Metternich, about 1865

Oil on canvas, lined
41.0 x 29.0 cm
Stamped signature bottom right in red
NG 3337

Pauline Sandor (1838–1921) was the wife of Prince Richard Metternich, the Austro-Hungarian Ambassador at the Court of Napoleon III from 1860–71. She herself was known as the 'ambassadress of pleasure' for the *tableaux vivants* she devised for the entertainment of the court. A devotee of fashion, she particularly patronized the designer Worth, who used her to make fashionable his new styles of dress, such as the crinoline in 1856. The great society portraitist Franz Xaver Winterhalter also painted her portrait in 1860 (private collection) and the seascapist Eugène Boudin painted her on the beach (Metropolitan Museum of Art, New York). Degas's portrait (Fig. 52) is a partial copy of a *carte-de-visite* photograph of 1860 of both her and her husband by Eugène Disdéri (1819–1889), (Fig. 51).[1] The photograph shows her full-length standing next to her husband with her left arm tucked under her husband's right, showing only the fingers. In the painting, her husband has been eliminated, she has been cropped and Degas has not shown her left arm. He has also added the colour-scheme to what was a black and white image: painting her military-style jacket yellow and adding a gold wallpaper. He has simplified the bold design of her skirt into a quiet grey and turned the lace shawl she carries into a swathe of black at the bottom of the painting.

The painting is on canvas, which has been lined. It seems probable that the lining was carried out as a result of a small tear, noted by Eric Maclagan at the Degas sale (see p. 49) and now seen in the X-ray in the grey wrap alongside the hand (Fig. 53). In a letter to Charles Aitken, Director of the Tate Gallery, Maclagan asked whether the painting should be 're-lined or otherwise treated … here [i.e. in Paris] … or will you have her as she is and deal with her over there'. It is not clear where the lining took place, but the absence of any *douane* stamp on the back of the lining canvas suggests it might have been in London. In any event, the liner removed the tacking edges, but did not otherwise alter the size of the painting: cusping visible around the edges in the X-ray indicates that the canvas retains its original dimensions – and, indeed, was probably replaced on its original stretcher.

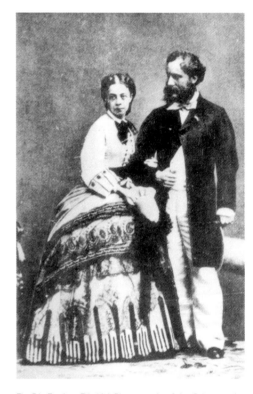

Fig. 51 Eugène Disdéri, Photograph of the Prince and Princess de Metternich, about 1860.
Carte-de-visite.
Paris, Bibliothèque Nationale

Fig. 52 *Princess Pauline de Metternich*, about 1865.
London, National Gallery, inv. NG 3337

Following pages:
Fig. 53 X-ray composite of Fig. 52
Fig. 54 Infrared photograph of Fig. 52

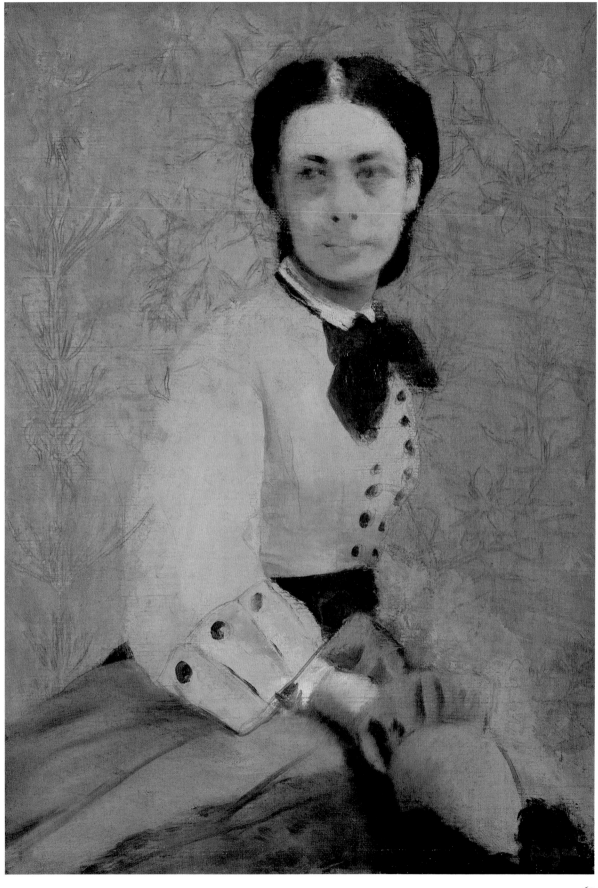

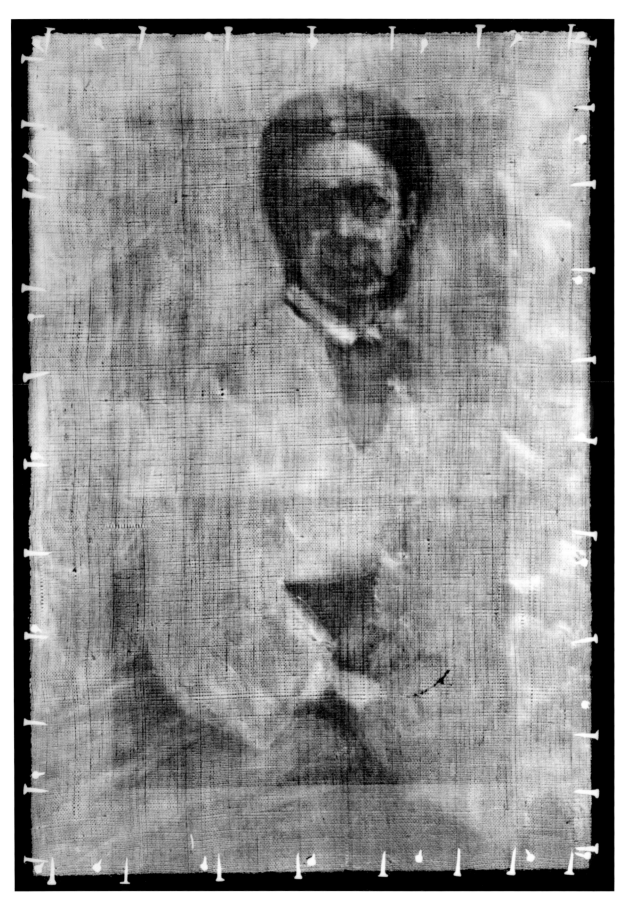

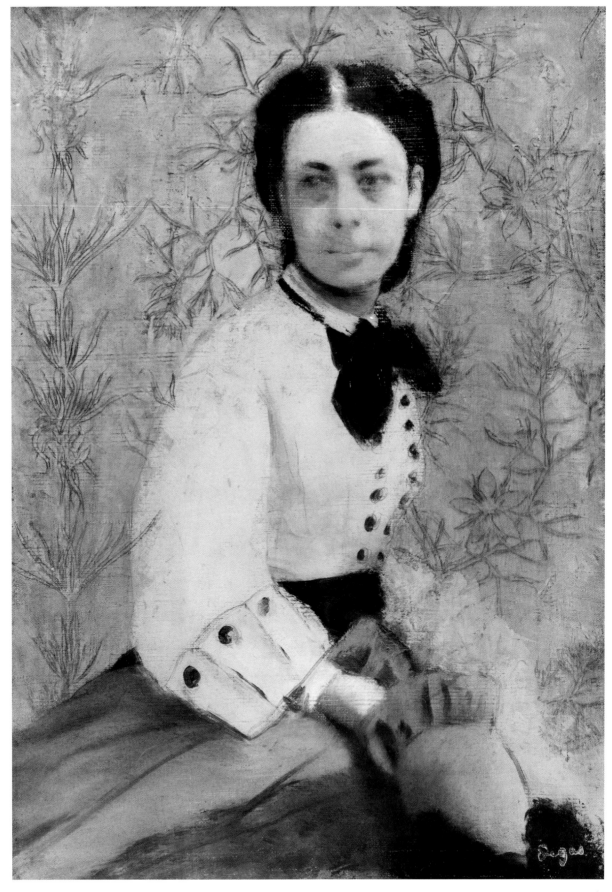

The canvas, relatively coarse and irregular for a painting of this size, is of standard height for a No. 6 size, but of non-standard width. It was prepared with a white ground, likely to be a regular commercial preparation. The dominant tonality of the picture is a salmon pink colour, which underlies most of the surface paint and is only absent in the bottom part. An underdrawing in pencil delineates the main outlines and can be seen in the infrared photograph (Fig. 54) – particularly in the bodice of the yellow jacket, alongside the shadow of the arm and where the painted buttons differ slightly in position from the drawn ones. The wallpaper design, which does not appear in the original *carte de visite* photograph, has been carefully drawn, also in graphite pencil – and apparently traced, since the pattern repeats itself fairly exactly, especially in the vertical motif at the left (Fig. 55). Tracing would also explain why the pattern overlaps the figure in places, since the process of laying translucent paper over the canvas would have slightly obscured the outlines. The precise source of the traced design has yet to be identified.

The paint follows the drawn outlines closely for the most part. The dark reserve for the black bow at Princess Metternich's neck, seen clearly in the X-ray, indicates that the yellow of the jacket was painted around it rather than under it. There is one significant partly visible pentimento at the lower right, where a patch of the background colour is lighter than the rest. This alteration may be explained by referring back to the *carte de visite* photograph in which the arm of the Prince and part of the sitter's black stole occupy this area. Degas was presumably undecided about how to paint this part and left a space, which he subsequently filled in with a colour that did not match the background. He does not seem to have painted the black stole here, since there is no black paint under the surface, but part of the stole does reappear as an unattached black patch in the bottom right corner, on which the red studio stamp was placed.

It is evident from examination of the paint structure under the microscope that Degas developed the image considerably from its photographic source; this is particularly true of the background setting. As a first stage Degas appears to have laid in the figure of the sitter in a thin brown wash-like paint, over which he developed her pose and at least part of the background virtually in monochrome, probably using the photograph as a guide to light and shade in the composition. There is evidence in the paint layer structures that Degas may have laid in a little local colour, left the picture for a while, and then returned to it to elaborate the colour scheme and wallpaper design. He also added late touches to the figure; for example the grey paint of the skirt passes over the yellow-green background colour at the left edge of the picture.

Fig. 55 Detail of infrared photograph showing wallpaper pattern

Fig. 56 Paint cross-section from yellow-green background wallpaper at the left of Fig. 52, showing surface paint containing Naples yellow and the pink underlayer, composed of lead white mixed with a lake probably containing cochineal dyestuff on a substrate of tin oxide. The dark, semi-monochrome undermodelling is visible beneath over a pure white ground. Magnification 95X

Fig. 57 Paint cross-section from the wallpaper design at the left of Fig. 52, showing a thin yellow-green paint containing Naples yellow over a layer of black graphite (pencil) used for the floral design. The pink underlayer and preliminary workings of the background can be seen beneath. Magnification 135X

Fig. 58 Detail of face in Fig. 52

REFERENCES
Davies 1970, pp. 47–8; Lemoisne 1946–9, Vol. II, p. 46, no. 89; Kendall, in Liverpool 1989, no. 4.

NOTE
1 Rewald 1937, p. 89; Stelzer 1966, pp. 113f; Scharf 1968, p. 146; Schmoll, in Munich 1970, p. 51, no. 162; Terrasse 1983, no. 4.

The shimmering colour of the wallpaper is made up of several layers over the monochrome modelling: a peach-coloured paint is followed by a thick pale rose pink layer containing lead white and a strong cherry-red lake pigment. This particular lake, which has been identified in the work of several of Degas's contemporaries (Delacroix, Monet, Renoir, Seurat and Monticelli) has a tin oxide-containing substrate and, where analysis has been possible, has been shown to contain cochineal dyestuff. The influence of this quite strong colour can be seen through the upper layer which appears greenish yellow and consists largely of Naples yellow (lead antimonate yellow) with some earth pigment and a little black (Fig. 56). The overall effect of this yellow, applied over the pink in such a way that it is sometimes thick and sometimes thin, is to convey a greenish gold setting for Princess Metternich. After the paint had dried, Degas drew the design of the wallpaper, and then softened it here and there with a veil of the yellowish paint (Fig. 57).

The handling of the paint is concise and varied to suggest the different surfaces within the picture. The painting of the face is particularly interesting since it differs strikingly in effect from the original photograph. In the photograph, the Princess's features are sharply focused and prominent. In the painting, they have been softened and blurred, both to glamorise the sitter and to suggest movement – as if she has suddenly turned to look at the viewer. This is achieved both by actual blurring of the wet paint on the surface – the underlying structure seen in the X-ray is sharper – and by a beautifully summary handling of the features. The nose is indicated by two perfectly placed dots – compare the heavy shadow in the photograph – and the mouth by a single line of black paint between the lips, of varying width produced by varying the pressure on the brush (Fig. 58).

3 Young Spartans Exercising, about 1860

Oil on canvas, lined
109.5 x 155.0 cm
Red studio stamp at bottom right
NG 3860

Two groups of adolescents, girls on the left and boys on the right, engage in a confrontation. The form that this meeting takes is ambiguous and has been variously described as a courtship ritual or a direct challenge to a fight.[1] The figure of the lunging girl certainly gives the appearance of a provocation even if her companion, her weight on her back leg, grasps her arm as if in restraint. The boys engage in various poses of varying degrees of aggression. Degas himself noted the subject in a notebook in about 1860: 'girls and boys wrestling in the Plane-tree grove, watched by the elderly Lycurgus and the mothers.'[2] It was described in the catalogue of the fifth Impressionist exhibition of 1880, a show in which it was not in the end included, as 'Young Spartan Girls provoking some Boys (1860)'. The plane tree grove has disappeared but the town of Sparta is visible in the distance and in the left background Degas has included the rock from which malformed Spartan infants were thrown. In the middle distance a group of mothers stand unconcerned; included among them is Lycurgus, who, according to Plutarch in his *Life of Lycurgus*, ordered Spartan girls to engage in wrestling contests with each other, a source read by Degas. He was also probably influenced by the account in Abbé Barthélemy's *Voyage du jeune Anacharsis en Grèce*, published in 1788:

> Spartan girls are not raised at all like those of Athens. They are not obliged to stay locked up in the house spinning wool, nor to abstain from wine and rich food. They are taught to dance, to sing, to wrestle with each other, to run swiftly in the sand, to throw the discus or the javelin, and to perform all their exercises without veils and half naked, in the presence of the kings, the magistrates, and all the citizens, not excepting the young boys, whom the girls incite to glory by their examples, or by flattering praise or stinging irony.[3]

Apart from these texts Degas may have also been inspired by the example of Gustave Moreau who was exploring related themes of classical Greece. But classical subject-matter aside, the painting is also about emerging

Fig. 59 *Young Spartans Exercising*, about 1860. London, National Gallery, inv. NG 3860

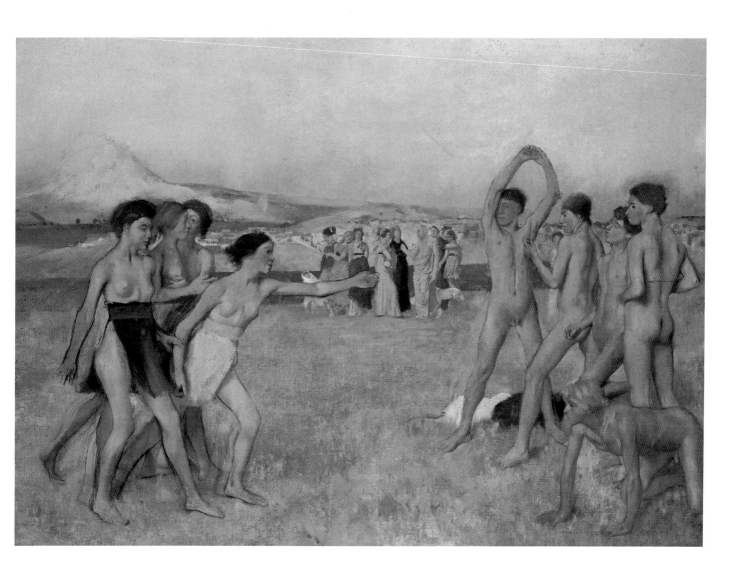

adolescent sexuality and the meeting of the sexes on a equal footing.

Degas first began work on this theme in around 1860. He painted two versions of the subject, and produced a large number of studies, of which there remain known a number of notebook entries, 16 drawings and 4 oil studies.[4] He began with some brief notebook sketches, including studies from the antique, followed by two compositional drawings (Fig. 60) and a number of figure drawings before producing the first painted version, which he left in monochrome (Fig. 61). This version features more obvious Hellenist components, such as the building and the figures themselves.[5] After another spate of drawings and a further oil compositional sketch (see Fig. 62), in which he removed the trees and architecture, he started work on this painting. He then produced further oil sketches of the girls and youths. Degas reworked this version in about 1865 and again in the late 1870s. At this point he painted over the classicised heads of the figures with real heads drawn from contemporary Parisian youth. The result is that some of the faces, such as those of the boy with the stick behind his back and the boy with his left leg thrust forward, have a mask-like quality. This painting was of great importance to Degas, and along with other history paintings and copies after other artists it remained in his studio until his death.[6]

Fig. 60 *Compositional Study for Young Spartans*, about 1860.
Pencil, brush and brown wash on paper, 22.5 × 33.2 cm.
Private collection, inv. anonymous sale, Christie's, London, 2 December 1986, Lot 205.
© Courtesy of the owner

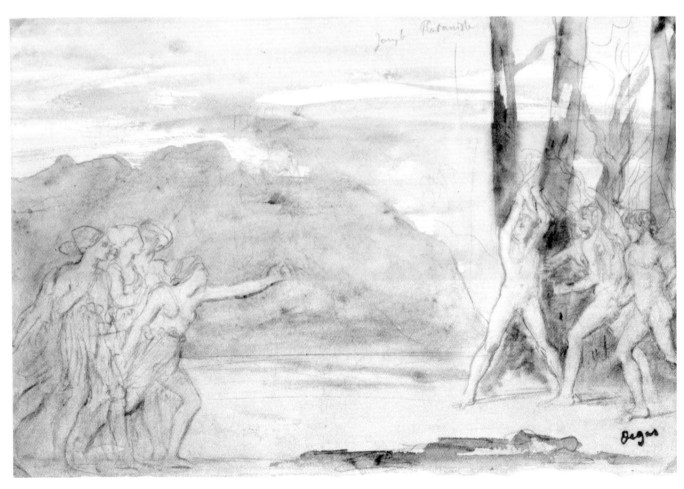

The evolutionary process that led through the numerous sketches, drawings, studies and paintings to the National Gallery picture that we see today was a long and complex one. Along the way were many changes of emphasis and detail, but the basic design of the group of girls at the left and the group of boys at the right seems to have been intended from the very beginning. What is probably one of the first compositional sketches shows this arrangement set against a mountainous backdrop with large tree trunks (presumably the plane tree grove) behind the boys at the right (see Fig. 60). The group of adults and infants in the background is not yet present.

From initial ideas such as this, the development of the composition proceeded through three main phases, with various drawings and studies assignable to each. The first phase culminated in the monochromatic Chicago canvas (see Fig. 61); the second led up to the oil sketch in the Fogg Art Museum (see Fig. 68), and its fairly accurate translation to the London canvas (see Fig. 59); the third phase encompassed everything that happened to the London painting subsequently. In examining the progression from stage to stage, it is best to chart the changes to the composition in four principal areas: the group of girls, the group of boys, the adults and other figures in the background, and the landscape setting.

Fig. 61 *Young Spartans*, about 1860. Oil on canvas, 97.4 × 140 cm. Art Institute of Chicago, Illinois, Charles H. and Mary F. S. Worcester Collection, 1961, inv. 1961.334

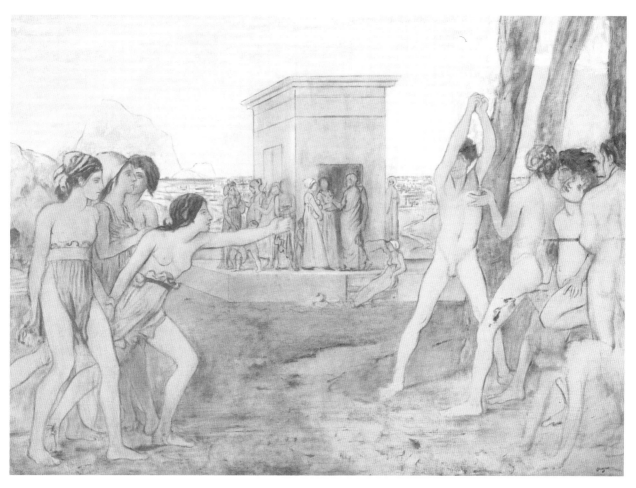

The Chicago painting, on canvas, is an extraordinary image. Abandoned around 1860 and never exhibited, it remains a pale *ébauche* or *grisaille* – a detailed drawing with yellowish grey monochrome shading, awaiting colour layers that never materialised. Four girls appear at the left – although there is an extra pair of legs, suggesting that another figure is concealed behind the foremost one. (This ambiguity is multiplied in the final London painting where alterations to the composition have left a bewildering number of legs below the girls.) The central group of adults and children stands on a terrace around a flat-roofed temple and a woman sits stretched out across the steps in front of them. A compositional sketch exists that shows the temple, albeit with a pitched roof rather than the flat roof seen in the painting, and reveals more of the fifth girl. At the right, five boys stand in various poses, and one kneels on all fours. Behind them, three tree trunks remain of the plane-tree grove, and in the distant background the city of Sparta is spread out, with mountains at the left. In the foreground a winding path separates the two groups of young people.

Degas made a number of magnificent studies for several of the figures, although it is sometimes difficult to establish a precise order relative to the Chicago, Fogg and London paintings. For example, a drawing of the taunting girl with her arm flung out (Fig. 62) shows her right, lower, arm straight as in the Chicago picture, but her outstretched left arm and the position of her head correspond more closely to the final London version. But other sequences are clearer: two drawings show the boy with his arms raised (Figs 63 and 64), the face concealed by the right arm. The first is three-quarter length and is generally assumed to be the earlier of the two, exploring the pose and reflecting Degas's earlier academic studies; in the second, wholly realised, full-length study, the shading of body and limbs exactly matches that seen in the Fogg composition. A figure of a striding man with his head turned away

Fig. 62 *Young Spartan Girl*, about 1860.
Pencil and black crayon on tracing paper; 28 × 36 cm.
Paris, Musée du Louvre, inv. RF 11691 recto

Fig. 63 *Study for the Youth with Arms Upraised*,
about 1860.
Pencil on paper.
Detroit Institute of Arts, Michigan. Bequest of
John S. Newberry, 1965, inv. 65.149

Fig. 64 *Study for the Youth with Arms Upraised*,
about 1860.
Pencil and black chalk on paper.
New York, Metropolitan Museum of Art,
Robert Lehman Collection, inv. 1974.280

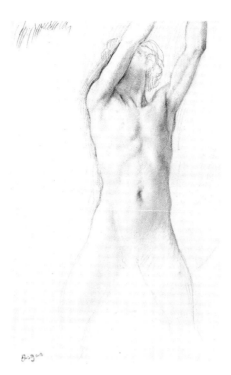
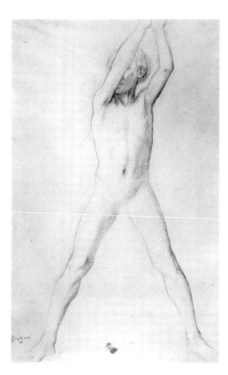

Fig. 65 *Two Naked Youths* (*Deux adolescents nus*),
about 1860.
Pencil on grey paper, 32.1 × 24.6 cm.
Paris, Musée du Louvre, inv. RF 15492 recto

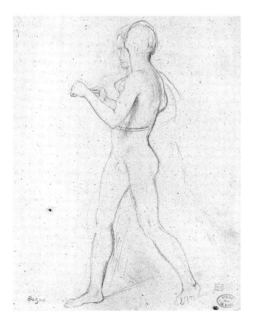

(Fig. 65) resembles the second boy from the left, but the positions of the legs
are reversed. Another drawing exists for the boy at the right with his back to the
viewer and a stick hooked between his elbows. The woman on the temple steps
seems to be based on a figure that Degas copied from a Marcantonio engraving
after Raphael (Fig. 66).[7] Working from such drawings as these, Degas set down
the composition of the Chicago canvas, but almost immediately began to revise
it. There are signs of washing, scraping and reworking in the background and in
the group of boys. The crawling boy is particularly indistinct – but would begin
to be resolved in the next stage of working.

One strange drawing, now in Kansas, relates to the Chicago picture and
shows the figures of the central group, exactly the same size as in the painting
but in reverse (Fig. 67). It is on tracing paper, laid down on another sheet of
paper, and is pricked and scored around the outlines from the concealed side.
It is much altered from its original state, having been mounted the wrong
way round and redrawn and coloured on the exposed verso by a later hand.
Fortunately, an old photograph exists of it in its uncoloured state, and details
such as the fact that there was no drawing in the area obscured by the
foreground girl's outstretched hand make it clear that it is a direct tracing from
the surface of the Chicago picture. It seems to have been made to assist in the
transfer of this part of the composition to the London canvas, although the

figures there are slightly smaller. Degas's use of tracing for replicating whole or partial compositions is well known for his pastels, but less commonly encountered in his oil paintings.

At the next stage, Degas assembled all his revised ideas in the Fogg oil sketch (Fig. 68). The temple has disappeared, although the central figures, only summarily indicated, are still arranged along the same terrace. The trees behind the boys have also disappeared except for the faint suggestion of a couple of large branches projecting from the right edge. The mountain behind the girls is taller and shifted to the left. The girls themselves have remained essentially unaltered, but significant changes have begun in the group of boys. The boy standing second from the left now faces the girls instead of looking away, and a drawing corresponds to this changed position (Fig. 69). The position of the boy on all fours is now clear and follows a drawing that is squared up, probably for subsequent use in first phase of the London picture (Fig. 70).

The Fogg oil sketch clearly represented some sort of resolution of the composition for Degas, since he transferred it without alteration to the London canvas. There is an exact correspondence between the X-ray of the latter, which reveals its lower layers with remarkable clarity (Fig. 71), and the oil sketch. From the evidence of the X-ray, in which all the figures appear detailed and fully finished, there is every reason to suppose that Degas completed the painting of the composition in this state and that it remained like this for some time. Intensive work on the project had lasted from 1860 into 1861, but there was to be an appreciable period – certainly a few years – before Degas returned to the painting and made major revisions. The traditional assumption is that he reworked it in the mid-1860s and again in the late 1870s, but the possibility that he added more touches in the 1880s or 90s cannot be excluded. How Degas changed the London painting in these later campaigns can be deduced from

Fig. 66 Copy of Marcantonio's engraving after Raphael's *'Judgement of Paris and Parnassus'*, about 1854, detail from a larger sheet.
Brown ink on cream tracing paper, 31.2 × 15.2 cm. Cambridge, Massachusetts, Fogg Art Museum, Harvard University Art Museums. Anonymous gift in memory of W.G. Russell Allen, 1956, inv. 1956.10

Fig. 67 *Classical Figures*, about 1860.
Sanguine crayon on tracing paper (pin-pricked). Lawrence, Kansas, Spencer Museum of Art, Kansas University Museum. Gift of Dr and Mrs Hugo Emmerich, 1960, inv. 1960.0075

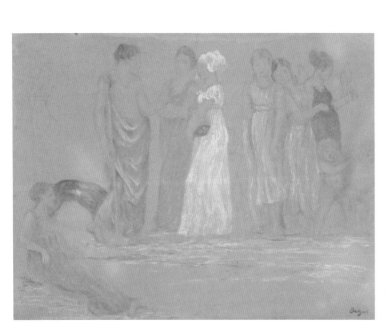

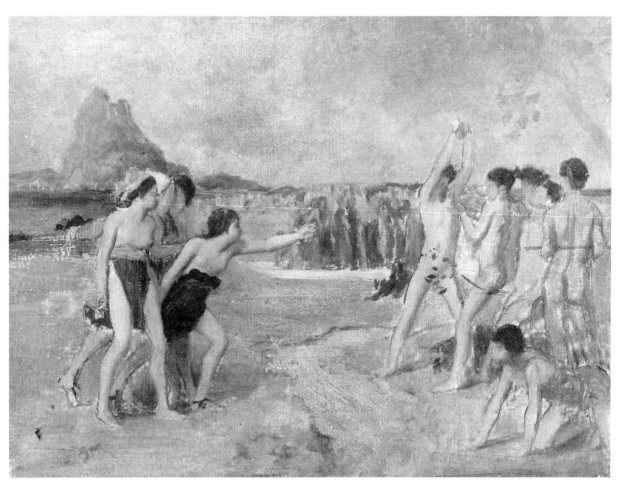

Fig. 68 *Study for the whole composition* of *Young Spartans*, about 1860–1.
Oil on paper mounted on another sheet of long fibred paper, then on cardboard on wood panel 21.8 × 28.3 cm.
Cambridge, Massachusetts, Fogg Art Museum, Harvard University Art Museums. Friends of the Fogg Museum Fund, the Alpheus Hyatt Fund, the
William M. Prichard and Francis H. Burr Memorial Funds, 1931, inv. 1931.51

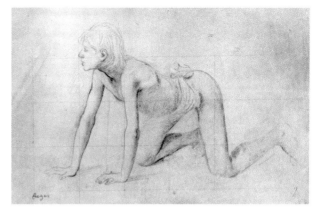

Fig. 69 *Study of Boy in Attitude of Defence*, about 1860.
Pencil and black chalk on paper, 21.3 × 34.3 cm.
New York, Metropolitan Museum of Art, Robert Lehman Collection
1975, inv. 975.1.610

Fig. 70 *Study of kneeling Boy* 1860.
Pencil and black chalk, 22.9 × 35.6 cm.
Toledo Museum of Art, Ohio. Museum purchase, 1923, inv. 23.13

Fig. 71 X-ray composite
of Fig. 59

a direct comparison between the image that we see today and the X-ray, which maps the first 'finished' state.

The distant landscape, for example, was made less dramatic: in particular, the mountain was lowered and the double peak, seen in the oil sketch and in the X-ray, was simplified. The landscape and sky are multi-layered and thickly painted as a result of repeated reworking, always in linseed oil-containing paint. The repainting was clearly carried out in several phases, sometimes applying further drawing in a thin grey or brown paint (Figs 72 and 73). In the foreground, the winding path dividing the girls from the boys (clearly visible in the X-ray and as layers of warm beige paint in Fig. 72) was eliminated so that the same muddy grass now extends uninterrupted between the two groups. Examination of the paint layer structure shows that at no stage was the painting varnished. It seems, therefore, that Degas never regarded it as finished.

At the left, Degas drew and redrew the girls' legs many times, leaving all the outlines visible. The foremost girl – in a more or less upright posture in the oil sketch and the X-ray – now leans back, acting as a counterbalance to the girl that plunges forward. Her legs have been repositioned further apart, bracing herself to restrain her companion and, at the same time, her right arm, previously held down at her side, now swings out and backwards. Examination of the paint in this region confirms Degas's reworkings here. For example, a cross-section from the left heel of the girl leaning forward shows the presence of several layers of dull greenish landscape paint beneath the pale pinkish beige of her foot (Fig. 74). It is clear also that the landscape paint was applied in at least two campaigns. The dark paint beneath the sole of her foot is visible in the cross-section as a thin brown underpaint over the greens of the landscape. The layer structure of her roughly sketched right leg, seen between the paler coloured legs of the foreground girl, shows a greater degree of indecision on the part of the artist; immediately above the pale grey ground there is some suggestion of a pale flesh-coloured lay-in but Degas then applied several layers of green landscape paint. This sequence was then repeated, with a slightly darker pink layer for flesh, again obliterated by the landscape. The final position of this leg was then applied as two very thin layers of dark flesh paint and shadow. An oil sketch that shows the new positions must have been painted at this late stage in order to envisage the changed dynamic between the two figures (Fig. 75). The fact that the passage of paint between the foreground girl's feet was landscape until the very last reworking of her companion's right leg confirms this.

Degas changed the central group significantly in his reworking of the painting. The X-ray indicates that the frieze of adults and infants was copied

Fig. 72 Paint cross-section from dull green scumble, foreground of Fig. 59, over painted-out path. The warm beige paint of the path, over which a thin layer of intermediate drawing is visible, is present beneath the reworked foreground.
Magnification 185X

Fig. 73 Paint cross-section from warm pink of sky, left-hand side of Fig. 59, showing Degas's reworking of this area in several layers of varying colour.
Magnification 175X

Fig. 74 Paint cross-section of pinkish-beige of centre girl's foot over several layers of brownish green representing the foreground landscape in Fig. 59.
Magnification 265X

Fig. 75 *Young Spartan Girls* (*Petites Filles Spartiates*),
about 1860.
Oil on canvas laid down on board.
Private collection, inv. anonymous sale,
Christie's, New York, 9 November 1994, Lot 4,
Lemoisne 74

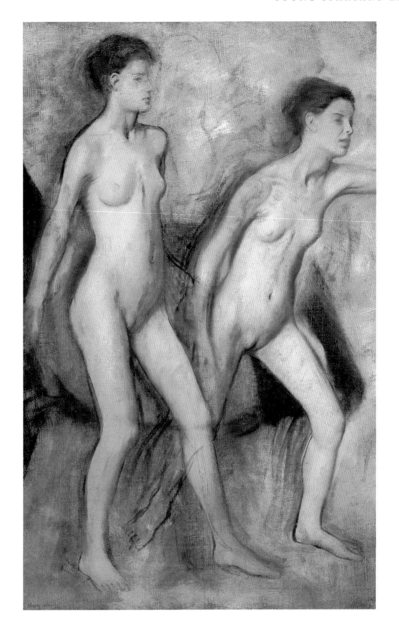

directly from the Chicago painting, probably with the aid of the Kansas tracing.
Extra figures were inserted in the empty space to the right of the old man
Lycurgus, where the corner of the temple intervened in the Chicago version.
The platform on which they stand and the steps with the reclining woman are
clearly visible in the X-ray, but Degas painted them out so that the figures
now stand directly on the grass and the woman is no longer visible (Figs 76,
77 and 78). The woman in conversation at the left end of the group has also
been eliminated, and the two wrestling infants behind the outstretched arm

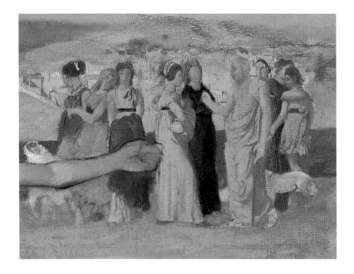

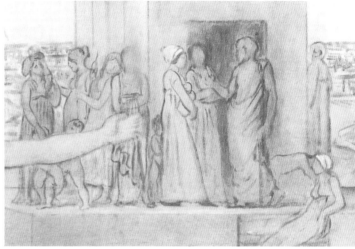

Fig. 76 *above left* Detail of London painting (Fig. 59)

Fig. 77 *left* X-ray detail of London painting

Fig. 78 *above* Detail of Chicago painting (Fig. 61)

Fig. 79 Detail of boys' legs in London painting (Fig. 59)

have been converted into a single child, wrapped in an outsize towel. There is a considerable contrast in thickness between the paint of the figures themselves – which are thinly painted directly on the canvas priming – and the surrounding areas where Degas has painted thickly and rapidly, suppressing unwanted details.

The group of boys is the area that Degas altered most radically. The left-hand boy has been shifted to the right: the previous outline of his right leg and hip is visible outside the present one, and his left leg and hip have been extended over the background. An outline of this leg drawn across the leg of the second boy seems to have been done to check that the new position was correctly continuous where it passes out of sight (Fig. 79). The upper part of the left hand

REFERENCES

Lemoisne 1946–9, Vol. II, p. 34, no. 70; Cooper 1954a, no. 21, Cooper 1954b, p. 120; Cooper, in Paris 1955, no. 18; Gordon and Forge 1988, pp. 44–7; Boggs, in Paris, Ottawa and New York 1988–9, pp. 98–100, no. 40; DeVonyer and Kendall, in Detroit and Philadelphia 2002–3, pp. 238–40.

NOTES

1 On the subject-matter see particularly the following: Pool 1964, pp. 306–11; Salus 1985, pp. 501–5; Nochlin 1986, pp. 486–8; Broude 1988, pp. 640–59.

2 Notebook 18, p. 202. Reff 1976, Vol. I, pp. 99–100.

3 Jean-Jacques Barthélemy 1788, reprinted Paris 1836, p. 293.

4 For discussions of the studies see particularly the following: Ittmann 1966, pp. 38–45; Burnell 1969, pp. 49–65; Thomson 1988, pp. 40–8.

5 On the Chicago version see Brettell and McCullagh, in Chicago 1984, pp. 32–5.

6 Degas intended to exhibit it at the fifth Impressionist Exhibition in Paris in April 1880 but although it was listed as no. 33 in the catalogue it was not included. For the exhibition and reviews see the following: Moffett, in Washington and San Francisco 1986, pp. 300–1 and Berson 1996, Vol. II, p. 147, no. V–33.

7 The authors are grateful to Caroline Campbell for pointing out this connection.

boy was also transformed. The arms have been moved apart so that his face is no longer hidden; it is now clear that he is observing the girls from behind his right arm. In fact, all the boys now look directly at the girls – a dramatic change from the Chicago painting and the oil sketch where they were hardly acknowledging them at all.

To the right of the second boy in the Chicago picture, the oil sketch and the X-ray are two boys standing close together, the nearer one with his face turned sharply upwards. In the revised London painting, they are combined into a single figure, his face slightly raised, but observing the girls obliquely. There is a marked shift in right hand boy with the stick, also. Previously he had been squarely positioned, his back to the viewer: now he is half turned towards the girls, his head further to the left and in full profile.

Finally, the pose of the crawling boy was adjusted. There is a blurring of the X-ray in the area of his face, which suggests that Degas tried more than one angle for the head, although the final position does correspond more or less to the initial drawing. More importantly, the boy's left arm was moved outwards allowing the point of his knee to be glimpsed inside it – which had not been possible before: this is evident in an infrared photograph (Fig. 80). An oil sketch of the boy (Fig. 81) shows the arm and knee in this position and therefore, like the oil sketch of the two girls, must have been made to try out this late change of pose.

Fig. 80 Infrared photograph of kneeling boy in London painting (Fig. 59)

Fig. 81 *A Crawling Nude Youth*, about 1860–2. Oil on oiled paper mounted on board, 24.2 × 31.7 cm. Cambridge, Massachusetts, Fogg Art Museum, Harvard University Art Museums, inv. 1927.62. Gift of Mrs Albert D. Lasker, 1927

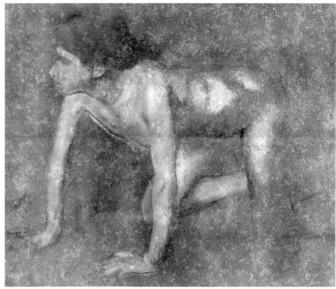

4 Miss La La at the Cirque Fernando, 1879

Oil on canvas, lined
117.2 x 77.5 cm
Signed lower left: degas (part of the g is missing)
NG 4121

La La, or Miss La La, sometimes referred to wrongly as Miss Lola, was a circus performer traditionally described as a mulatto and famous for her acts of strength. In this picture she is being hoisted to the roof of the circus, suspended by her teeth from a rope, which passes over a pulley above (Fig. 83). Other feats of strength included hanging upside-down from a trapeze holding a cannon from a chain held by her teeth, as shown in this poster (Fig. 82). In February 1879 she came to London to perform at the Royal Aquarium, Westminster. Hanging upside-down, she progressed from suspending a boy, a woman and then a man by her jaw to the finale, which was described in some detail in *The Era*:

> Six men strain their muscles to lift to her a cannon of no mean dimensions. This also she supports by her teeth alone, never leaving her hold even when, the match being applied, the gun is fired and gives a tremendous report.[1]

The Cirque Fernando was built in 1875 on the boulevard Rochechouart at the corner of the rue des Martyrs, near the place Pigalle and close to Degas's home. It was later known as the Cirque Médrano or Boum-Boum after the clown who became its owner. Degas made a number of preparatory studies for this painting, including notebook studies, an oil and pastel sketch, and eight further pastel and pencil drawings, four of them between 19 and 25 January 1879, all but one of which concentrate on the figure. The final drawing is a study of the setting itself. Degas exhibited this painting at the fourth Impressionist Exhibition, 1879.[2]

Miss La La at the Cirque Fernando is painted on canvas and is of non-standard dimensions; there is paint on all four tacking edges. The ground is a creamy off-white colour in oil. The X-ray (Fig. 84) reveals some cusping along the top and left edges but none along the bottom or at the right. These observations may be explained by the fact that the painting appears to have been cut down from a larger composition – a small reduction at the top and left, and more at the bottom and right – and remounted on a smaller stretcher.

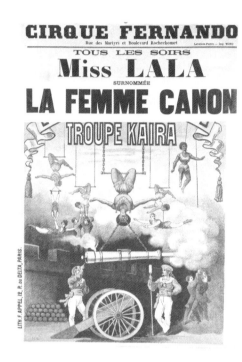

Fig. 82 *Poster for the Cirque Fernando.* Photograph, Paris, Bibliothèque Nationale, inv. E9178

Fig. 83 *Miss La La at the Cirque Fernando,* 1879. London, National Gallery, inv. NG 4121

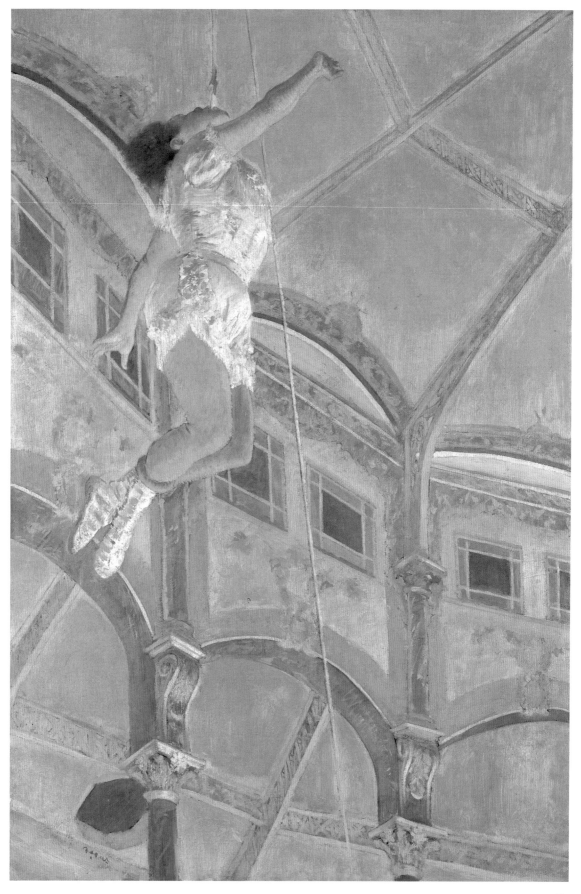

Fig. 84 X-ray composite of Fig. 83

Fig. 85 *Study of Miss La La at the Cirque Fernando,* 1879.
Pastel on paper, 48.6 × 31.8 cm.
Louisville, Kentucky, Collection of the Speed Art Museum. Bequest of Mrs Blakemore Wheeler, 1964, inv. 1964.31.19

Fig. 86 *Preparatory drawing for Miss La La at the Cirque Fernando,* 1879.
Black chalk with pastel on paper, 47 × 32 cm.
University of Birmingham, Barber Institute of Fine Arts, inv. 36.7

Fig. 87 *Study of Miss La La at the Cirque Fernando,* 1879.
Black crayon, 45.6 × 24 cm.
Detroit Institute of Fine Arts, Michigan.
Bequest of John S. Newberry, 1965, inv. 65.148

The paint on the tacking edges consists of similar, if somewhat brighter, colours to the finished painting and so appears to belong to a slightly more extensive earlier stage of the present subject.

What becomes clear from examining the X-ray is that Degas struggled with placing the hanging figure within the interior space, and may well have altered the format of his canvas as part of that process. The one area of the X-ray that is more or less unaltered is Miss La La herself. One early study (dated 19 January 1879; Fig. 85) had shown her head-on, but this viewpoint was not pursued. Degas quickly settled on the present view from below and to the side, and the existence of several drawings for the figure in this pose – including a squared-up pastel (Fig. 88; dated 21 January) and a squared up drawing (Fig. 86; dated 25 January) – indicate that Degas had drawn, re-drawn and perfected it before embarking on the painting. In two of the studies, (e.g. Fig. 87) different positions for the right arm and hand were tried out. The Tate Gallery pastel study (dated 24 January; Fig. 89) shows the legs in a different position, the right leg hanging vertically instead of bent backwards. There is no indication of this pose in the X-ray of the painting, so we may conclude that he had abandoned this idea in favour of the pose seen in the drawings. In the painting, there are minor adjustments of outline in Miss La La's arms, and the profile of her face has been shifted but, essentially, she remained static while the circus building was rearranged around her.

The extent of the alterations can be seen in the right half of the X-ray, where earlier roof beams can be seen intersecting at a steeper angle with those of the present composition. The arches above the pairs of windows can be seen in a

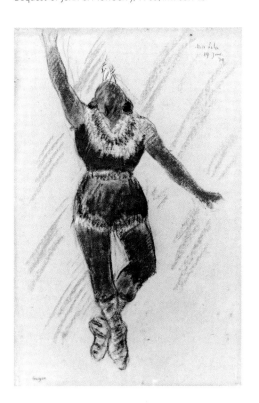

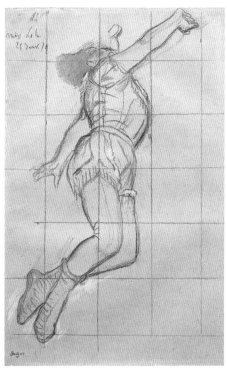

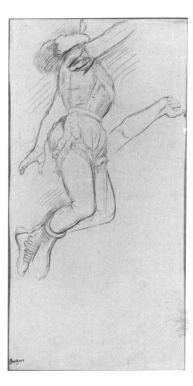

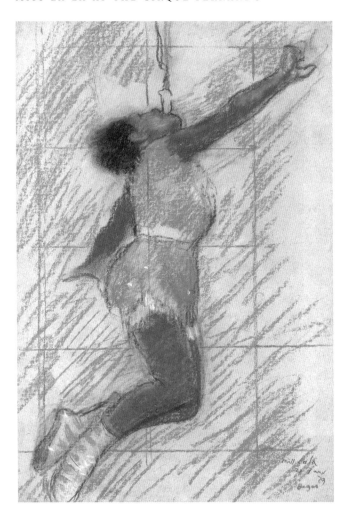 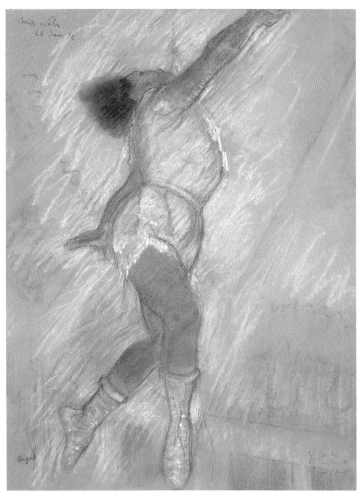

lower position than the present ones: the arch to the right of the figure in the final composition intersects with her waist, whereas the earlier arch appears just below her knee. The effect of this earlier arrangement was to push the figure higher into the roof, to make the perspective more vertiginous; the final composition makes the roof shallower and lowers the figure relative to the arches. An unexplained feature of the X-ray is the flurry of short diagonal strokes to the right of and below the figure, which no longer show on the surface. What these are is not clear, but they may relate to an impression of dazzling light around the figure that appears in the pastel study as rapid diagonal hatching.

An infrared reflectogram mosaic of the painting (Fig. 90) shows extensive drawing and reveals an even more complex evolutionary process than is visible in the X-ray. The sheer confusion of Degas's attempts to pin down the structure

Fig. 88 *Miss La La at the Cirque Fernando*, 1879.
Pastel and pencil on paper, 46 × 30 cm.
Dated and inscribed lower right; stamped with the mark of the Degas sale.
Courtesy of E. & R. Cyzer Gallery, London

Fig. 89 *Preparatory drawing for Miss La La at the Cirque Fernando*, 1879.
Pastel on paper, 61 × 47.5 cm.
London, Tate, inv. NO4170

Fig. 90 *opposite* Infrared reflectogram mosaic of Fig. 83

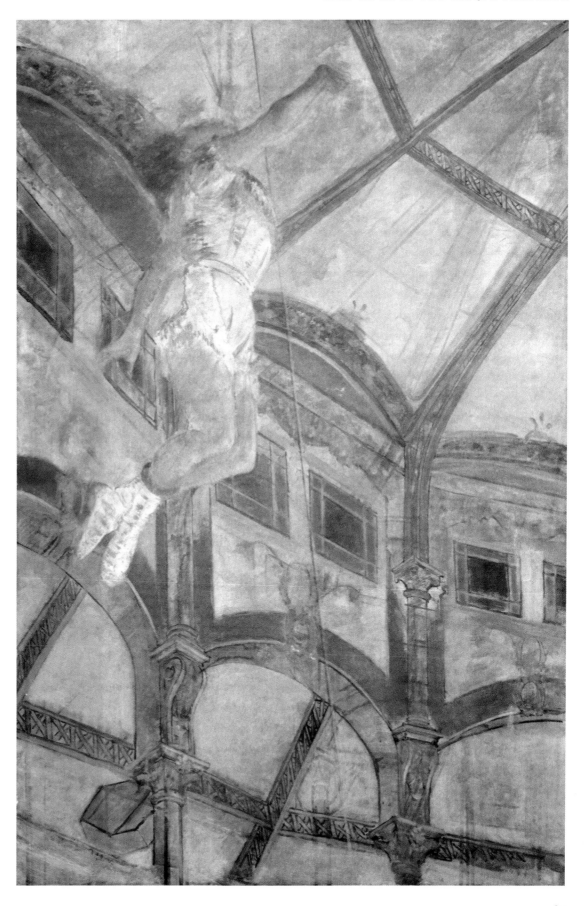

makes it difficult to decipher, but there appear to be three separate sets of roof beams, not two. The steeper beams described above were the first attempt, and were certainly painted, since they are visible in the X-ray. There is then a second set, one of which passes through Miss La La's torso and terminates at the left edge of the picture, near her hand. Another of the same set passes under her thighs and finishes in the region of her feet and the third more or less follows the line of the existing right hand beam, but continues further to terminate in one of the central windows. Finally, the two beams that were eventually painted were also drawn. At the same time, various different drawn positions for columns, arches and windows appear in the lower half of the composition, including a clearly delineated pair of columns with an arch on a slightly smaller scale at the bottom right.

It is useful to compare these various attempts with known preparatory studies. Those that place the figure within the building show her both higher than, and lower than, her final position in the painting. In the Tate pastel (see Fig. 89) she is higher – the roof beams, although only sketchily indicated, seem to be at an angle somewhere between the first and final positions in the painting, while the pairs of windows are much lower. In the fascinating oil/pastel sketch (Fig. 91), she is lower down – her knees well below the bottom tier of arches. In this study, Miss La La's hand is raised – unlike any of the drawings or the final painting – and the vertical format of the sketch also allows the spectators below to be seen. Degas's first drawing of the architecture alone seems to have been a page in one of his notebooks (Fig. 92); it was annotated with some observations and the next page contained detailed colour notes of the interior.[3]

Of most relevance to the underdrawing is the detailed drawing of the architecture now in the Barber Institute, Birmingham (Fig. 93), which is complicated by pentimenti, diagonal construction lines and squaring-up. Significantly, it corresponds closely with the second set of three beams observed in the underdrawing, with a striking similarity in the way the uppermost beam terminates near the left edge. Presumably, however, the composition was becoming overcrowded with architectural detail and Degas decided to reduce the number of beams to two, slightly differently placed. In doing so, he effectively moved closer in to the space depicted in the Barber drawing, eliminating the upper beam. Vertical and horizontal lines ruled on the drawing seem to coincide with the framing of the architecture by the edges of the present painting – as if Degas was selecting the part of the drawing that would define his final field of view in the painting. Altering the format of the

Fig. 91 *Study of Miss La La at the Cirque Fernando*, 1879.
Oil and pastel on canvas, 89 × 39.5 cm.
Private collection (formerly in the collection of Pierre Matisse), Sotheby's sale, New York, 12 May 1999, Lot 222

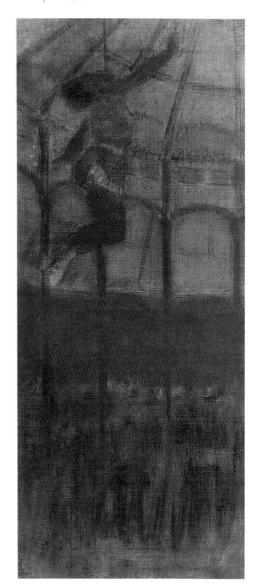

Fig. 92 *Architectural study for Miss La La*, 1879.
Pencil on paper, 16.7 × 11.1 cm.
Paris, Bibliothèque Nationale, Degas notebooks,
carnet 23, p. 36

Fig. 93 *Architectural background for Miss La La
at the Cirque Fernando*, 1879.
Black and red chalk on two sheets of joined
pink paper, 47 × 32 cm.
University of Birmingham, Barber Institute of
Fine Arts, inv. 38.10

canvas may well have been part of this process of shifting the viewpoint.

An intriguing footnote to Degas's evident problems with the architectural setting is provided by Walter Sickert, who annotated his copy of Paul Jamot's monograph on Degas. Sickert noted that when he saw the present painting in Degas's studio in the rue Pigalle, the artist told him that 'he had been unable to solve the problem of perspective and had hired a professional for the drawing of the architecture of the ceiling.'[4] What this implies for the works under discussion here is not clear. Could the Barber Institute drawing, with its many construction lines, actually be by the unnamed professional? Or the corrected underdrawing on the painting itself? Or was there some other architectural drawing, now lost, that Degas referred to for the Barber drawing and the painting?

The sequence of working during these alterations was complex. Several of the earlier roof beams and the lower arches were certainly painted, because they show in the X-ray and are visible in raking light as thick brushstrokes beneath the present surface. A cross-section from one of the painted-out beams shows that it was painted a fairly strong green, containing viridian, and the pigment mixture is very similar to that found in the visible paint of the architectural structure. To eliminate the unwanted beams, Degas painted an opaque layer which varies in colour from beige, brown, grey and muted green, across the background and around the figure. He then re-drew the architecture on top – there are indications of intermediate drawing in fluid dark paint within the sequence of layers – and commenced painting it (Figs 94 and 95). While it is clear from the X-ray and from examination of the paint structure that Degas made considerable modification to the architecture of the domed roof and at the right, the lower half of the composition to the left remains relatively unchanged – the paint structure is simple and straightforward in these areas. For example, the greenish colour of the wall at the very bottom of the painting is made up of a single layer of white, viridian, and earth pigments over brownish-grey underpaint.

The predominant orange light that suffuses the whole scene was a major change Degas made somewhat later: by applying a layer of dull orange paint over large parts of the background, he transformed an image that was essentially

Fig. 94 *far left* Paint cross-section from dull orange brown of the canopy (upper left of Fig. 83), showing various stages of the architecture beneath and corrections in the design represented by a dark line of intermediate 'drawing' in paint.
Magnification 135X

Fig. 95 *far left, below* Paint cross-section from dull orange brown from wall above the arch (left-hand side of Fig. 83) showing several re-workings of the colour composition here. Before the final orange-coloured paint was applied to large areas of the background composition (see Fig. 96), this part of the architecture had been a light greenish brown.
Magnification 125X

Fig. 96 Paint cross-section of dull orange from background architecture seen through arch (lower left-hand side of Fig. 83) showing the application of a final semi-translucent, hot orange-toned paint over an earlier mid-greenish-blue colour. The off-white ground is visible beneath.
Magnification 135X

REFERENCES

Lemoisne 1946–9, Vol. II, p. 294, no. 522; Cooper 1954a, no. 25, and 1954b, pp. 120–1; Alley 1959, pp. 54–5; Davies 1970, pp. 51–3; Pickvance, in Edinburgh 1979, no. 47.

NOTES

1 *The Era*, 16 March 1879.

2 On the exhibition and reviews see the following: Moffett, in Washington and San Francisco 1986, pp. 258 and 279, no. 74 and Berson 1996, Vol. II, p. 110, no. IV–62.

3 There are several studies in the notebooks for this painting; Reff 1976, Vol. I, pp. 132, 135–7, notebook 29, p. 27 and notebook 31, pp. 18, 21, 30, 36–8, 45, 48 and 70.

4 This is related in Sutton 1986, p. 230. The annotated copy of Jamot is in the Institut Néerlandais, Fondation Custodia, Paris. Sickert made a similar annotation in a second copy of Jamot which is now in the library of the Courtauld Institute, University of London.

cool in tone to one that is strikingly hot. This paint is quite different in constitution to that used in the rest of the picture, which is conventional oil paint (Fig. 96). Although it contains linseed oil binder, it also includes a high proportion of a natural resin that gives the paint film a higher degree of saturation and relative translucency than the paints used elsewhere. The bulk of the pigment consists of a synthetic orange-red iron oxide mixed with varying proportions of zinc white. Neither of these materials is particularly transparent in itself, but when combined with a high refractive index paint medium, as here, the resulting paint layer is less opaque and covering where applied thinly. The effect of this additional paint has been to clarify the structure of the roof by bringing it forward, while tying it visually to the lower part of the architecture. In both these areas it is quite thickly applied; it is used more subtly and thinly in the clerestory around the windows. The orange colour unifies the composition while serving as a foil for the suspended figure of Miss La La.

5 At the Café Châteaudun, about 1869–71

Pencil and *essence* on wove paper, mounted on canvas
23.7 x 19 cm
Signed top left in black crayon: Degas
NG 6536

The central figure examines the newspaper with a magnifying glass, while the
other looks through his lorgnette. This is an early exploration of a theme of the
café or café-concert which was to become central to Degas's oeuvre. There are
several preparatory sketches in one of Degas's notebooks in the Bibliothèque
Nationale in Paris, which spans the years 1867–74, but it is reasonable to suggest
a dating of 1869–71 for the painting (Fig. 97).[1] Indeed, Degas was supposed
to have told the first owner, Charles Vignier, that he had painted it in 1869.
The studies explore the two men in various poses (Figs 98 and 99). In the first
the two men are seen face on; in the second the man holding the magnifying
glass is seen in profile with a more summary sketch of the other man in the
background. The latter is repeated at the right, and worked over with black,
grey and red wash. Two other drawings are explorations of the man with the
magnifying glass, one showing him in profile and the other from the back,
with one hand touching the back of his head. The two men also appear along
with a third man in an independent drawing, *Au Café*. Seated at a corner table,
the three are conversing rather than examining a newspaper.[2] None of these
studies is followed through in the final painting, where the readers are
repositioned. They are executed in a sketchy manner, their faces bordering
almost on caricature.

The painting is on cream coloured wove paper, cut from a larger sheet and
with a slightly ragged edge at the left, now mounted on card. It is essentially a
pencil drawing coloured with diluted oil paint (*essence*).[3] Small damages at the
corners are probably holes made when the drawing was pinned to a board for
painting. Pencil lines are clearly visible in the area of the newspaper on the table
and a central vertical axis is ruled in the upper background. All the outlines of
the figures are drawn but are mostly obscured by the paint on top.

The density of colour in the image varies greatly. The wall is lightly shaded
with thinned grey, and the frames with faint yellow; the clothes of the two men
and the seat back are in denser blacks and browns. The nearer man has light
touches of red on his nose and cheeks, but the face of his companion is entirely

Fig. 97 *At the Café Châteaudun*, about 1869–71.
London, National Gallery, inv. NG 6536

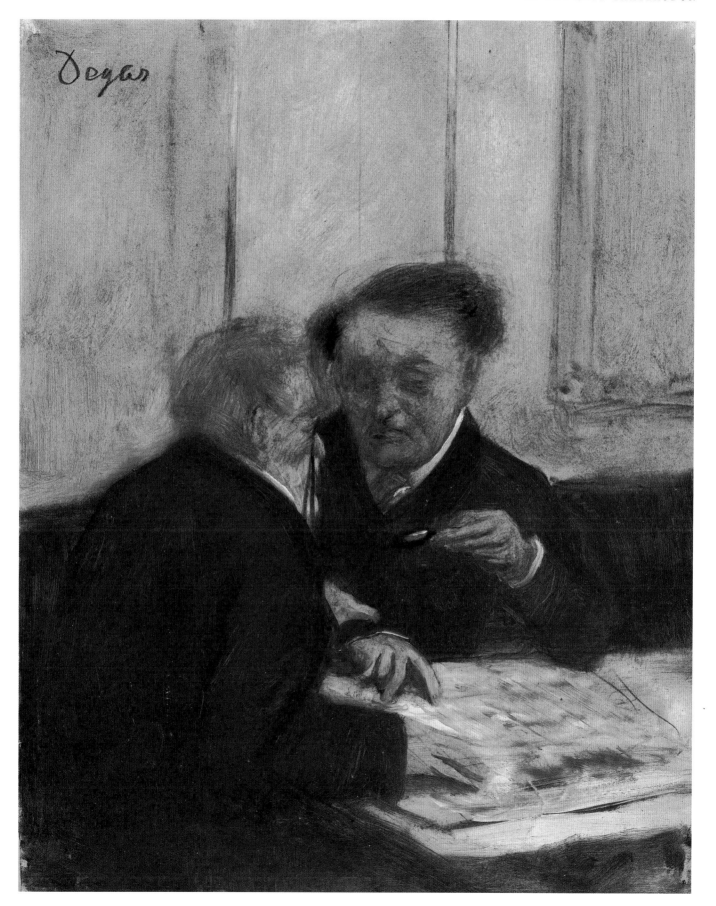

Fig. 98 *Notebook sketches*, about 1869–71.
Pencil on paper, 19 x 23.6 cm.
Paris, Bibliothèque Nationale,
carnet 8, p. 19

Fig. 99 *Notebook sketches*, about 1869–71.
Pencil and wash on paper, 23.6 x 19 cm.
Paris, Bibliothèque Nationale,
carnet 8, p. 21

Fig. 100 Infrared reflectogram mosaic detail of hands and table from Fig. 97

REFERENCES
Lemoisne 1946–9, Vol. II, p. 110, no. 215; *National Gallery Report April 1991–March 1992*, London 1992, p. 14.

NOTES
1 See Reff 1976, Vol. I, pp. 110–11, notebook 22, pp. 19, 21, 23 and 25.
2 Black pencil, 22.5 × 31.5 cm, Degas 4th studio sale, 2–4 July 1919, no. 76.
3 Confirmed by FTIR analysis.

colourless. The painting was finished with touches of bright white for the newspaper, the edge of the table, the magnifying glass, lorgnette, collars and cuffs. Degas used the painting stage to make small but telling alterations to the gestures of the men (Fig. 100). In the pencil underdrawing, the right arm of the nearer man curved round in front of his chest, away from the viewer: without redrawing it, Degas painted it extended forward, the hand resting on the newspaper. The right hand of the further man was drawn clenched, the fingers curled under against the table – but they were painted, again without redrawing, straightened and pointing obliquely at the other man. By making these adjustments of position, Degas subtly strengthened the interaction between the two strange companions.

6 Beach Scene, about 1869–70

Oil (*essence*) on paper on canvas
47.5 × 82.9 cm
Width of each piece of paper: Left, 19.9 cm; Centre, 31.5 cm; Right, 31.5 cm
Signed bottom right in black paint: Degas
NG 3247

In the foreground a nurse combs the hair of a little girl after her swim in
the sea (Fig. 101). She lies under the protective shade of a parasol, and a further
parasol, basket and her swimming costume lie on the sand beside her. The
two-dimensionality of these objects is striking compared with the figures; the
costume in particular has the appearance of a paper cut-out intended for a
cardboard dress-up doll. In the left background a family group head off out
of the picture, the nurse carrying the infant, the mother and two children
huddled up in their towels.

In 1869 Degas travelled to the Channel coast where he did a series of
landscapes and seascapes in pastel. Some of these at least would probably have
been drawn in front of the subject, although a number may have been executed
in the studio from memory. There is no such ambiguity surrounding this scene.
When Degas was later asked how he had painted the picture he stated:

> It was quite simple. I spread my flannel vest on the floor of the studio and
> had the model sit on it. You see, the air you breathe in a picture is not
> necessarily the same as the air out of doors.[1]

It is one of four such beach scenes Degas painted at this period either in oil
on canvas or *essence* on paper. The others are *Peasant Girls bathing in the Sea
toward Evening* (private collection); *Women combing their Hair* (Phillips
Collection, Washington, DC); and *Nursemaids on the Beach* (Norton Simon
Foundation, Pasadena). The carefully mapped-out composition with smooth
bands of sand, sea and sky, shows a debt to Manet's *On the Beach, Boulogne-sur-
Mer* (Fig. 102), and also to Japanese prints. The subject of combing the hair was

Fig 101 *Beach Scene*, about 1869–70.
London, National Gallery, inv. NG 3247

Fig. 102 Edouard Manet, *On the Beach,
Boulogne-sur-Mer*, about 1869.
Oil on canvas, 32 × 65 cm.
Richmond, Virginia Museum of Fine Arts, collection
of Mr and Mrs Paul Mellon 1985, inv. 85.498

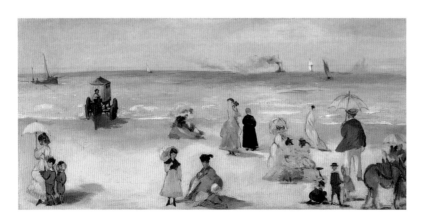

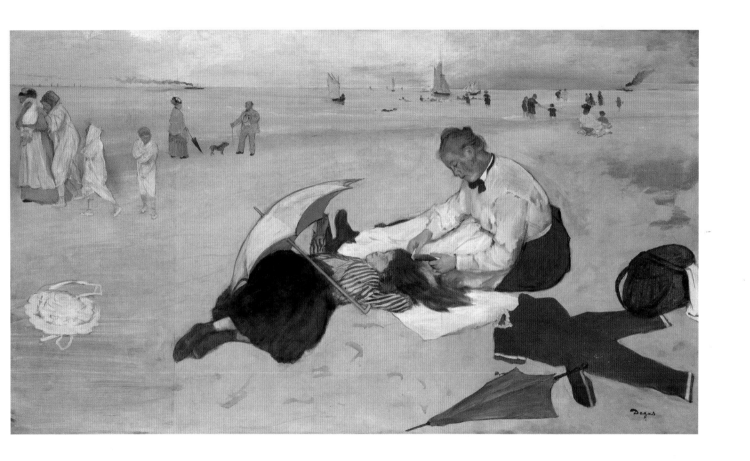

very much part of Japanese domestic imagery, and of course became a central theme in Degas's own oeuvre. The three sheets of paper stuck together are an echo of a Japanese wood-block triptych. The main point of difference with the Manet is Degas's prominent foreground group, on which the viewer's eyes focus. Degas exhibited the painting with the title of *Bains de Mer; Petite fille peignée par sa bonne* at the third Impressionist Exhibition in 1877.[2]

Beach Scene is a celebrated example of Degas's use of *peinture à l'essence* on paper – a striking image, given brilliance and clarity by the crisp thinness of the paint and the white paper beneath. Something of the luminous nature of the medium may be seen by studying details such as the tassel of the parasol at the right or the white bonnet at the left (Figs 103 and 104). But, despite its apparent directness, the evolution of this painting was complex, proceeding through several stages – some of which, even now, are not fully understood.

Examination with infrared provides information about both the structure of the support and the evolution of the composition. Of the three pieces of paper that make up the painting support, the centre sheet seems to have been the starting point for the composition: the lying girl fits almost exactly within its width, from the toes of her shoes to the main part of her hair. The sheet at the right was then apparently added to it, the two pieces being pasted together on a further sheet of thin paper, which is still present beneath them. The centre and right-hand sheets are of identical size, which might suggest that they came from the same stock of paper or were leaves from the same sketchbook. However, their reflectance in infrared (Fig. 105, see pp. 100–1) is different – the centre sheet appears darker – suggesting that they may not have come from precisely the same source and this is borne out also by microscopical examination of the paper surface. An alternative explanation is that the centre sheet is simply

Fig. 103 Detail of tassel in Fig. 101

Fig. 104 Detail of bonnet in Fig. 101

turned over: the settling of fibres during the paper-making process can lead to appreciable differences between the front and back surfaces. Finally, the narrower left-hand sheet was added by mounting it, together with the already combined centre and right-hand sheets, on to a stretched canvas support. Analysis of the inorganic components of the three sheets of paper suggests that the centre and right-hand pieces are closely similar, while that at the left differs. What is not clear is how rapid a process this all was – how much time elapsed between the single sheet becoming two, and the two becoming three. There is extensive drawing across all three sheets that is difficult to explain unless the enlargement progressed relatively quickly. This is supported by the fact that the constitution of the light yellowish paint of the beach on each of the three sheets of paper is the same, that is, lead white with some translucent natural yellow ochre.

Infrared reflectography shows that there is detailed drawing for all the principal parts of the painting, and some which does not appear to belong to this painting at all (see Fig. 105). The girl was the first part to be drawn, with the brush, with great fluidity and beauty. The addition of the right-hand sheet was then followed by the drawing of the nurse and the paraphernalia surrounding the two figures – the open parasol, the blanket on which the girl lies and the bathing costume spread out at the right. Painting of the figures and objects in *essence* was begun. The yellow paint for the beach goes around the main forms and does not underlie them. In the brush drawing and the initial stages of painting, significant alterations of outline were made. The girl's skirt was originally longer – revealing less of her ankles – and fuller around her knees. The near edge of the blanket beneath her was originally wider and set further back. Behind her, the shapes of the parasol and of the nurse's feet were also changed. Next to the nurse's skirt, the beach paint is thick and cracked, indicating changes in the painted outlines here too.

At some point in this complex development, Degas decided to add the third sheet at the left – and here the sequence of working becomes difficult to decipher. What makes it so is the presence of large-scale drawing, apparently unrelated to the present composition. Above the two principal figures, a series of receding wheel-like shapes on horizontal 'tracks' can be seen – together with ruled horizontal and vertical lines running to the top edge of the picture. Several theories have been advanced as to what they might represent. Most plausibly, it has been suggested that Degas may have intended to include wheeled bathing machines – an example of which is, significantly, shown in Manet's *On the Beach, Boulogne-sur-Mer* (see Fig. 102) and which can be seen

Following pages:
Fig. 105 Infrared reflectogram mosaic of Fig. 101

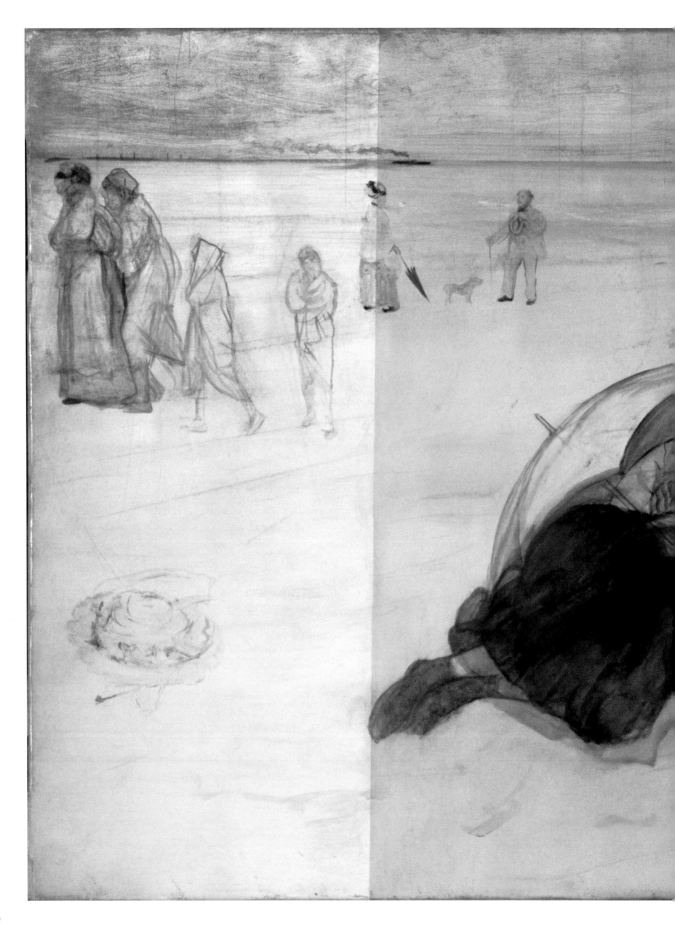

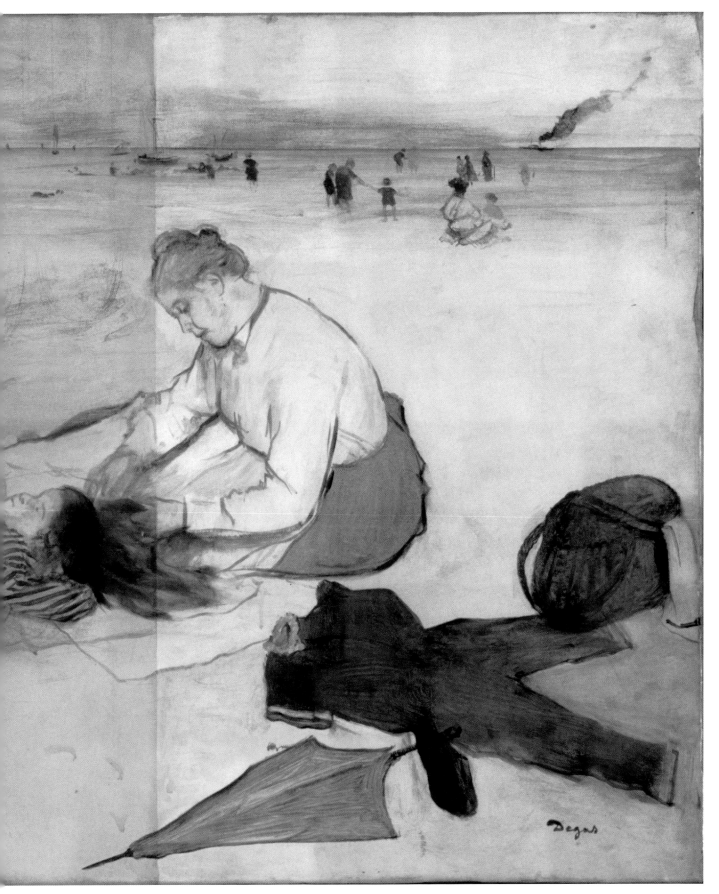

in contemporary photographs (Fig. 106). The vertical drawing lines might correspond with their striped superstructures. It has also been suggested that the shapes might belong to an entirely different abandoned composition – perhaps an arcade or the arches of a bridge, drawn with the paper the other way up. However, this is highly unlikely since the mysterious forms overlap on to the left-hand sheet, which, as we have seen, was probably added when the present composition was already underway.

One puzzling aspect of the left-hand sheet is why the paint of the sand there is so discontinuous with that on the centre sheet – darker in tone and more roughly painted. Since the underdrawn 'wheels' and 'tracks' continue across both parts, one might suppose that the left-hand sheet had already been added and that the painting would therefore be all of a piece. One possible explanation for the difference is that the left-hand section was developed through the drawing stage and the initial painting stages alongside, but not yet joined to, the other sections. When it came to be physically attached, the painting of the sand was already partly completed and it did not quite match: there are clear attempts in the surface layers to blend the two parts together across the join.

The background figures and boats were drawn in and painted over the already largely completed sand and sea. Two of them were deliberately placed to help disguise the paper joins – the woman with her furled parasol at the left and the distant sailing boat at the right. The drawing of the group at the left is especially striking for its boldness and animation (Fig. 107). Their poses changed somewhat between drawing and painting: for example, the striding boy was originally further away and the head of the nurse carrying the baby was originally lower. In the final stages of painting, various details were added – the

Fig. 106 Bathing machines at St Leonards-on-Sea, East Sussex, about 1895.
Photograph: Hulton Archive/Stringer 2004
Getty Images, London

Fig. 107 Detail from Fig. 105 showing left-hand group.

Fig. 108 Detail from Fig. 105 showing sky, top left

REFERENCES
Bodkin 1932, plate XXVII; Lemoisne 1946–9, Vol. II, p. 222, no. 406; Davies 1970, pp. 46–7; Smith, in London 1981; Herbert 1988, pp. 274–80; Kendall, in New York and Houston 1993, pp. 115–21.

NOTES
1 Vollard 1937, p. 47.
2 For the exhibition and reviews see the following: Moffett, in Washington and San Francisco 1986, p.198 and Berson 1996, Vol. II, p. 73, no. III–50.
3 Mills and White 1981, p. 67. The white paint used for the towel contains poppyseed oil.

bonnet at the left and the parasol and basket on the sand at the right. Original paint on the paper edging at the left and right sides of the canvas indicates that the composition was by no means complete when the three sheets of paper were mounted on the canvas. Part of the white paint of the towel hanging out of the basket continues over the edge at the right, and the sky and sea were extended slightly on to the canvas support at the left.[3] The smaller figures and boats in the distance were painted in without being drawn.

As a footnote to what it tells us of the evolution of the composition, the infrared image also reveals part of a tantalising clue on the left-hand sheet. Near the top, under the paint of the sky, is some writing: the name 'Degas' and some figures can be discerned (Fig. 108). Could these be the remains of his instructions to the mounter about the dimensions of the piece of paper being added? Such written notes are evident in at least one other work where a paper support was subsequently enlarged (see p. 32).

7 Hélène Rouart in her Father's Study, about 1886

Oil on canvas, lined
162.5 x 121 cm, outer 0.5 cm all round covered by brown paper
NG 6469

The sitter was the daughter of Degas's friend, the industrialist, painter and collector, Henri Rouart.[1] He amassed a rich collection of modern French painting, including works by Degas himself, Corot, Millet, Manet, Monet, Cézanne and Puvis de Chavannes. Degas regularly dined at the Rouarts's, among whose other guests was the young Paul Valéry who was much impressed by the older artist's wit:

> Every Friday the faithful Degas, sparkling and unbearable, enlivens the dinner table at M. Rouart's. He spreads wit, terror, gaiety. He mimics piercingly and overflows with caprices, fables, maxims, banter. He has all the characteristics of sharply intelligent injustice, unerring good taste, and a passion which is concentrated but lucid . . . His host, who adored him, used to listen with admiration and indulgence, while the other guests . . . relished these displays of irony, aesthetics or violence coming from this wonderful magician with words.[2]

Degas first painted Hélène sitting on her father's knee in 1870 (private collection; Fig. 110), and later, in around 1874–5, attracted by her red hair, he resolved to paint her again. When she was 21, he wrote to Rouart, 'Your daughter who has always had such pretty colouring must by now be dazzling.'[3] Degas originally planned to paint her with her mother, who was then to be substituted with her father, but the final picture shows her alone, leaning on the back of her father's empty chair (Fig. 109). There are a number of studies, the first two of which relate to Degas's early conception for the portrait, one of them with Hélène's mother lightly sketched in at the edge, the other with the daughter alone (Fig. 111). There are none surviving of Hélène with her father, but a notebook drawing explores the pose of Hélène perched on the arm of his chair (Fig. 112), and two further drawings show her in the same position wearing a blue striped dress and a sash (Figs 113 and 114). These are followed by a sketch of her leaning on the back of the chair (Fig. 115) and Degas made a final detailed drawing of her hands, almost as they appear in the portrait (Fig. 118).

Fig. 109 *Hélène Rouart in her Father's Study*, about 1886.
London, National Gallery, inv. NG 6469

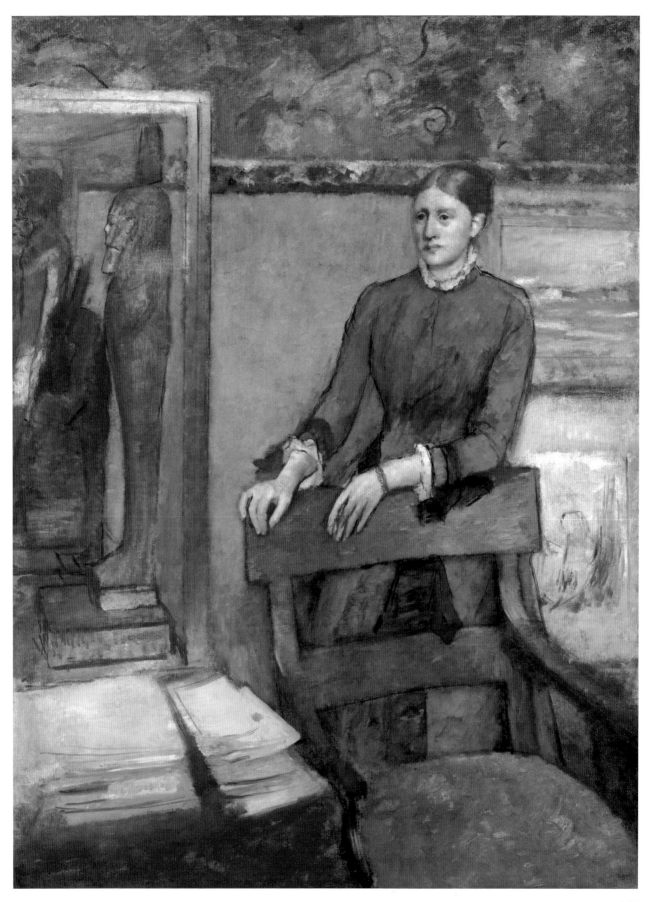

Fig. 110 *Hélène Rouart on her Father's Knee*, 1871–2.
Oil on canvas, 63.5 x 74.9 cm.
Private collection

The painting includes a number of pictures and objects from her father's collection.[4] On the wall behind her hangs Corot's *Castel dell'Ovo in Naples*, 1828, now in a private collection, and a drawing by Millet, *Peasant Girl Seated by a Haystack*, about 1851–2, now in the Cabinet des Dessins, Musée du Louvre, Paris. There are three Egyptian statues in the glass case behind her, their size exaggerated by Degas. They were possibly acquired by Henri on his visit to Egypt in 1878.[5] A Chinese wall-hanging across the top of the picture is painted in a strongly coloured, fine-grained red iron oxide pigment similar to Venetian red. The overall warm tone of large parts of the picture results from Degas's use of a wide range of iron oxide reds, oranges and browns of this type, for example in the chair, tablecloth, papers and the Egyptian objects in the vitrine. More conventional red pigments such as vermilion are used rather scarcely.

The portrait is painted on very fine canvas of non-standard size, prepared with a commercial ground based on lead white. The canvas is lined and the tacking edges are no longer present. The lining seems to have become necessary to repair small damages that are scattered across the painting and around the edges – although whether these happened while it was still in Degas's studio is not known. Equal cusping of the canvas threads at all four edges in the X-ray, suggests that the composition has not been cut down. The X-ray (Fig. 116) also

Fig. 111 *Portrait study of Hélène Rouart standing*, 1886.
Pastel and charcoal on tan paper,
48.9 × 31.7 cm.
Los Angeles County Museum of Art, Mr and Mrs William Preston Harrison Collection, 1935, inv. 35.19.2

Fig. 112 *Study of Hélène Rouart sitting on the Arm of a Chair*, 1886.
Pencil on paper, 16.2 × 9.8 cm.
Paris, Bibliothèque Nationale, carnet 6, p. 206

Fig. 113 *Study of Hélène Rouart sitting on the Arm of a Chair*, 1886.
Pastel, 49 × 34 cm.
Private collection, Sotheby's Sale, 1.12.1987 Lot 16

Fig. 114 *Study of Hélène Rouart sitting on the Arm of a Chair*, 1886.
Pastel on pale blue paper, 49 × 34 cm.
Private collection

Fig. 115 *Hélène Rouart leaning on a Chair*, 1886.
Black chalk on paper laid down on board,
31.1 × 20 cm.
Private collection

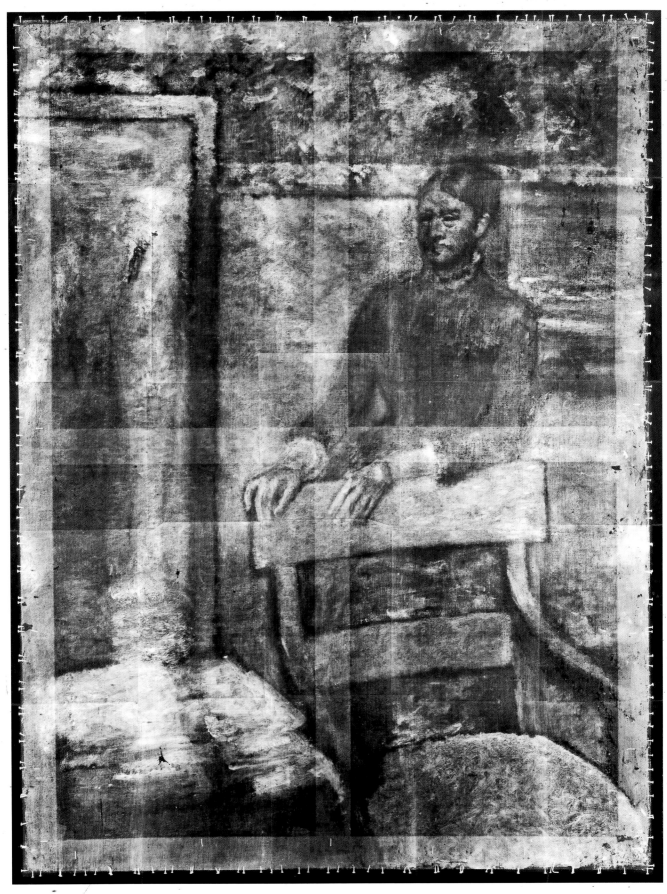

Fig. 116 X-ray composite of Fig. 109

shows that Degas set down the portrait with little significant alteration – although, as usual, outlines were adjusted and readjusted as he worked. Hélène's basic pose in the painting followed the sketch in which she stands behind her father's empty chair with her hands resting along its back (see Fig. 115). Her dress, with its lace trim, is similarly cut around the neck in both sketch and painting, but the sleeves are a little longer in the painting. The skirt is less full to the right of the chair and has the dark sash and matching cuffs shown in the earlier sketches but not this final one.

The composition was mapped out with broad dark lines and basic shading on the white ground. These first outlines are difficult to see in the finished painting, since they are covered by later multiple contours. However, the brownish monochrome undermodelling layer, largely of a red-brown iron oxide pigment with black – the *ébauche* – is plainly visible in the centre of the bodice where the blue dress colour is largely absent. The paint on top is complex and variably structured throughout the painting. The dress is blue-toned, but the faint stripes of the preliminary pastel sketches have given way to a complex layering of colour that creates a shimmering quality to the fabric of the dress. The warm underlayers shining through the blue give the effect of shot silk. The blues are based on Prussian blue combined with varying amounts of lead white and some cerulean blue (cobalt stannate pigment) in the greenish areas. Black is also used to give the darkest tones. Changes of contour are obvious in Hélène's shoulders and arms: her left shoulder has been raised and her left arm broadened – but the alterations were left incomplete so that the background is clearly visible through them. Degas's final outlining of the dress is of two kinds. The first is a brilliant red that, at first glance, appears to have the dry quality of pastel (Fig. 117): however, close inspection shows it to be red oil paint

Fig. 117 Detail of red outline in Fig. 109

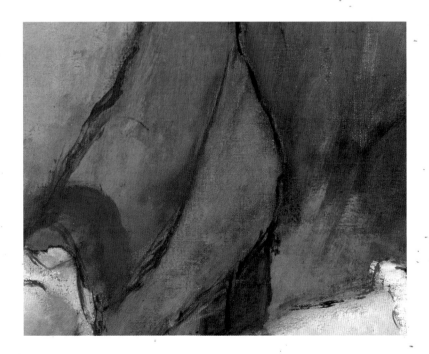

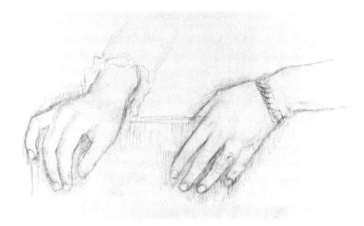

Fig. 118 *Study for Hélène Rouart's Hands*, 1886.
Charcoal on tracing paper laid down on brown paper, 25 × 41 cm.
Formerly in the collection of Steven Schwartz, lent to the Art Institute of Chicago, Illinois, inv. S113. Private collection, inv. anonymous sale, Christie's, New York, 13 May 1987, Lot 105

Fig. 119 Detail of hands in Fig. 109

Fig. 120 Detail of hands in Fig. 116: X-radiograph

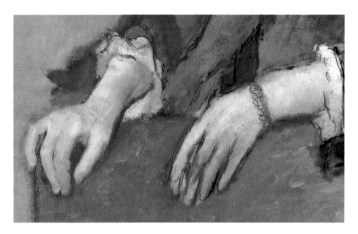

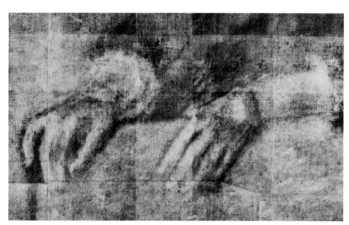

containing vermilion brushed out with very little diluent.[6] The second, which passes over the red, is the repeated bold blue line that surrounds the entire figure and seems to represent Degas's last touches to the painting. Even at that ultimate stage, he was revising the contours – for example, the edge of the skirt at the lower right was shifted outwards with the rapidly painted blue outline that overlaps the background and the late change to the arm of the chair (see below).

Hélène's hands, too, have undergone some revisions and it is possible to chart them by comparing the preliminary drawing with the final painting and its X-ray (Figs 118, 119 and 120). The X-ray shows that the hands were set down exactly as they appear in the drawing, including the engagement ring on the third finger of her left hand. The right hand, with its little finger hooked over the corner of the chair back, was left unchanged during subsequent alterations to the painting, except that the lace cuff was moved a little higher up the wrist. However, Degas revisited the left hand, painting out the ring (which is still

Fig. 121 Paint cross-section from the pink and green wallpaper, to the left of the sitter's head in Fig. 109, showing Degas's multiple applications of varying colours for this area of the background. Magnification 370X

REFERENCES
Lemoisne 1946–9, Vol. III, p. 504, no. 869; Boggs 1962, pp. 67–9, 74, 128; *The National Gallery Annual Report, January 1980–December 1981*, London, 1982, pp. 46–9; Gordon, in London 1984; Kendall, in Liverpool 1989, pp. 18–23, no. 6; Baumann and Karabelnik, in Zürich and Tübingen 1994–5, pp. 72–7.

NOTES
1 For Henri Rouart and the Rouart family see Distel 1990, pp. 177–89, and Rouart 2001.
2 Valéry 1938, p. 16. Quoted by Gordon, in London 1984, p. 4
3 Letter from Degas to Henri Rouart, October 1883. Quoted in London 1984, p. 6.
4 For a discussion of these see Reff 1968, pp. 158–62 and Reff 1976a, pp. 137–40.
5 For the symbolism of these statues see Reff 1995, pp. 66–7.
6 White et al. 1998, p. 94.

faintly visible through the surface paint) and redefining the fingers so that they curved downwards a little more. The original and revised outlines are all visible, giving the hand the appearance of flickering movement, as if Hélène is shifting it along the chair back as we watch. The suppression of the ring cannot be explained by any change in Hélène's circumstances: she married Eugène Marin, went on to have three children and died in 1929. Degas painted it out for reasons that are not difficult to imagine – presumably wishing to emphasise the presence of the unseen father rather than the future husband.

The portrait was still in Degas's studio when he died in 1917 and the signs of reworking on its surface confirm that he returned to it more than once during the thirty years or so that it remained there. A cross-section of the mottled pink and green wallpaper to the left of the figure of Hélène Rouart, for example, reveals a surprising number of layers and colours and suggests Degas's working and reworking of the colour and texture of the paint here (Fig. 121). As well as the constant redefining of outlines, there is an especially heavy passage of overpaint at the lower right, around the arms of the chair. This muddy paint has all the hallmarks of Degas's habit of repainting areas of – or sometimes entire – earlier works in old age, much to the annoyance of their current owners. According to Vollard, Henri Rouart himself foiled Degas's 'mania for adding final touches to his pictures, no matter how finished they were' by chaining the *Danseuses* he owned to the wall. The reason for the repainting of the chair arms in the present composition is not clear: they are present in all the preliminary sketches. A cross-section of the paint from the left arm of the chair suggests that it was present in the initial stages of the composition, although its colour was cooler and closer to that of the present seat. The arms may have been scraped down and repositioned slightly higher and the red-brown earth pigment applied by Degas to give greater prominence. The present angle was reinforced by that final blue outline of the skirt at the right.

8 Woman at a Window, about 1871–2

Oil (*essence*) on paper, mounted on linen
61.3 x 45.9 cm
Signed bottom right: 'Degas'; stamped in red, bottom right: 'Degas'
London, Courtauld Institute of Art Gallery

The sitter for this unfinished painting is unknown, although according to a later owner of the picture, Walter Sickert, she was a Parisian *cocotte*. In his copy of Jamot's monograph on the artist, Sickert recorded in an annotation that Degas had told him it was painted 'during or soon after' the Siege of Paris in 1871 and that, during the Siege, he had bought her a piece of raw meat 'which she fell upon, so hungry was she, & devoured it raw'.[1]

This vision of a half-starved woman falling on a scrap of food is at odds with this serene image of a sombrely-dressed lady seated against the light, her head with its delicately-drawn profile inclined towards the window (Fig. 122). Unusually for Degas's less finished works, most of which remained in his studio at his death, this painting left his hands, either as a sale or a gift. Sickert later bought the painting from Degas's dealer Durand-Ruel in around 1901–2 as a present for his former wife. He wrote to his patron Sir William Eden to announce his purchase: 'I have just bought Degas's *finest* work, had my eye on it for 12 years or so!, for £400! for Mrs Sickert, and sold the one I bought for £74 or so to an American for £3000.'[2]

Degas's interest in *contre-jour* (against the light) effects is evident in many of his works, and a notebook page from the 1860s of a figure silhouetted against a window seems to anticipate the present composition (Fig. 123).[3] In that sketch, the tonal contrast is achieved conventionally with dark pencil on white paper – but here, in the painting, the situation is reversed: the paper support is dark and stands for areas in shadow, while the light beyond the window consists of thinly brushed dense white paint. So deep a colour is the support and so imprinted is it by the impression of the canvas weave behind, that it is at first difficult to recognise it as paper. But paper it is – a single buff coloured medium weight wove sheet, mounted on a stretched canvas. The sheet measures 63 × 48 cm, standard Royal size, and on the left turnover edge is the embossed stamp, DE CANSON–FRERES–VIDALON–LES–ANNONAY, the paper manufacturer in the Ardèches known to have provided many of the papers used by Degas (see also Cat. 11). It is turned around the sides of the stretcher, covering some

Fig. 122 *Woman at a Window*, about 1871–2. London, Courtauld Institute of Art Gallery, inv. P1932.SC.88

112

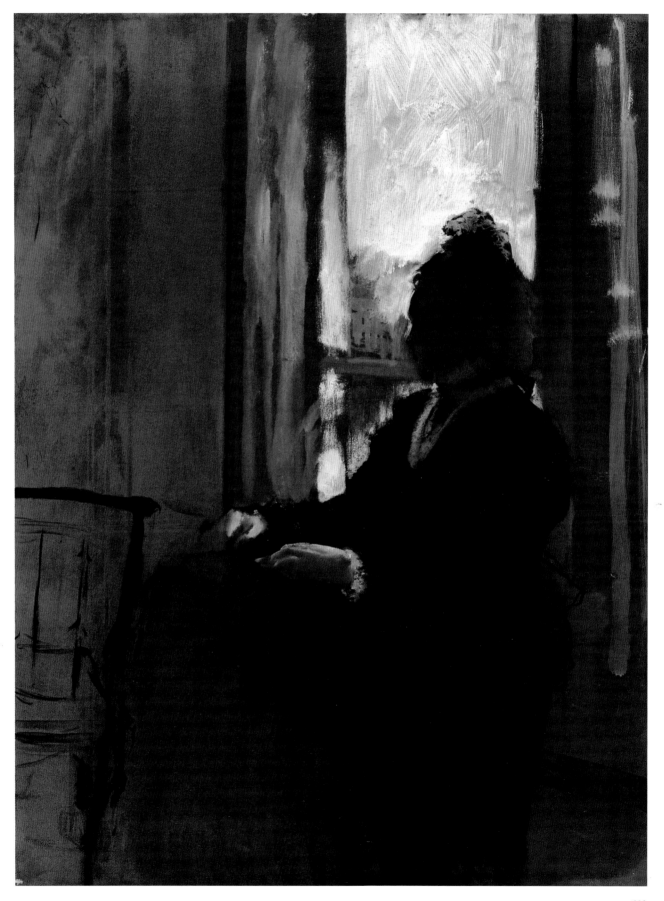

Fig. 123 *Woman at a Window*, about 1860.
Pencil on paper, 5.6 x 9.7 cm.
Paris, formerly Marcel Guérin, carnet 3, p. 25 verso

of the canvas tacks – indicating that it was glued on to the already stretched canvas before painting.[4] Two other important paintings in *essence, Racehorses before the Stands* and *The Pedicure* (see Figs 20 and 21) have similar structures of paper on stretched canvas and are of identical dimensions – suggesting that Degas had a number of these specialised supports prepared around, or shortly before, 1870.

The unprimed paper was prepared for painting with a thin wash of red colour, which deepened its original buff tone to a light red-brown. Later layers of varnish and the effects of age have darkened the paper still more. The figure was outlined with a rapid, lucid and fluent brush drawing, which shows clearly in an infrared photograph (Fig. 124), and then blocked in with thin washes of black *essence* paint. As usual with Degas, there are multiple contours – particularly down the woman's back, where the black outline was modified with a paler tone and then redrawn with more brushed lines. The lower part of her skirt and her face are only faintly washed with black and were smudged and dabbed to achieve the delicate soft look of a watercolour, contrasting with the bold, fluid outlines of the chair.

The composition is given its extraordinary impact and subtlety by the use of light coloured *essence* paint – most obviously in the broad slab of white for the sky, but also in touches on the figure itself. White is used not only for collar and cuffs, but also for the faint reflection on the sitter's neck and jaw and for the almost indiscernible upper outline of her left arm. The shape of the upper part of the figure is almost wholly defined by the white around it: the profile of the

REFERENCES

Cooper 1954a, no. 22; House, in London 1994, p. 88, no. 16; Lemoisne 1946, Vol. II, p. 206, no. 385. Far, House et al., in Cleveland, New York (etc.), 1987–8.

NOTES

1 This copy of Jamot is in the Fondation Custodia, Paris (Collection F. Lugt). See also an account in Sickert 1923.
2 Sutton 1976, pp. 111–12.
3 Reff 1976, Vol. 1, p. 109.
4 Technical information in this catalogue entry is taken, with grateful acknowledgement, from: Emma Wesley, 'Degas at the Courtauld: a technical examination of six works by Degas in the Courtauld Institute Gallery', final year research project, Department of Conservation and Technology, Courtauld Institute of Art, London, 2003.

head is delineated and corrected with a fine brush and white paint – and the silhouette of the right arm has been reduced and redefined with bold verticals of white. Pale colour is used for the greenish decoration in her hair and, with highlights in pure white, for the brilliantly focused play of light across her half-clenched hands.

Although the painting is clearly not formally finished, Degas was evidently satisfied enough to sign it and part with it. Today, although much altered by darkened varnish, it remains a celebrated example of the power and extraordinary economy of Degas's unique *essence* technique.

Fig. 124 *Woman at a Window*, infrared photograph of Fig. 122
London, The Samuel Courtauld Trust, Courtauld Institute of Art Gallery, inv. P. 1832.SC.88

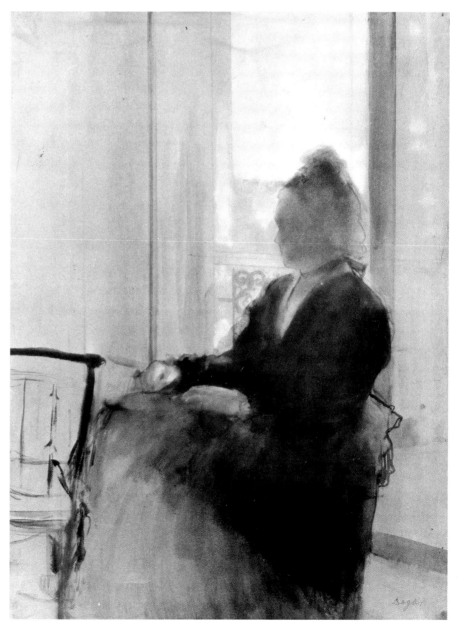

9 Portrait of Elena Carafa, about 1875

Oil on canvas, lined
70.1 x 55 cm
NG 4167

The sitter was the first cousin of Degas. Her mother, Stefanina, Duchessa Montejasi-Cicerale, was the youngest sister of Degas's father. Like other members of Degas's family they lived in Naples.[1] Degas accompanied his dying father from Turin to Naples in the winter of 1873–4, and was again in the city for the funeral of his Uncle Achille in 1875. He either painted this portrait during these visits or when Elena was on a visit to Paris. Elena was born in 1855, and would have been about 20 at the time. Leaning back in her chair, her fingers intertwined with what may be a piece of cloth or the leaves of a book, she gazes directly at the viewer, poised and self-assured (Fig. 125). In an earlier portrait painted by Degas in 1865–8 of her with her younger sister Camilla, born in 1857 (Fig. 126) she again looks directly and surely at the spectator, while Camilla looks pensively away, her uncertainty heightened by a lack of definition in her features. Degas again painted the two sisters with their mother in about 1876 (Museum of Fine Arts, Boston).

Elena Carafa is painted in linseed oil on canvas of non-standard size, which was lined, probably in the 1920s; the tacking edges are no longer present. The canvas is prepared with a thin off-white commercial oil ground of lead white extended with barium sulphate, on which Degas began by sketching out the

Fig. 125 *Portrait of Elena Carafa*, about 1875. London, National Gallery, inv. NG 4167

Fig. 126 *Elena and Camilla Montejasi-Cicerale*, about 1865–8.
Oil on canvas, 57.5 x 73.7 cm.
Hartford, Connecticut, Wadsworth Atheneum Museum of Art. The Ella Gallup Sumner and Mary Catlin Sumner Collection Fund, 1934, inv. 1934.39

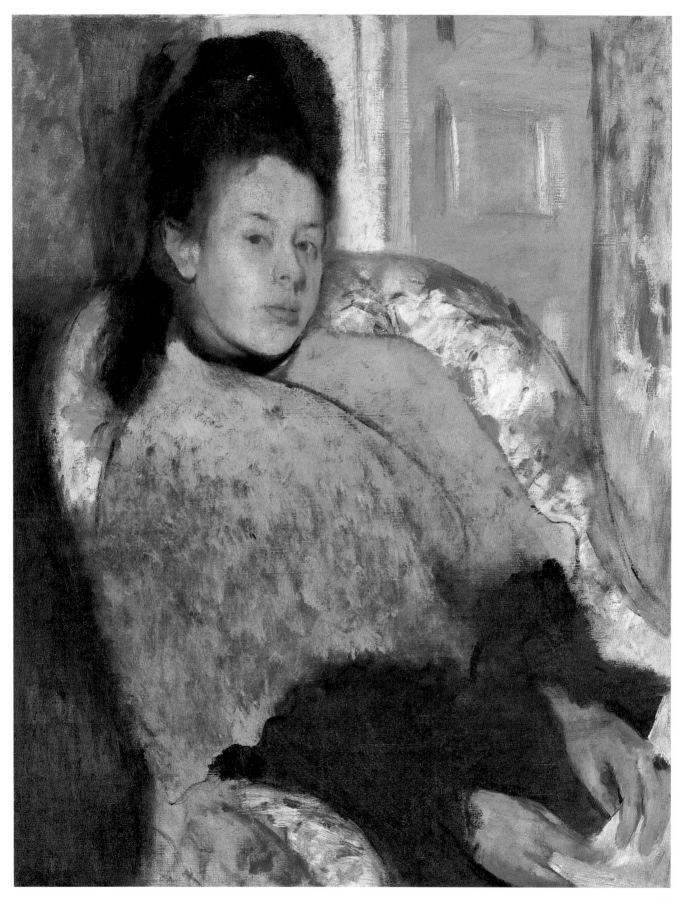

main forms with brush and dark paint. Technical examination has shown that
the painting is dominated by the startling change of pose, revealed in the X-ray
(Fig. 127). In the finished portrait, the sitter challenges the viewer with a direct
glance, while in the X-ray image she looks with a pensive, unfocused gaze
towards the right. Looked at in sequence, the two positions suggest an almost
dynamic encounter between painter and sitter – as if she is first discovered lost
in thought, but then turns to confront the observer. Of course, Degas's idea
for the change of composition may, indeed, have resulted from just such a
movement by his subject.

Although the alteration in the position of the head represented a major
change in the visual impact of the portrait, in terms of technique it was
achieved with curiously little repainting. The near side of the face – the position
of the near eye and the nose – is more or less unchanged: Degas simply

Fig. 127 X-ray composite of Fig. 125

extended the face by enlarging the far cheek and eye, and then repositioned the whites and irises of both eyes to look directly at the viewer. The former profile can be seen faintly through the surface paint. Interestingly, little of the present angle of the face is visible in the X-ray – confirming that the alterations were made with thin, light paints containing almost no lead white.

As well as turning the face, Degas extended the piled-up hair towards the right with a dark paint of black pigment mixed with red lake, as more would be seen in this head-on position – the white fleck in the centre of the hair is presumably the end of a hairpin. This paint is more translucent than that applied earlier and the change is easily visible on the picture. More obviously, he also shifted Elena's left shoulder so that her upper body is angled more towards the viewer instead of to the side. The shoulder was raised by repainting the area from the join in the shawl up to the new angular outline, with paint of a slightly bluer tone than the rest of the shawl. The previous, lower profile of the shoulder and the pattern of the chair fabric show clearly through the added paint. There is a marked difference in texture and gloss between the stages of painting – the second phase being richer and glossier than the first: this became apparent when the painting was cleaned and a heavy discoloured varnish was removed. Close examination also reveals that the upper part of Elena's costume appears originally to have been black and the greenish shawl was added at an early stage. The blue-green paint consists of emerald green with French (synthetic) ultramarine and white, with small quantities of other pigments to give a greyer tonality. Emerald green with white and a little black is used for the pale grey green of the wall behind the sitter.

As usual in his paintings, Degas has used varying levels of finish to focus the viewer's eye. Face and hands are relatively sharp and mark the ends of the principal diagonal of the figure. Moving away from this axis, the focus diminishes: the pattern of the chair, enclosed by the normal multiple outlines at the right, gives way to the rapidly sketched background of door and wallpaper. At the left, the red of the curtain echoes the red flower in Elena's hair; both are painted in vermilion. The colour of the deeper red paint behind the sitter's head is intensified with a glaze of transparent madder lake. The vermilion reds merge with a flat patch of indistinct black shadow, which curves in and defines the back of the chair. This very dark paint contains black pigment and iron oxide red in variable proportions, giving a shifting quality, and the whole passage is unified with a glaze of the same transparent madder pigment.

REFERENCES
Lemoisne 1946–9, Vol. II, p. 168, no. 32; Davies 1970, pp.53–4; Baumann and Karabelnik, in Zürich and Tübingen, 1994–1995, pp. 195–8, and no. 120.

NOTE
1 For a discussion of Degas in Naples and portraits of his family there see the following: Guérin 1928, pp. 372–3 and Boggs 1963, p. 275, note 28.

10 Carlo Pellegrini, about 1876–7

Oil on laid paper, strip-lined
62.6 x 34.2 cm, tapering to 33.4 cm at the bottom
L699

Pellegrini (1839–1889) was a famous portrait caricaturist who settled in England in 1864. He was a contributor to *Vanity Fair*, publishing his drawings under the signature 'Ape' (Fig. 128). His caricatures of politicians and other notables of the day were drawn almost entirely from memory, and became extremely popular. Degas may have been introduced to him by either Whistler or James Tissot. In about 1876–7 Pellegrini painted a half-length of Degas which he inscribed in the bottom left-hand corner 'à vous/Pellegrini'. This portrait by Degas, inscribed 'à lui/Degas' was most probably a return present (Fig. 129).[1]

Degas has emulated Pellegrini's own style in this portrait, with its placing of the gesticulating figure in a narrow upright format, although Degas has eschewed a neutral background, and added some indications of a setting.

The portrait is painted on a piece of laid paper cut from a larger sheet, with the original deckle edge still present at the bottom. The paint medium appears to be solely oil, used for the most part in the form of *essence*. Previous descriptions of the technique of this painting have speculated on the medium, judging it to be not only oil, but also partly gouache and partly pastel. Certainly the dry strokes at the upper right corner resemble pastel, but close examination indicates that they are basically fluid brushstrokes applied with very little diluent. The paint for the yellow background and Pellegrini's dark suit is classic *essence* – oil paint drained of most of its medium and diluted with mineral spirits or turpentine until it flows and blends like watercolour. In this form it has almost no thickness and, essentially, just stains the surface of the paper as it dries to a matt finish. In Pellegrini's head, and also his collar and cuff, oil paint is used conventionally – with thickness and impasto, with fluid and broken brushstrokes. In his forehead, the thick pink paint contains a great lump of congealed pigment (Fig. 130).

The portrait is painted so directly that there is little in the way of detailed preliminary drawing, either with pencil or with brush. Only the broadest outlines were set down rapidly with brush and dark paint. In places, the final outlines do not quite correspond with the initial sketching-in. For example,

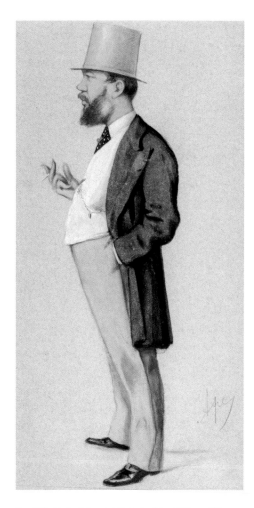

Fig. 128 Carlo Pellegrini, *Portrait of Lord Wharncliffe*. From *Vanity Fair*, 14 August 1875. London, National Portrait Gallery, NPG 4699

Fig. 129 *Carlo Pellegrini*, about 1876–7.
London, National Gallery, L699

Fig. 130 Detail of face in Fig. 129

Pellegrini's right arm and elbow have been shifted down slightly, his jacket has been lengthened and his shoes made more pointed; originally, his nose was lower and longer and his right hand has been shifted to the right. The clearest alteration is to the hat held behind his back, which was sketched in higher and then moved down: the first position is only partly obscured by the *essence* repainting in this area.

In the background, the trunks of small trees were summarily indicated – but one that appeared to be growing from the top of Pellegrini's head was painted out with green grass colour. The strange shape at the upper left seems to be the back of a man's coat with his legs indicated by the vertical streaks below.

REFERENCES
Lemoisne 1946–9, Vol. II, p. 222, no. 407; Boggs 1962, pp. 53, 127; Alley 1981, pp. 145–8; Baumann and Karabelnik, in Zürich and Tübingen, 1994–5, p. 38.

NOTE
1 See Alley 1958, p. 171.

11 After the Bath, Woman drying herself, about 1890–5

Pastel on wove paper laid onto stout millboard
103.5 x 98.5 cm
Studio stamp, bottom left
NG 6295

The nude female figure seen after her bath was one of the constant themes of
Degas's art in his later years. He studied these women in oil paintings, pastels
and sculptures. Most often he showed them drying themselves in more or
less complicated poses, some almost painfully contorted. In many, a female
attendant accompanies the bather. The pose here (Fig. 131), where the nude is
alone, seated on a low upholstered chair, rubbing the nape of her neck with a
towel, her right hand resting on the rim of the adjacent tub, is relatively relaxed,
with little sense that the body is under strain. Indeed, the bather wears a homely
slipper on her left foot, a detail rarely found elsewhere in this series but richly
suggestive of domesticity, ease and the comfortable privacy of the boudoir.
This heavily worked pastel, with its dominant yellow-green tonalities, set off by
the red highlights in the carpet and of the model's hair, most closely resembles
a more rosy-hued version of the same subject (Norton Simon Museum,
Pasadena). A large charcoal drawing (Fig. 132) shows the same figure more-
or-less in outline and with little indication of the surrounding décor. In other
variants, the figure's right arm is brought around to rub her lower back, while a
related pastel in the Courtauld Gallery, London, shows the model with left arm
raised and right arm reaching across the breast to dry her left side. All together,
the bather pictures can be seen to constitute a series or sequence 'mapping' the
intimate process by which a female nude dries herself,
each body part touched and tended in turn.

After the Bath is one of Degas's large cumulative
pastels in which he began with a tightly composed
figure study and then expanded it to include more
space for background and foreground. The support
consists of seven pieces of the same opaque wove
paper, with a slightly pink tone caused by scattered
red and brown fibres visible under magnification. It
was probably designed as a pastel paper, although it
might have been made as a wrapping paper. The most

Fig. 131 *After the Bath, Woman drying herself,*
about 1890–5.
London, National Gallery, inv. NG 6295

Fig. 132 *After the Bath,* about 1890–2.
Charcoal on tracing paper, 49.7 x 64.4 cm.
Cambridge, Massachusetts, Courtesy of the Fogg Art
Museum, Harvard University Art Museums. Bequest of
Meta and Paul. J. Sachs, 1965, inv. 1965.257

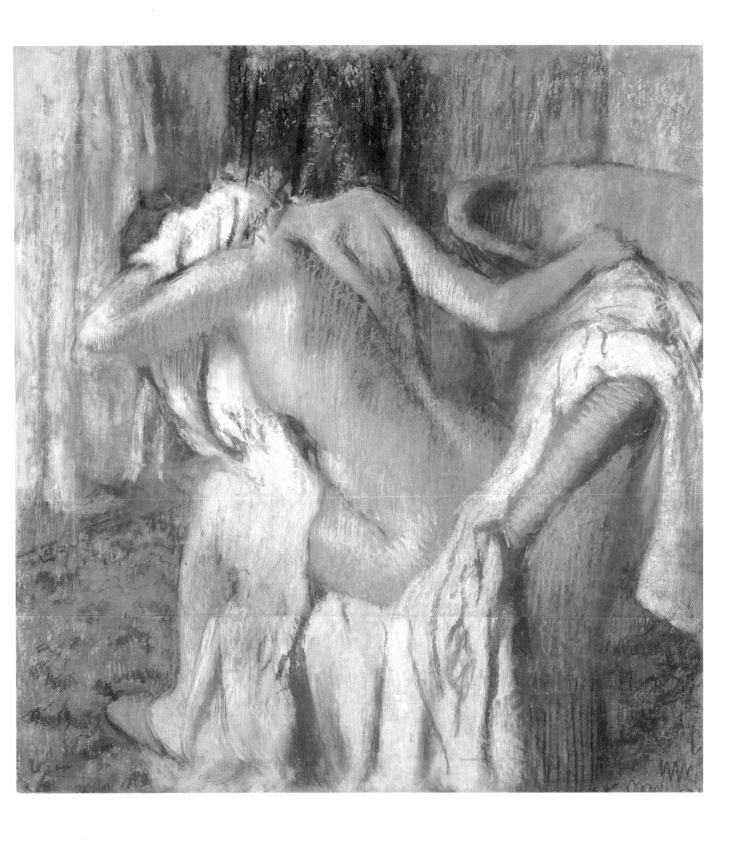

likely manufacturer was Canson et Montgolfier's Vidalon mill at Annonay in the Ardèche, which supplied many artists' colourmen in Paris with paper designed for all sorts of uses.[1] The pieces are mounted edge to edge on millboard, possibly with another supporting layer of paper in between (see diagram, Fig. 133).

Degas seems to have begun by drawing the figure across only the two largest sheets, in a very similar pose to the Fogg Art Museum drawing (Fig. 132). In both cases, the elbow is clipped by the left edge of the paper, the upper edge is just above the head and shoulder, and the lower edge cuts the figure below her thigh and knee. The right hand resting on the chair back is slightly differently placed – a little closer and higher in the Fogg drawing. The same initially horizontal format is seen in the charcoal and pastel drawing, *Woman drying her Hair*, which was subsequently extended at top and bottom, but not fully finished (Fig. 134). The drawing is broadly sketched out in charcoal and can be seen between the colour layers in several places.

In the National Gallery picture, Degas then decided to extend the composition by adding extra pieces of paper, but not before he had started to colour the drawing – since a clear difference in the density of colour can be seen between the initial part and the added sections (Fig. 135). His habit of extending partially

Fig. 133 Diagram of paper construction for Fig. 131.

Fig. 134 *Woman drying her Hair after the Bath*, about 1893–8.
Pastel and charcoal on tracing paper; 84.1 × 105.4 cm.
New York, Brooklyn Museum of Art, Museums Collection Fund, 1921, inv. 21.113 (L953)

Fig. 135 Detail of leg in Fig. 131

completed pastels with strips of paper and the visits to his *colleur* for gluing them together have been vividly described (see p. 31). The skill of these paper mounters in achieving such perfectly aligned joins must have been remarkable. It is likely that any existing pastel would have been fixed beforehand and, under magnification, the paper surface and the lowest layers of colour do indeed have the distinct shine of fixative. Degas's chosen craftsman was normally Lézin on the rue Guénégaud, but in this case he seems to have used the firm of Adam-Dupré on the rue Fontaine, whose label is on the back of the supporting board (Fig. 136). As well as framing and restoration, this company clearly specialised in the mounting of photographs, maps and other works on paper. The same label has been found on the back of the large, multi-figured *Bathers*, now in the Art Institute of Chicago, suggesting that Adam-Dupré's shop was, along with Lézin's, a regular port of call for Degas.[2]

With the addition of the five further pieces, Degas extended his drawing and continued to add colour. The woman's elbow was slightly re-drawn to overlap the added piece at the left, and her legs, the towels and the chair were continued downwards. The black outlines were continually reinforced as Degas worked and appear both below and on top of the pastel layers. The use of pastel is typically varied throughout the picture. For many of the intermediate layers, the colour has the characteristic smeared appearance that occurred when the pastel sticks were wetted: this is especially evident, for example, in the white towel held next to the woman's red hair. Most of the vigorously hatched surface colours are of bright, unfixed pastel – Degas's common practice to render the tonality more brilliant as he worked on top of lower layers which were slightly muddied and dulled from wetting and fixing. The woman's torso and arms are particularly striking with their vertical strokes of violet for the shadows and creamy white

Fig. 136 Label on back of supporting board for Fig. 131

19 bis, RUE FONTAINE, 19 bis

AU FOND DE LA COUR

ENCADREMENTS
en tous genres

ENCADREMENTS

COLLAGE
de
PHOTOGRAPHIES POUR ALBUM

PASSE-PARTOUT ARTISTIQUES

ADAM-DUPRÉ

MONTAGE
de
Plans et Cartes Géographiques

SPÉCIALITÉ
Pour la Photographie

DORURE

Spécialité d'Encadrements de Dessins
AQUARELLES & PASTELS
Spécialité de Tendage de PARCHEMIN
Nettoyage & Remargement de Gravures
VERNISSAGE, RENTOILAGE ET RESTAURATION DE TABLEAUX
Fabrique de Moulures en Chêne et Bois de toutes essences
UNIES ET SCULPTÉES
BAGUETTES CHIMIQUES
CADRES EN TOUS GENRES

for the lit areas – extending slightly outside the drawn outlines to suggest the flickering play of light and movement. The chair back too is a bravura piece of pastel work – a more or less continuous zig-zag of yellow over orange, balanced by the use of the same colours for the slipper at the left. The two huge white towels are subtly differentiated by the use of pale blue highlights and violet shadows.

The palette of colours used for this picture shows the wide range of pastels available;[3] for example there are at least three blues, three or four greens, a similar number of reds and pinks and a number of other tones together with black and white. Apart from the muted mauves, where Degas blended several colours together by rubbing, probably with his fingers, each of these shades indicates the use of a separate pastel stick. Unlike an oil painting, a pale blue, for example, is not easily made by using a mixture of dark blue with white. The powder blue colour below the model's foot consists of a single pastel colour comprising an intimate mixture of white, Prussian blue, French ultramarine and a little black. This combination of pigments was very finely ground by the manufacturer and formed into a stick with the addition of a little binder, usually gum arabic. After it had dried, it could then be packed with others and

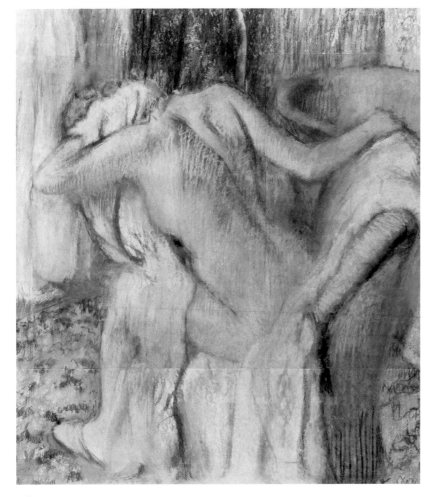

Fig. 137 Infrared photograph of Fig. 131

Fig. 138 Dispersed pigment particles under the microscope from deep reddish purple colour, lower right of Fig. 131. The pastel contains a mixture of pigments: French (synthetic) ultramarine, red iron oxide, madder lake and black.
Magnification 280X

sold, much as is the case today. The darker blues of the background are a similar mixture, but lack the white component.

Rather surprisingly, the very dark, cold dense greens, which have the appearance of viridian, are in fact based on virtually pure Prussian blue. The widespread occurrence of this pigment in the darker passages of the composition accounts for the almost black appearance of these areas in the infrared photograph (Fig. 137); Prussian blue absorbs infrared radiation very strongly. The brighter, yellower greens appear to contain a mixture of blue and yellow pigment. The strongest, bright yellow pigment, on the sitter's slipper for example, consists of cadmium yellow combined with a bright yellow natural ochre in a single stick of pastel. The orange colour of the carpet, to the left, also contains a natural earth pigment, this time a bright reddish orange.

The model's red hair consists largely of vermilion with a little rose-coloured madder lake pigment and a trace of black. The madder lake also occurs in the pinkish brown of the curtain to the left where it is mixed with red earth, some vermilion and some white and black. In the context of nineteenth-century painting, and the pigments that have been identified in the works of other artists, including Degas's contemporaries Monet and Renoir, a pale orange fluorescence in ultraviolet illumination indicates that the lake must contain madder dyestuff.[4] This characteristic fluorescence was noted for certain particles in the Degas red pastel samples. The madder pigment occurs again, in small quantities, in the beautiful mixed reddish purple strokes between the chairback and the towel, which also consists of French ultramarine, a strongly coloured red iron oxide and a black charcoal-like pigment with an unusual splintery particle form (Fig. 138). This pastel colour almost certainly contains some white in addition.

Analysis of the white pastel in this work, in a sample from the towel, showed that it is most likely based on a white clay mineral such as china clay (kaolinite) with another white, such as chalk. In the coloured pastels, which often contain a white pigment to lighten the tone, the type of white chosen has a bearing on the hardness and thus the handling qualities of the pastel.

After the Bath remained in the studio and bears the red atelier stamp at the bottom left – placed on a little patch of colour, rubbed with a finger, no doubt, especially for the purpose.

REFERENCES
Lemoisne 1946–9, Vol. III, p. 554, no. 955; Davies 1970, p. 55; Kendall, in London and Chicago, 1996, pp. 84–5, 230–1, no. 47.

NOTES
1 The authors are grateful to Peter Bower for information on the paper.
2 See Brettell and McCullagh, in Chicago 1984, pp. 188–91.
3 Maheux et al. 1988; Norville-Day et al. 1993.
4 Kirby et al. 2003, pp. 25–6.

12 Russian Dancers, about 1899

Pastel and charcoal on tracing paper with addition at the bottom 8.5 cm wide,
laid down onto a wove paper support on millboard, 73.0 x 59.1 cm
Stamped, lower left in red ink: degas
NG 6581

On 1 July 1899, the painter Berthe Morisot's daughter, Julie Manet, recorded a
visit to Degas in her diary:

> He talked about painting, then suddenly said to us: 'I am going to show you
> the orgy of colour I am making at the moment,' and then he took us up to
> his studio. We were very moved, because he never shows work in progress.
> He pulled out three pastels of women in Russian costumes with flowers in
> their hair, pearl necklaces, white blouses, skirts in lively hues, and red boots,
> dancing in an imaginary landscape, which is most real. The movements are
> astonishingly drawn, and the costumes are of very beautiful colours.[1]

It is not clear which three pastels Julie Manet saw that day, nor has the
chronology of Degas's series of *Russian Dancers* pastels been established. Nor
indeed has the execution of the works been tied to the visit of a specific dance
troupe to Paris, where Degas might have seen them. (Almost certainly, however,
the dancers were not Russian, but Ukrainian or Slavic. All such troupes were
referred to as Russian at the time.) While dance was an intense fascination of
Degas's, the ballet being the subject of hundreds of paintings and pastels, here
the artist turned his attention to a more exotic and tempestuous form of the art,
tinged with the primitive energy of the distant steppes. Unlike ballerinas, clad
in thin tutus and satin slippers, their legs, arms and long necks exposed – the
instruments of their expressivity – these dancers are elaborately costumed and
shod from head to toe (Fig. 139). The movements of their voluminous skirts
and sleeves, and of the ribbons in their hair, set up elaborate counter-rhythms
to the movements of their bodies. In their frenzied, pounding dance, resolutely
earth-bound and derived from peasant tradition, these women can be seen
as anti-ballerinas and, as such, objects of novel fascination to the artist.

Degas seems to have studied the poses of individual figures, as well as the
grouping of the three figures that he would use here, in large charcoal drawings,
sparingly touched with pastel. For example, the central figure here is studied
alone on a large sheet in the Museum of Fine Arts, Houston (Fig. 140) and in

Fig. 139 *Russian Dancers*, about 1899.
London, National Gallery, inv. NG 6581

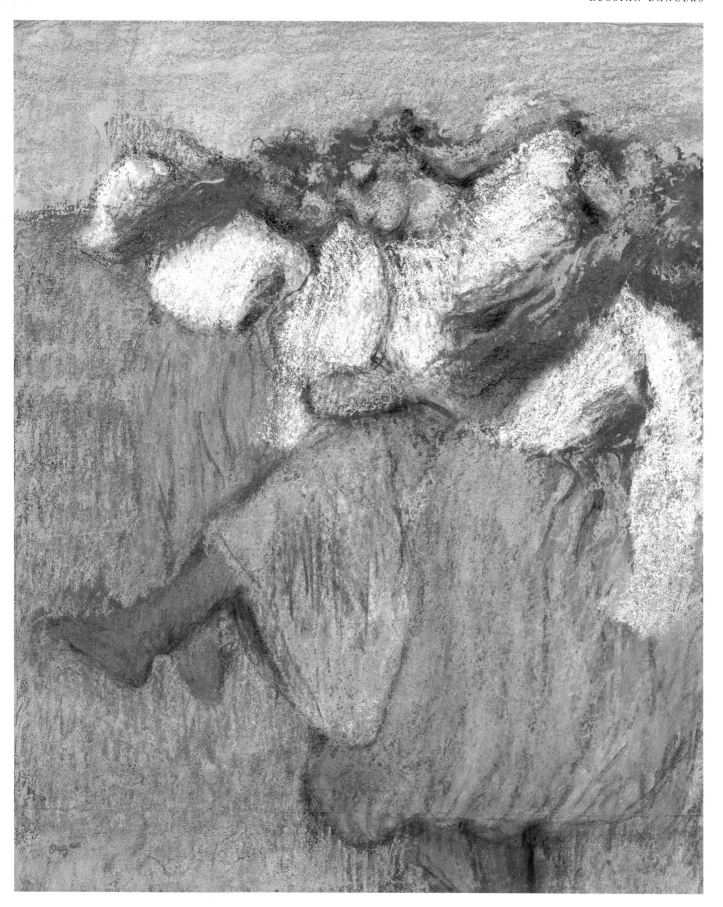

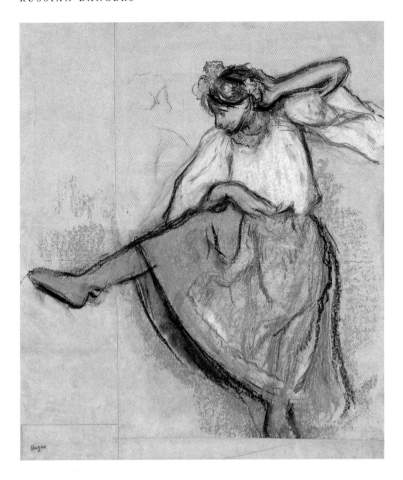

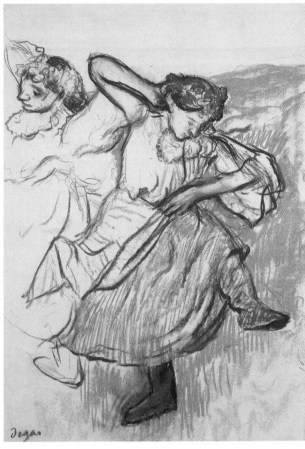

reverse in the sheet from Berwick-upon-Tweed (Fig. 141). The group of three figures is studied in a drawing in the Lewyt Collection (Fig. 142). All of these works are on tracing paper, allowing Degas to reverse figures at will, and to combine individual dancers in increasingly complex patterns. By mid-1899, when Julie Manet visited, it is clear that he had moved on from preliminary studies and was executing the group of highly-worked pastels, brightly impasted overall – indeed, encrusted with pigment; the 'orgy of colour' to which Degas referred – to which the present painting belongs. The artist added a large strip to the bottom of this sheet, though not enough to include the foot of the foreground dancer. This simple device of cropping the foreground foot, as well as an over-all blurring of forms, indicative of the energy with which Degas worked on this image, gives rise to the impression that we spectators are standing thrillingly close to the action here, almost more participants than audience.

The *Russian Dancers* series is the clearest demonstration of Degas's practice

Fig. 140 *Russian Dancer*, 1895.
Pastel and charcoal on joined tracing paper, laid down on board, 63 × 54 cm.
Houston Museum of Fine Arts, Texas.
Gift of the Sara Lee Corporation, inv. 1193

Fig. 141 *Russian Dancers*, about 1899.
Charcoal and pastel on tracing paper on paper, 67 × 47 cm.
Berwick-upon-Tweed, Borough Museum and Art Gallery

Fig. 142 *Three Russian Dancers*, about 1899–1905.
Charcoal and pastel on tracing paper, 99 × 75 cm.
Collection of Mrs Alex Lewyt

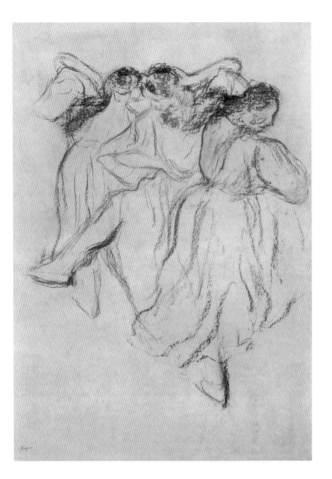

of reproducing and adapting images through tracing – and the National Gallery pastel, on tracing paper, undoubtedly had its origin in just such a copying process. The precise sequence of the series cannot be determined, although it is possible to identify closely related drawings and pastels with similar figures that either preceded or were derived from those in this particular work. The concept of tracing might lead one to expect the recurrence of figures of identical dimensions. Certainly some are close in size, either the same way round or in reverse, but to expect exact replication is to misunderstand Degas's aims in using the tracing method. He was not interested in merely producing duplicates; each tracing instead represented a new variation in the development of the theme. Although he might copy whole figure groups, he might also select only part of a drawing, change contours and add or subtract details as he traced. In his memoir of Degas, Vollard wrote of the way that the artist worked:

Because of the many tracings that Degas did of his drawings, the public accused him of repeating himself. [...] Tracing-paper proved to be one of the best means of 'correcting' himself. He would usually make the correction by beginning the new figure outside of the original outlines, the drawing growing larger and larger until a nude no bigger than a hand became life-size ... [2]

The National Gallery *Russian Dancers*, with its three closely overlapping figures, is very similar in design to the Lewyt drawing on tracing paper in charcoal with a few touches of red pastel (see Fig. 142). But, whereas the drawing shows the figures in their entirety, the National Gallery pastel has selected a closer view, cutting the composition at the right side and at the bottom. Nor is one a direct tracing of the other – the figures in the pastel are, in fact, smaller by a few centimetres than those in the drawing, even though they appear larger relative to the sheet they are on. The dancer in the Berwick drawing (see Fig. 141) is smaller still. So, although they are all on tracing paper, the precise relationship between similar figures is more complex than a simple transfer by tracing would suggest. Enlargement (or reduction) was involved, as Vollard's rather exaggerated anecdote implies.

However it was arrived at, a vigorous and detailed charcoal drawing on the smooth, slightly pink surface of the tracing paper forms the basis of the National Gallery pastel. It shows everywhere through the intense colour layers

as a dark framework for the composition. The centre dancer's foot, near the left edge, was originally in a flatter position – as it is in most of the other variants of this figure in the series – but was tilted upwards at the colour stage (Fig. 143). At some point, the extra strip of tracing paper was joined on at the bottom – held in place by a layer of paper on the back, but now curling and separating slightly from the main part. However, the join must always have been a little open, because there are accumulations of pastel colour within it (Fig. 144). The extra section was undoubtedly added while work was in progress rather than at the beginning, because the infrared image shows that the charcoal drawing for the grass does not continue on to it.

The layering of pastel on top of the drawing is complex and intricate, with brilliant superimposed colour contrasts and harmonies. The centre skirt has the close pairing of blue and blue-green, flanked by the other two skirts with the radiant complementary pair of blue over orange – a juxtaposition that is echoed in the hair ribbons of the figure at the right. The red hair of the left-hand dancer has one daring stroke of bright green and the red boots are also set against the green of the grass. The strongest pastel colours are provided by French (synthetic) ultramarine, chrome yellow (lead chromate), chrome orange (basic lead chromate), chrome green (a manufactured mixture of chrome yellow and Prussian blue), emerald green and viridian. Other pigments include red earth, an unidentified organic red pigment, chalk used as a white and bone black. Where there is virtually no medium binding the pigment (as in a pastel), chalk, which is translucent in oil medium, functions well as a bright white pigment. Some of the pastels, such as the bright chrome green, contain china clay (kaolinite) as a white extender. Analysis of samples has shown the presence of strontium, indicating the probable use of strontium sulphate or carbonate, also as an extender, for example in the blues. The properties and application of strontium white are similar to the very much more widely used barytes (barium sulphate).

The way that the pastel colours were applied and layered is highly distinctive. Many parts of the lower layers are of wetted pastel, and they appear to have been regularly fixed as work proceeded. The slightly gritty surface of the fixative would have provided a 'tooth' for the upper layers to take hold of. The pitted surface is also characteristic of Degas's late technique (Fig. 146) and is the result

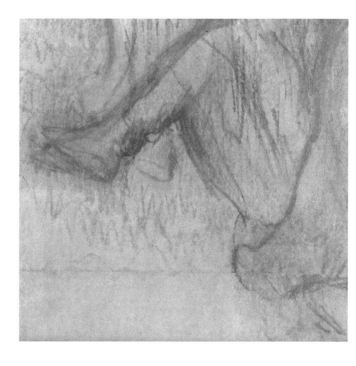

Fig. 143 Infrared reflectogram mosaic detail showing bottom left corner of Fig. 139

Fig. 144 Macro detail of join in Fig. 139

Fig. 145 Macro detail of pastel surface of Fig. 139

Fig. 146 Detail of dancer's face in Fig. 139

REFERENCES

Lemoisne 1946–9, Vol. III, p. 690, no. 1190; Kendall, in London and Chicago 1996, p. 278 and no. 95; Brettell and Lee, in Singapore and Canberra 1999–2000, pp. 32–5, no. 9.

NOTES

1 Manet 1987, p. 177.
2 Vollard 1937, p. 63.

of the wetted pastel clumping together to form islands of pigment. Subsequent fixing and further application of pastel to the not-quite-dry surface resulted in a build-up of pastel in these areas. Repeated layering of this kind led to the typically uneven, cratered texture seen here. Another problem that Degas encountered was that constant wetting and fixing could render the pastel dull and muddy. To compensate for this he would apply unfixed colours over the top to brighten the surface. The final pastel touches in *Russian Dancers*, the most brilliant strokes of pure colour in the headdresses and hair ribbons, were, and have remained, unfixed. Under the microscope they can be seen as tracks of loose pigment clinging precariously to the layers beneath (Fig. 145). It was not unusual for Degas to work in this way, sometimes totally altering a colour scheme at the final stages with passages of completely unfixed pastel.

13 Ballet Dancers, about 1890–1900

Oil on unprimed, very coarse canvas, unlined
72.5 x 73.0 cm
Degas stamp bottom right
NG 4168

Many of Degas's most inventive and complex multi-figure paintings of ballerinas are not set on stage but in rehearsal studios where the young dancers are being put through their paces. The girls inhabit the large space haphazardly, dancing, stretching or chatting in informal groups, creating casual patterns of movement and gesture that would never be seen on stage. The work-a-day setting also allowed Degas to introduce non-dancers to the scene, including dance instructors, mothers and guardians, sometimes to comic effect. In the foreground of *The Ballet Class* of about 1878–80 (Fig. 148), a woman in a flower-print dress and straw hat sprawls inelegantly on a chair, legs stretched out in front of her, reading a newspaper oblivious to the lithe ballerina limbering up directly behind. That dancer's abundant cascade of long hair contrasts with the balding head of the instructor, immediately adjacent. He in turn follows the movements of three dancers in front of a mirror on the far side of the room.

The harmonious grouping of those three dancers, one *en pointe* with left leg extended, the other two framing her with arms raised, must have pleased Degas as he utilised it again in the background of another *Ballet Class* perhaps from the late 1880s and now in the Bührle Collection in Zürich (Fig. 149).[1] There, the paint is applied much more freely, the figures more summarily defined. The foreground is dominated by a ballerina, right leg resting on a velvet bench, who adjusts a stocking. Between her and the three dancers a male figure (in eighteenth-century costume?) crowds the scene while another ballerina's disembodied leg juts into the space. Several years later Degas returned to the same composition in the present painting, now depicting five female dancers (Fig. 147). The enigmatic male figure of the Zürich painting has been suppressed. This picture is even more loosely painted, forms evoked more than delineated, on unprimed canvas of a very rough weave. Large areas of the canvas at the right are spared and the surface is

Fig. 147 *Ballet Dancers*, about 1890–1900. London, National Gallery, inv. NG 4168

Fig. 148 *The Ballet Class*, about 1878–80. Oil on canvas, 82.2 x 76.8 cm. Philadelphia Museum of Art, W. P. Wilstach Collection 1937, inv. 1937-2-1

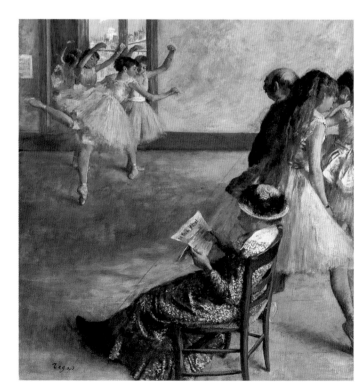

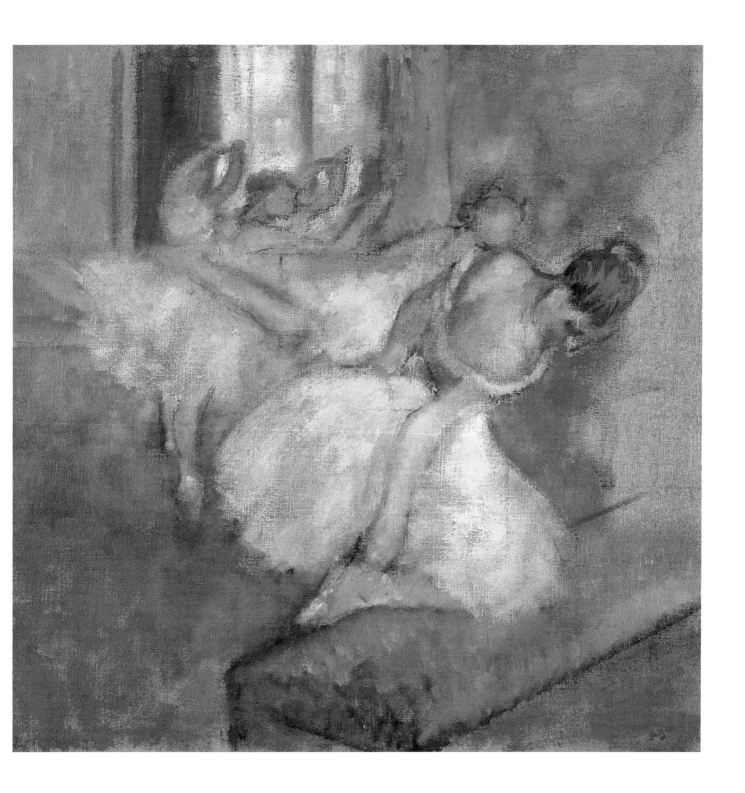

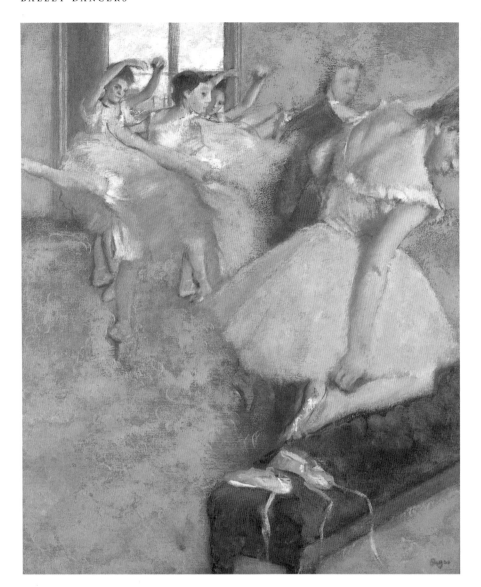

Fig. 149 *Ballet Class*, about 1880.
Oil on canvas, 62 × 50.5 cm.
Zürich, Bührle Collection

unvarnished. At the 2003 exhibition *Degas and the Dance* at the Philadelphia Museum of Art, the Philadelphia *Ballet Class* was the first picture visitors saw upon entering, the National Gallery's *Ballet Dancers* (Fig. 147), painted as much as twenty years later, the last before leaving. Thus, the continuity of Degas's pictorial concerns, his ability to reinvest figure groupings invented long before with new energy, was subtly underlined.

The coarse unprimed canvas of *Ballet Dancers* is mounted rather roughly on a square stretcher, which has the patent mark of the artist's colourman Bourgeois Ainé on its centre bar (Fig. 150). This particular mark was in use by the company after 1874, but by 1891/2 it had changed: the 'B' within the lozenge had

Fig. 150 Stamp on back of stretcher of
Ballet Dancers, Fig. 147

a winged staff of Mercury on either side. While this is of general interest for the dating of the painting, there is every possibility that Degas was re-using an old stretcher and that he stretched the canvas himself. Structurally, the painting is in its original condition – never having been removed from the stretcher and with all the original tacks still in place. Since raw canvas is considerably more flexible than primed canvas, the cusping of the canvas threads, where they have been pulled and tacked around the edges, is marked (Fig. 151).

The absence of ground dictates the technique and appearance of the painting profoundly. Painting directly on rough absorbent fabric is much more difficult than painting on a conventionally prepared canvas. The binder for the paint, which is quite rich in medium, has been identified as oil. The oil and diluent on the brush – instead of gliding and flowing across the relatively smooth, partly sealed surface of a normal ground – are quickly absorbed by the bare canvas, and the brush stroke becomes dry and broken. The first painted outlines with which Degas set down the composition are clearly visible around the figures, as are dark curving brushstrokes on the bare canvas at the right, laid down with a dense black paint containing a carbon black, possibly charcoal. Even in an underpainting as peremptory as this one, Degas's usual practice of sketching out an *ébauche* – no matter how rudimentary – is followed: in the back, arms and head of the foreground dancer, the basic modelling of shadows can be seen, painted directly on the canvas. There are also some horizontal and vertical lines below the paint in the right half of the picture, which have the appearance of squaring-up – as if at least this part of the design was transferred from a drawing. The foreground dancer, her hand reaching back to her ankle, is a pose that Degas repeated on several occasions, including a sculpture of a girl examining the sole of her right foot (Fig. 152).

The paint is applied to the canvas very directly, with broad scrubbing motions of the brush in large areas of the background and floor. The pale weave of the bare fabric beneath – the large patch at the right and smaller haloes around many of the other forms – gives a brilliant sense of improvisation to the whole painting. Degas used the way that the brush skipped across the rough canvas weave to suggest real textures within the painting. The dry, broken quality of the thicker light paint suggests the shimmer of translucent fabrics and the layered gauze of the dancers' tutus. Mottled, smoother brushwork imitates the velvet covering of the bench in the foreground. The only clearly fluid passage of painting is the bright red hair of the nearest dancer, painted in pure vermilion, which draws the eye from left to right across the canvas before sending it down her diagonal arm to the centrally placed foot. The red stands out in the

Fig. 151 Detail of stretched canvas of
Ballet Dancers, Fig. 147

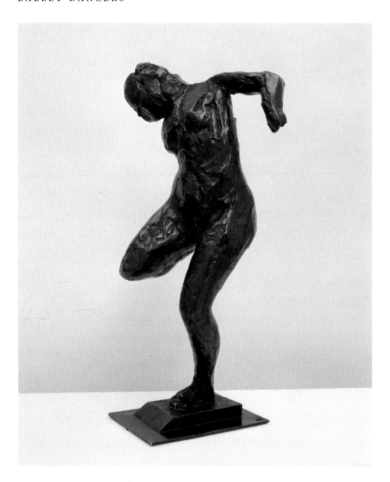

Fig. 152 *Dancer Looking at the Sole of her Right Foot,*
about 1895–1905.
Bronze, 46 cm high.
Private collection

composition as the complementary of the general greenish tone brushed across the background and used in the shadows of all the dancers' dresses.

Apart from the brilliant vermilion red of the dancer's hair and the cold green of the window in the background, painted in virtually pure viridian, the colours are muted and in one case composed of a rather unexpected mixture of pigments. The subtle mauve-greys in the picture are based on a combination of a fine red earth mixed with white and surprisingly large quantities of finely-ground viridian (Fig. 153). In the greener grey of the background at the right, there is rather more viridian and less red earth, laid over a pinkish paint comprising zinc white and a trace of red earth. The pale yellow-green background wall or curtain is a mixture of zinc white, and a transparent natural yellow ochre and viridian, while the yellowest shade on the opposite side of the window embrasure consists of essentially the same paint, although much richer in yellow ochre.

Ballet Dancers is rare in Degas's oeuvre for being painted directly on bare

Fig. 153 *Ballet Dancers*, top surface of paint sample from mauve-grey background, upper left-hand side, showing fine red earth with viridian and other pigments.
Magnification 245X

canvas. Another famous example is the extraordinary *Women ironing*, now in the Musée d'Orsay (see Fig. 17, p. 23), in which he similarly uses the weave and absorbency of the support to create a dry, fractured impasto that stands for real textures within the picture. Some of Degas's Impressionist contemporaries – notably Berthe Morisot – also used unprimed canvases for oil painting.

The relationship between the present painting and the closely similar composition in the Bührle Collection, Zürich, (see Fig. 149) is intriguing. They both depict more or less the same scene, but the Zürich painting shows a closer viewpoint – the figures of the dancers cropped by the left and right edges – and a hotter, browner tonality. The faces of the dancers are resolved and detailed in the Zürich picture, whereas they are literally featureless in the London painting for all except the first dancer. The most curious aspect of the Zürich picture is the man in the red jacket, whose head and upper body occupy the position of the second dancer in the London painting. He then appears to metamorphose into the lower body and legs of the same dancer – one leg outstretched and the other foot *en pointe* just visible below the skirt of the foreground figure. Presumably he is supposed to be standing immediately in front of the second dancer, perhaps even supporting her with his left arm, but the effect is highly ambiguous. The dating of the two paintings is far from clear, although it is reasonably assumed that the London painting is a decade or more later. However, both paintings bear the red atelier stamp at the lower right, indicating that they remained in the studio, and Degas may have reworked the Zürich picture long after it was painted, inserting the man over the head and body of the second dancer. Then, with the rapidly mapped London painting, Degas revisited the composition and reinstated the dancer he had eliminated in the first version.

REFERENCES
Lemoisne 1946–9, Vol. II, p. 332, no. 588; Davies 1970 p. 54; Browse 1949, plate 84; Cooper 1954a, p. 95; Alley 1959, pp. 53–4; Kendall, in London and Chicago 1996, p. 256 and no. 84; DeVonyer and Kendall, in Detroit and Philadelphia, 2002–3, p. 258.

NOTE
1 See Bührle, in Washington, Montreal, Yokohama and London 1990–1, no. 33.

14 Combing the Hair (La Coiffure), about 1896

Oil on canvas, unlined
114.3 x 146.7 cm
Degas stamp on the back turnover
NG 4865

This painting, once in the collection of another master of vibrant colour, Henri
Matisse, is one of Degas's most audacious late works, an almost monochromatic
study in fiery reds (Fig. 154). The famously acerbic critic Douglas Cooper in
fact meant to praise the work when on one occasion he referred to it as 'the big
red monster'.[1] Indeed, it is the intensity of colour that sets the painting apart
from other versions of this theme, a favourite of the artist's later years, where
a seated women is tended to by a maid who gives her long red hair a firm
brushing, pulling her backwards in her chair and causing her to raise a hand
to head to steady herself. A smaller pastel in a private collection (Fig. 155) is
somewhat more conventionally coloured and detailed. Similarly sketch-like and
abbreviated in detail is an oil painting in the Nasjonalgalleriet, Oslo (Fig. 156)
where the woman leans forward rather than back as the maid runs a brush
through the thick tresses. Perhaps the closest comparison, however, is with the
equally audacious *After the Bath* (*Woman drying herself*) in Philadelphia, also

Fig. 154 *Combing the Hair* (*La Coiffure*), about 1896.
London, National Gallery, inv. NG 4865

Fig. 155 *Woman combing her Hair*, about 1892–6.
Pastel on tracing paper, 56 × 56 cm.
Private collection

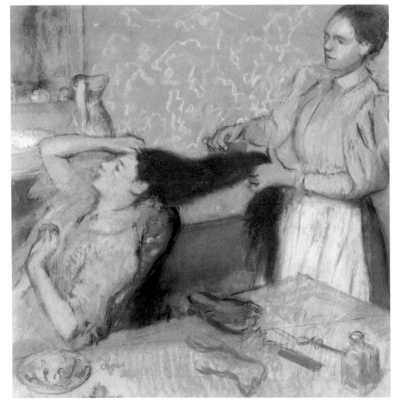

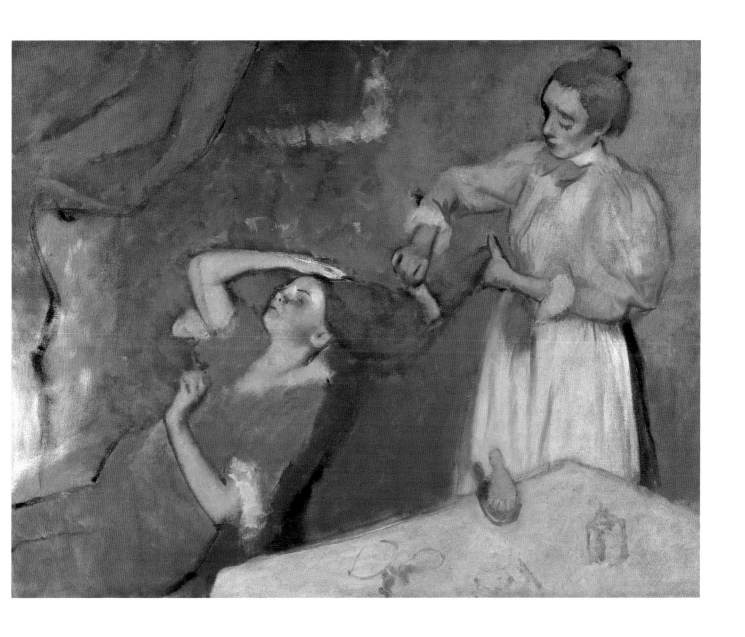

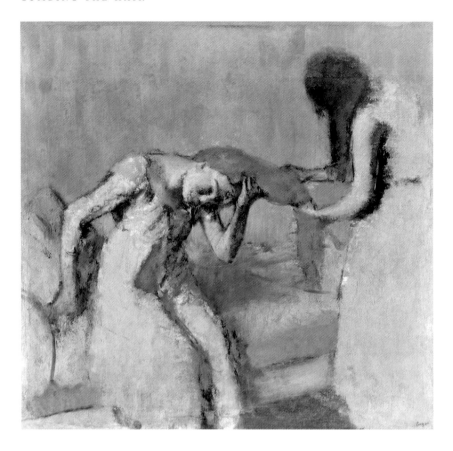

Fig. 156 *La Coiffure*, about 1896–1900.
Oil on canvas, 82 × 87 cm.
Oslo, Nasjonalgalleriet, inv. NG.M.01292

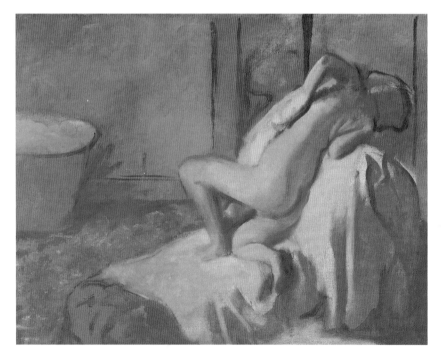

Fig. 157 *After the Bath* (*Woman drying herself*),
about 1896.
Oil on canvas, 89 × 116 cm.
Philadelphia Museum of Art, Pennsylvania. Purchased
with funds from the estate of George D. Widener,
1980, inv. 1980-6-1

of about 1896 (Fig. 157). This has to do not only with the red tonality that dominates the canvases but also with the physical tension within the bodies of the women that one senses in both paintings.

At the time of the posthumous sales of Degas's collection in Paris in 1918, this picture was among those works the National Gallery hoped to acquire but it was struck off the list when a committee member determined that the canvas was unfinished. It did not enter the collection until nineteen years later.

Combing the Hair has undergone two changes of format since being painted – the first, an enlargement, carried out by Degas himself, and the second, returning it to its original size after the sale of 1918. For the painting, Degas used a standard no. 80 size canvas supplied by Tasset et Lhote of 31 rue Fontaine in Paris, whose large stamp is still visible on the back of the unlined canvas (Fig. 158); the same firm also supplied materials to Van Gogh and Signac. Unusually, the plain weave structure has a double thread running in one direction but not the other. The canvas was prepared with a normal commercial creamy white ground containing lead white, some chalk and a little yellow earth. Degas completed the composition that we see today and then, presumably wishing to take advantage of the large amounts of canvas that were turned around the sides of the stretcher, decided to enlarge the painting. It was taken off its existing stretcher and re-stretched on a larger one. This had the effect of adding an extra 7 cm of canvas at the bottom, 3 cm at the top and 2 cm at either side. The part of this recovered canvas adjacent to the painted composition had the commercial priming already in place and Degas primed the remainder with a layer of chalk-containing priming tinted with a little yellow so as to match the original. The difficulty with doing this, of course, was that all the tack holes from the initial stretching were now evident on the front of the picture – a problem that was solved by filling them with a rough grey oil putty of lead white and chalk or gypsum.

Degas never pursued his ideas for extending the composition and the painting remained in his studio in the same state until his death. A photograph taken at the 1918 sale shows the extra canvas at the bottom, but the photographer has cropped the image at the top and sides so those narrow borders are not visible (Fig. 159). For the sale, the red studio stamp was added at the lower right, on the blank lower strip, and the dimensions given in the sale catalogue (124 × 150 cm) confirm that it was indeed sold in its enlarged format. Then, at some point during the nineteen years after the sale and before the painting came to the National Gallery, it was returned to its original size. It is highly unlikely that it was replaced on its original stretcher – from which it

Fig. 158 *Combing the Hair*
Stamp on the back of the canvas

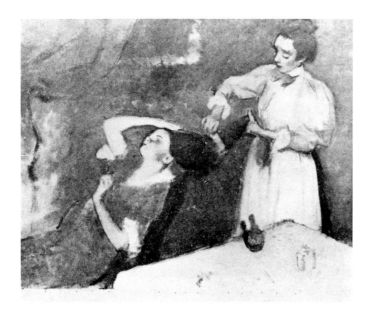

had been separated years before in Degas's studio – but, since it had been a standard size, supplying a new one would be straightforward. The excess canvas was turned around the sides of the stretcher once more, and the evidence for its temporary change of format remains visible on the reverse – four obvious tacking edges behind the present ones and the red studio stamp, now upside-down, at the back of the bottom right corner (Fig. 160).

Combing the Hair is remarkable for the breadth and rapidity of its technique, its bold brushstrokes skipping across the prominent canvas texture. Its dense red tonality battles against the luminosity of the white ground that shows through on the points of the canvas weave and is left partly exposed at the left side. The composition was sketched out in bold sweeps of the brush with dark paint containing charcoal (Fig. 161), such as that seen delineating the lower part of the curtain at the left. An infrared photograph (Fig. 162) gives an idea of the broad framework of brushstrokes that defined the main forms, although it must be remembered that some of the lines visible here are also finishing contours. In general, the composition was developed as it was set down, but there is a pentimento in the upraised elbow of the seated woman. The only preparatory mark of any precision is a short, ruled vertical line that appears to define the position of the woman's eye (Fig. 163).

The application of colour is largely straightforward, although some parts are layered in more complex ways than might be imagined. The area of the woman's head and upper hand, for example, is beautifully direct – working over the white ground and the brushed underdrawing with pink flesh tone, brown-red

Fig. 159 Photograph of *La Coiffure* as it appeared at the Degas sale, with the expanse of blank canvas still visible at the bottom.
Reproduced from *Catalogue des tableaux, pastels et dessins par Edgar Degas et provenant de son atelier.* Paris, Galerie Georges Petit, 6–8 mai 1918

Fig. 160 Detail of back of *La Coiffure*: turned over tacking edges with studio stamp

Fig. 161 Paint cross-section from broad dark outline of paint, left edge of Fig. 154, containing charcoal pigment, over red-brown background lay-in.
Magnification 200X

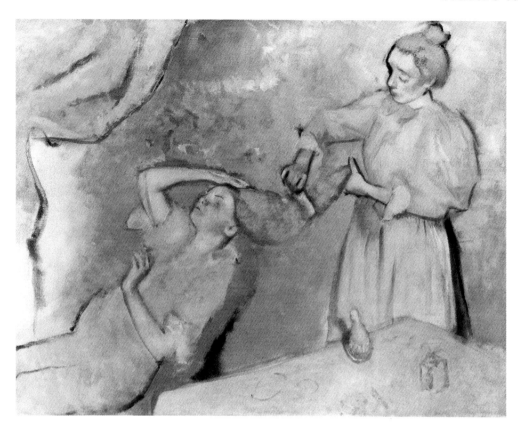

Fig. 162 Infrared
photograph of Fig. 154

Fig. 163 Detail of
woman's face in Fig. 154

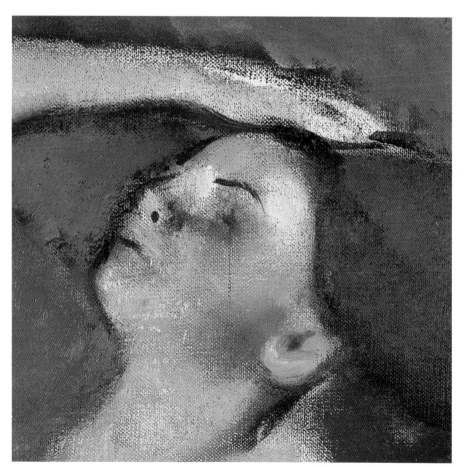

shadows and white highlights for the sheen of the skin and the upturned nose. A few heavy black strokes for the hand and profile, the eyebrow and mouth, and dots for the nostril and closed eye complete the impression of a face and gesture poised in discomfort while the maid completes her task. The maid herself is a more complex area of painting, thickly worked, boldly outlined and with darker underlayers for her pink blouse. The tablecloth is a solid passage of pale paint, outlined in red, with the hairbrush – and other objects not clearly developed – sketched in brown.

The overwhelming colour of the background, the woman's dress and hair and the curtain was worked and reworked to achieve an extraordinary variety of red tonalities, ranging from cool dull crimson, through scarlet, to hot bright orange. The wide range of reds is provided essentially by three pigments: a strongly-coloured red earth such as Venetian red, vermilion and the more orange-toned red lead (lead tetroxide). For example, the brownish-pink layer underlying the curtain and the woman's dress at the left is based on red earth mixed with lead white, and left exposed in the lightest area of the curtain where it is scumbled over the priming. In the upper, richer brown-red of the curtain, this layer is covered with a paint largely composed of the red earth mixed with a little vermilion and red lead. The scarlet red of the dress, however, is brushed in with vermilion containing small amounts of the other two reds over the pink underpaint (Fig. 164). The bright orange red background behind the maid at the right is painted with red lead and a little viridian green to render the paint a little cooler and less prominent, while the brightest most orange-toned colours of the background are probably pure red lead.

In this overwhelmingly red painting, a few accents of different colour are used: yellow earth in the hairbrush and viridian, most noticeably, in the diffuse cool blue green of the light-coloured tablecloth. Here it is blended with a soft mauve that echoes the colour of the maid's blouse. A similar combination of shifting muted mauve and green is used in other compositions such as *Ballet Dancers* (Cat. 13).

It is difficult to be certain of the precise order of development of the various parts of the background, but the thick triangle of darker red between the maid and the back of the chair seems to have been one of the last areas to be painted. The woman's near shoulder, too, seems to have been modified at a late stage: an X-ray shows that it was originally broader and that Degas reduced its width by extending the brown of the chair over it (Fig. 165).

Combing the Hair has many similarities with *After the Bath (Woman drying herself)* in Philadelphia (see Fig. 157). Both are painted on pre-primed canvases

Fig. 164 Paint cross-section of young woman's scarlet dress in Fig. 154, showing an upper layer largely of vermilion over an underpaint containing red earth, white and some charcoal.
Magnification 200X

Fig. 165 X-ray detail of woman's shoulder in Fig. 154

supplied by Tasset et Lhote – although the Philadelphia painting is smaller, a standard no. 50 size, compared with no. 80 for the London picture. The canvases appear to be from the same roll of cloth: they are both plain weave, with the thread doubled in one direction but not the other. The compositions of both are sketched out in bold dark lines, which are also used for finishing contours. Both have pentimenti in the positioning of limbs – the woman's right arm and elbow in *Combing the Hair*, the left leg and knee in *After the Bath*. Both use the same red-brown shadows and pale highlights for the smooth, gleaming skin tones. Both have a tonal counterpoint of white fabrics in the right foreground to set off the hot colours in the rest of the painting. But, above all, they share the astonishing variety of reds that map out the background. In *After the Bath*, the bath itself and the wall at the left are smooth reds with a little white mixed in, while the darker floor in front is roughly painted to suggest the coarse texture of a rug. A different red again is used for the near end of the couch on which the woman lies, and behind her, the lighter red of the wall is more broken, divided by bold black verticals that intersect her body.

Both unsigned, the London and Philadelphia paintings are traditionally considered magnificent unfinished works – but the question remains: should we continue to think of them as incomplete, given the broad limits of what constituted a finished work in Degas's oeuvre? Jean Boggs has suggested that Degas, although perhaps intending to do more to the Philadelphia painting, came to believe that it was resolved and deliberately left it in its present state.[2] It is clear that Degas did contemplate some more work on *Combing the Hair*, since he enlarged the format and prepared the reclaimed edges for painting by filling the tack holes. But just how much more work was envisaged? Was it more than simply extending the present composition to the new borders? Richard Kendall has speculated on a more radical idea – that these red paintings may have been just a preliminary stage, a monochromatic base on which layers of contrasting colour would be superimposed. He points to the late work *Group of Dancers* (National Gallery of Scotland) in which red preparatory layers underlie brilliant greens and silvery whites.[3]

Notions of finish are so difficult to define for Degas that we can only point to the fact that the Philadelphia and London paintings were not developed further. Rather than speculating on the possibility, or even probability, that they are unfinished, they should be viewed more as compelling evidence of Degas's increasing interest in pictorial abstraction in his later years, and of his daring play with viewers' expectations of what pictorial completeness might mean.

REFERENCES
Lemoisne 1946–9, Vol. III, p. 654, no. 1128; Davies 1970, pp. 54–5; Kendall 1985, pp. 19–31; Boggs, in Paris, Ottawa and New York 1988, pp. 553–4, no. 344; Kendall, in London and Chicago 1996, pp. 113–4, 118, 218–20, no. 42; Dumas et al., in London 1997, pp. 89 and 256.

NOTES
1 Douglas Cooper, correspondence, National Gallery Archives.
2 Boggs 1988, p. 552.
3 Kendall 1996, pp. 113–14.

Notes

Edgar Degas: Illustrious and Unknown

1 Cited by J.S. Boggs in Paris, Ottawa and New York, 1988–9, p. 23.
2 Paul Valery, quoted in Loyrette 1993, p. 56.
3 Degas 1987, p. 319.
4 Cited in Fenton 1998, p. 134.
5 On Degas as an art collector, see Dumas in London 1996 and New York 1997.
6 Cited in Loyrette 1988, p. 18.
7 On Degas's notebooks, see Reff 1976b.
8 On Degas as a portraitist, see Boggs 1962, and more recently Zürich and Tübingen 1994–5.
9 Reff 1976a, pp. 200–38.
10 Cited by Loyrette 1988, p. 72.
11 The most thorough analysis of Degas's depiction of the ballet is now by DeVonyar and Kendall, in Detroit and Philadelphia 2002–3.
12 Boggs, in Paris, Ottawa and New York 1988–9, p. 80.
13 Kendall, in London and Chicago 1996, p. 102.
14 Manet 1979, entry for 4 March, 1896, p. 77.
15 On Degas's photography, see New York, Los Angeles and Paris 1998–9.
16 On Degas's landscapes, see Kendall, in New York and Houston 1993–4.

Degas At Work

1 Vollard 1937, p. 70.
2 Rouart 1945; Fletcher and DeSantis, 1989.
3 Vollard 1937, p. 70.
4 Notebook 13, p. 43 in Reff 1976b, Vol. 1, p. 80; also a letter dated 26 April 1859 to Gustave Moreau quoted in Loyrette 1993, p. 133.
5 Kendall, in London and Chicago 1996, p. 110–11; see also Delbourgo and Rioux 1974, Couëssin 1989 and Roquebert 2001 for other examples of Degas's materials and technique.
6 New York 1997, cat. no. 87, pp. 149–51.
7 Kendall in London and Chicago 1996, p. 112, quoting Halevy 1960.
8 Kendall in London and Chicago 1996, pp. 113–15, for discussion of finish.
9 Vollard 1937, p. 67.
10 Boggs, in Washington 1998, cat. nos 16 and 100, pp. 49–58 and 160–5.
11 Ruhemann 1968, p. 207.
12 Fletcher and DeSantis 1989, p. 259.
13 Maheux 1988, pp. 23–4.
14 Lloyd and Thomson, in London 1986, p. 15.
15 Boggs and Maheux 1992, p. 42.
16 Janis, in Cambridge 1968, cat no. 1; Adhémar and Cachin 1974 p. 269; Boggs and Maheux 1992, p. 12.
17 Numbers from Maheux 1988, p. 25 and Adhémar and Cachin 1974, appendix.
18 Maheux 1988, p. 44.
19 Kendall, in London and Chicago 1996, pp. 77–83.
20 Blanche 1919, p. 295; Lafond 1919, p. 20.
21 Kendall, in London and Chicago 1996, p. 81; Degas 1945, p. 117.
22 Vollard 1937, pp. 62–3, 68.
23 Alice Michel 1919, pp. 631–2.
24 Chialiva 1932, pp. 44–5.
25 Vollard 1937, p. 68.
26 Michel 1919, p. 458.
27 Vollard 1937, p. 68.
28 Moreau-Nelaton 1931, pp. 267–70.
29 Kendall 2002, p. 26.
30 Washington 1984–5, pp. 46–9, 60–1.
31 Dumas et al., in New York 1997, cat. no. 218.
32 Boggs and Maheux 1992, pp. 20–1; see also Maheux et al. 1988.
33 Vollard 1937, p. 63.
34 Rouart 1945, quoted in Boggs and Maheux 1992, p. 31.
35 Maheux and Boggs 1992, p. 154.
36 Pia DeSantis, 'An Examination of the Degas Pastels at the Fogg Art Museum', unpublished research project 1984, quoted in Maheux 1988, pp. 80–1, note 40.
37 Maheux 1988, p. 37.
38 Fletcher and Desantis 1989, p. 256.
39 Reff 1976b, p. 140.
40 Fletcher and Desantis 1989, pp. 256–65.
41 Rouart 1945, p. 10 quoted in Fletcher and Desantis 1989 p. 261.
42 Reff 1976b, pp. 277–8.
43 Rouart, quoted in Adhemar and Cachin 1974, p. 14.
44 see Clifford S. Ackley in Boston 1984, p. ix. The standard catalogue of the prints is by Adhémar and Cachin 1974.
45 Degas 1945, no. 16, pp. 33–6.
46 Rouart 1945 p. 62 .
47 Adhémar and Cachin 1974, p. 77.
48 Janis, in Cambridge 1968.
49 Kendall, in Copenhagen 1994.
50 For Degas's visit to Jeanniot, see Kendall, in New York and Houston, 1993–4, pp. 145–182.
51 Jeanniot 1933, Quoted in Adhemar & Cachin, 1974, pp. 78–9.
52 Shackleford, in Washington 1984–5, pp. 66–7.
53 Kendall, in Omaha, Williamstown and Baltimore 1998, pp. 40–3.
54 Essay by Arthur Beale in Omaha, Williamstown and Baltimore 1998, p. 98.
55 Vollard 1937, p. 89.
56 Barbour 1995, pp. 28–32. For Degas's methods in general see Sturman and Barbour 1995.
57 Barbour 1995, p. 32.
58 Letter to Royal Cortissot 1919, quoted by Tinterow, in New York 1997, p. 609.
59 Probably by Bartholomé and Albino Palazzolo: see Beale, in Omaha, Williamstown and Baltimore 1998, p. 100.
60 Beale, in Omaha, Williamstown and Baltimore 1998, pp. 97–108.

61 Fénéon 1970, pp. 65–6.

62 Cahn 1989a, esp. pp. 60–80; Pissarro 1980, pp. 177–8, 198–9, 206–7.

63 Havemeyer 1961, p. 250.

64 Cahn 1989b; Cahn, in Amsterdam and Vienna 1995.

65 Reff 1976b, Vol. 1, p. 79, notebook 13, p. 10; p. 88, notebook 15, p. 6. For the Bellelli family see also Reff 1968, p. 131.

66 This is clearly seen from the examples in Reff's study: see Reff 1968.

67 Reff 1976b, Vol. 1 p. 139, notebook 33, p. 1; Reff 1968, p. 157.

68 Reff 1976b, Vol. 1; see, for example, p. 133, notebook 30, pp. 19, 25, 26; p. 135, notebook 31, p. 9, 10, 11, 13; p. 139, notebook 32, pp. 19, 20, notebook 34, p. 23; notebook 37, p. 2; Vollard 1937, p. 65; Cahn in Amsterdam and Vienna 1995, p. 130.

69 Cahn in Amsterdam and Vienna 1995, pp. 134–6.

70 Vollard 1937, p. 65; Havemeyer 1961, p. 250.

71 Cahn 1989b, p. 292. Several frames are illustrated in colour in Cahn in Amsterdam and Vienna 1995.

72 Vollard 1937, p. 65.

Degas and the National Gallery

1 There were three collection sales, the first held at the Galerie Georges Petit, March 26–7, 1918, the second at the Hôtel Drouot, 15–16 November 1918, and the print sale, also at Hôtel Drouot, 6–7 November 1918. Four of the five atelier sales were held at Georges Petit, of which the first and main was between 6–8 May 1918. The other three were on 11–13 December 1918, 7–9 April 1919, 2–4 July 1919, and the print sale was at the Galerie Manzi-Joyant, 22–23 November 1918.

2 The first account of Degas's collection was by Paul Lafond 1918. The most recent studies on Degas's collection are the following: Dumas, in London 1996, pp. 3–72; New York 1997.

3 New York 1997, p. 25.

4 The main recent studies on the sales and the National Gallery's involvement are Sutton 1989; London 1996; New York 1997.

5 Fry 1918, p. 118.

6 Holmes gives an account in his autobiography: 'Early in March 1918, while I was bargaining with Roger Fry for a little painting, now attributed to Butinone, he brought me a catalogue of the pictures collected by Degas which were shortly to be sold in Paris. The collection included several notable works by Ingres, Delacroix and other French masters, unrepresented at Trafalgar Square yet badly needed to illustrate the development of modern art. Though I wholly agreed with Fry as to their extreme desirability, I could see no chance at that critical time of getting any money for such a venture. But one of Fry's friends, Maynard Keynes, then a great power at the Treasury, was also roused by the opportunity, and said that if an official request were made for a Special Grant to acquire some of the pictures, he would back it. We were incurring, without question, enormous liabilities for our Continental allies: a few good French pictures would be worth more to us in the end than most of that dubious paper. Lord Curzon at once recognised the value of the suggestion, made the requisite application in Whitehall, and obtained a grant of £20,000.' Holmes 1936

p. 335. He writes of his trip, the auction and the return journey on pp. 336–42.

7 Keynes's role in the sale is related in Sutton 1989 and in Emberton 1996, pp. 22–8.

8 The pictures bought were Ingres, *Monsieur de Norvins*, *Oedipus and the Sphinx, Angelica saved by Ruggiero, Pindar and Ictinus*; Delacroix, *Louis-Auguste Schwiter, Abel Widmer*; Corot, *The Roman Campagna, with the Claudian Aqueduct*; Forain, *The Tribunal* (now Tate); Gauguin, *A Vase of Flowers*; Manet, *The Execution of Maximilian, Woman with a Cat* (now Tate); Rousseau, *The Valley of Saint-Vincent*; Ricard, *Portrait of a Man*, plus a number of drawings by Delacroix and Ingres, and one drawing then attributed to David, all now in the British Museum. Keynes tried to persuade Holmes to buy a painting by Cézanne, *Still Life with Apples*, but failing, bought it for himself. It is now in the Fitzwilliam Museum, Cambridge, on loan by the kind permission of the Provost and Scholars of King's College, Cambridge.

9 The main studies on the collecting of modern painting by public institutions at the beginning of the twentieth century are: Cooper 1954a; House, in London 1994 and Dumas and Schapiro, in Atlanta, Seattle and Denver 1999, pp. 65–76.

10 Rutter 1927, p. 154. This refusal, as related by London 1994, p. 31, note 8, is not recorded in the National Gallery Board Minutes.

11 *Report of the National Gallery Committee*, HMSO, London, 1914, pp. 24–6.

12 For example at the Board Meeting of 13 October 1918 the acquisition of Degas's, *Woman at a Window* was discussed. This painting, now in the Courtauld Insititue of Art, was being offered by Mrs Cobden Sanderson, and £300 – £800 was considered an approximate price. At a subsequent meeting on 6 March 1919, it was reported that the offer of the picture was being withdrawn. The price was actually £2,000. Board Minutes, Tate Archive.

13 This matter was raised at the Board Meeting of 14 May 1918 at the National Gallery. Minutes, National Gallery Archive.

14 For an account of the relationship between Degas and England see Sutton 1989, pp. 277–88. *Degas and Britain*, to be shown at Tate Britain, London and the Phillips Collection, Washington DC, 2005–6, will explore the work of Degas and Toulouse-Lautrec in connection with British artists who associated with them, for example Sickert.

15 George Moore also wrote an article on him in the *Magazine of Art*, 1890, later reprinted in the *Burlington Magazine*, Moore 1918, pp. 22–9 (January) and pp. 63–5 (February). On Degas's death Sickert published a memoire in the *Burlington Magazine*, Sickert 1917, pp. 183–92. For an anthology of criticism of his work see Flint 1984, especially pp. 275ff.

16 Cooper 1954a, p. 18. See also the following studies on the collecting of Impressionism: Dumas and Schapiro, in Atlanta, Seattle and Denver 1999, pp. 65–76; 2002, pp. 31–50; Fowle, in Louisville and Pittsburgh 2002–4, 31–50.

17 For an account of the furore see Pickvance 1963, pp. 395–98.

18 *The Spectator*, 25 February 1893.

19 D. S. MacColl 1898, p. 426, reprinted in Flint 1984, pp. 302–3.

20 Moore 1893, pp. 232–45, reprinted in Flint 1984, pp. 288–96.

21 Letter dated 30 April 1918 in Degas Sale file, 60.1, National Gallery Archives.

22 Letter in Curzon papers, Oriental and India Office, British Library, F112/57.

23 The letter of 1st May 1918 is in the Degas Sale file, 60.1, National Gallery Archive. Fry's choices were 15, 39, 53, 73, 98, 99, 112. Pastels: 127, 128, 148, 152, 155, 164, 171, 172, 175, 184, 194, 207, 214, 222, 272, 275, 281, 282, 294, 303. The Stoop pastel is now in the collection of Tate, presented by C. Frank Stoop in 1933 (N04711). See Sutton 1989, p. 268. Fry had already had experience of trying to acquire a Degas for a public collection. When he was curator of paintings at the Metropolitan Museum of Art, New York, 1906–7, he initiated the search for a Degas, and in 1906 tried to buy *Orchestra Musicians* (1870–1 and 1874–6), which is now in Frankfurt, but the museum would not put up enough money. In the case of Degas's sale, generally Fry's choices were ignored, and only three pastels, 171, 172 and 184 appear on the National Art Collections Fund wish list. In a later letter to Vanessa Bell, Fry lamented the failure to purchase one of these late works when describing a visit to Vollard's and what he showed: '. . . two late Degas oils – of the same kind as the late pastels of women getting out of tubs; they were magnificent. He got them for nothing at the vente Degas. Why wasn't it me instead of Holmes that day?' Fry has forgotten that it was not Holmes who was at the sale. Letter of 6 March 1924, to Vanessa Bell, in Fry 1972, pp. 549–50.

24 For a discussion of this see Tinterow, in New York 1997, pp. 75–108.

25 *Portrait de Famille* (the Bellelli family portrait) is in the Musée d'Orsay; *Mlle Fiocre* is now in the Brooklyn Museum; *La Coiffure* (*Combing the Hair*) is now in the National Gallery, London; *Au Foyer* is now in Ny Carlsberg Glyptotek, Copenhagen.

26 National Gallery Archives. This memorandum is published by Sutton 1989a, p. 27. There is a note of 4 May from the Treasury Chambers to Curzon stating that they are prepared to sanction the expenditure up to £3,000 on the purchase of the paintings mentioned by him. Curzon papers, Oriental and India Office, British Library, F112/58.

27 It was accepted at the Board Meeting of 13 October 1918. Minutes, Tate Archive.

28 Degas Sale file, 60.1, National Gallery Archives.

29 No. 4, *Portrait de Famille* went for 400,000 francs, No. 8, *Mademoiselle Fiocre*, went for 80,500 francs, No. 46, *Au Foyer*, went for over £4,000 and No. 48, *Portrait of Edmond Duranty*, went for over £4,000. No. 48, *Portrait of Edmond Duranty*, is now in the Burrell Collection, Glasgow.

30 Letter in Trustees' Correspondence, NG26/33, National Gallery Archives. No. 13 was obviously added at the last minute, for which Maclagan stopped bidding when he realised that he was up against the Luxembourg.

31 His report of 8 May, in which he explained how the bidding went, is published by Sutton 1989a, p. 272.

32 Minutes of the National Gallery Board Meeting, 9 February, 1937. The figure of £600 is a mistake, but it is possible that it was mixed up with the grant which was allocated by the National Art Collections Fund. There appears to be no written record of Curzon's comment. At this meeting there was evidently a lively discussion concerning the merits of the painting, its apparently unfinished state causing some concern with people.

33 This criticism is discussed by Sutton 1989a, pp. 269–70.

34 Typed letter of 16 October 1918, annotated. Curzon papers, Oriental and India Office, British Library, F112/58.

35 *The Times*, 8 May 1918, p. 3.

36 *The Times*, 10 May 1918, p. 5

37 *The Times*, 13 May 1918, p. 11.

38 Reported in the *The Times*, 2 March 1918, p. 9. Sutton 1989a, p. 270, notes this sale, writing that it was a shame that the National Gallery did not attempt to buy it. He gives the price of *Laundresses carrying Linen in Town (Les Blanchisseuses)* as 2,300 guineas.

39 Ibid.

40 Trustees Minutes, 19 March 1918, Tate Archive.

41 His exhibition had the title, *Catalogue of Pictures presented to the City of Dublin to form the nucleus of a Gallery of Modern Art, also Pictures lent by the executors of the late Mr. J. Staats Forbes and others.*

42 The loan was discussed at the Board Meeting of 19 February 1907, but the minutes state simply: ' A letter was read dated 17 January 1907 from Mr Hugh Lane offering to lend for two years his large collection of Modern Continental Painters. It was resolved that this offer be declined with thanks.'

43 Gregory 1921, pp. 56–7.

44 The letter read: 'The Trustees of the National Gallery have now viewed your collection of Modern Continental pictures as hung by the Director in Room XIX here, and are disposed to think that, while some of these pictures are well worthy of temporary exhibition in the National Collection, there are others which hardly attain to the standard which would justify their inclusion.' Lane papers, National Gallery Archive.

45 In the Lane papers there exists a piece of paper written in pencil, with two columns, 'In' and 'Out'. There are some crossings out, as minds were changed or a verdict by one was overturned by another. The Degas originally appeared twice under 'Out' but finally made it under 'In'.

46 Both reports in the Lane papers, National Gallery Archive.

47 Memorandum from Lord Redesdale to the Board of Trustees, Lane papers, National Gallery Archive.

48 For a full account see House, in London 1994, pp. 9–33.

49 For a selection of reviews see London 1994, pp. 243–46.

50 Rutter 1922, p. 35.

51 For a discussion of Courtauld's collecting in relation to critical debates on modern art of the period see London 1994, pp. 22–7.

52 For a discussion of these issues see Spalding 1998, pp. 122–24.

Bibliography

Adhémar and Cachin 1974
J. Adhémar and F. Cachin, *Degas: The Complete Etchings, Lithographs and Monotypes*, trans. J. Brenton (French edn *Edgar Degas, gravures et monotypes*, Paris 1973), London 1974.

Alley 1958
R. Alley, 'Notes on some works by Degas, Utrillo and Chagall in the Tate Gallery', *Burlington Magazine*, C, 1958, pp. 171–2.

Alley 1959
R. Alley, *Tate Gallery Catalogues: The Foreign Paintings, Drawings and Sculpture*, London 1959.

Alley 1981
R. Alley, *Catalogue of the Tate Gallery's Collection of Modern Art other than Works by British Artists*, London 1981.

Amsterdam and Vienna 1995
I. Cahn, 'Edgar Degas: gold or colour', in E. Mendgen (ed.), *In Perfect Harmony: Picture and Frame, 1850–1920*, exh. cat., Amsterdam, Van Gogh Museum; and Vienna, Kunstforum, 1995. Amsterdam 1995, pp. 129–38.

Atlanta, Seattle and Denver 1999
A. Dumas and M.F. Shapiro, *Impressionism: Paintings Collected by European Museums*, exh. cat., Atlanta, High Museum of Art; Seattle Art Museum; and Denver Art Museum, 1999. New York 1999.

Barbour 1995
D. Barbour, 'Degas's "Little Dancer": not just a study in the nude', *Art Journal*, 54, 2, 1995, pp. 28–32.

Barthélemy 1836
J.-J. Barthélemy, *Le voyage du jeune Anacharsis en Grèce*, Paris 1788, reprinted Paris 1836.

Beale 1998
A. Beale, '*Little Dancer Aged Fourteen*: the search for the lost *modèle*', in R. Kendall, *Degas and the Little Dancer*, with contributions by D.W. Druick and A. Beale, exh. cat., Omaha, Joslyn Art Museum; Williamstown, Sterling and Francine Clark Institute; Baltimore Museum of Art, 1998, pp. 97–108.

Berson 1996
R. Berson (ed.), *The New Painting: Impressionism 1874–1886*, 2 vols, San Francisco 1996.

Blanche 1919
J.-E. Blanche, *Propos de peintre: de David à Degas*, Paris 1919.

Bodkin 1932
T. Bodkin, *Hugh Lane and his Pictures*, Dublin 1932.

Boggs 1962
J.S. Boggs, *Portraits by Degas*, Berkeley and Los Angeles 1962.

Boggs 1963
J.S. Boggs, 'Edgar Degas and Naples', *Burlington Magazine*, CV, June 1963, pp. 273–6.

Boggs and Maheux 1992
J.S. Boggs and A. Maheux, *Degas Pastels*, London 1992.

Boston, Philadelphia and London 1984–5
S.W. Reed and B.S. Shapiro, *Edgas Degas: The Painter as Printmaker*, with contributions by C.S. Ackley and R.L. Perkinson [and others], exh. cat., Boston, Museum of Fine Arts; Philadelphia, Museum of Art; and London, Arts Council of Great Britain, Hayward Gallery, 1984–5. Boston 1984.

Brame and Reff 1984
P. Brame and T. Reff, *Degas et son oeuvre: A Supplement*, New York and London 1984. (See also Lemoisne 1946–9.)

Broude 1988
N. Broude, 'Edgar Degas and French feminism, ca. 1880: 'The Young Spartans', the brothel monotypes and the bathers revisited', *Art Bulletin*, LXX, 1988, pp. 640–9.

Browse 1949
L. Browse, *Degas Dancers*, London 1949.

Burnell 1969
D. Burnell, 'Degas and his "Young Spartans Exercising"', *Museum Studies*, The Art Institute of Chicago, 4, 1969, pp. 49–65.

Cahn 1989a
I. Cahn, *Cadres de peintres*, Paris 1989.

Cahn 1989b
I. Cahn, 'Degas's frames', *The Burlington Magazine*, CXXXI, 1989, pp. 289–92.

Cambridge 1968
E.P. Janis, *Degas Monotypes: Essay, Catalogue and Checklist*, exh. cat., Cambridge Mass., Fogg Art Museum, Harvard University, 1968. Cambridge Mass. 1968.

Chialiva 1932
J. Chialiva, 'Comment Degas a changé sa technique du dessin', *Bulletin de la Société de l'histoire de l'art français*, XXIV, 1932, pp. 44–5.

Chicago 1984
R.R. Brettell and S.F. McCullagh, *Degas in The Art Institute of Chicago*, exh. cat., Chicago, Art Institute of Chicago, 1984. New York 1984.

Cleveland, New York (etc.) 1987–8
D. Farr, J. House, R. Bruce-Gardner, G. Hedley and C. Villers, *Impressionist and Post-Impressionist Masterpieces: The Courtauld Collection*, exh. cat., Cleveland Museum of Art; New York, Metropolitan Museum of Art (etc.) 1987–8. New Haven and London 1987.

Cooper 1954a
D. Cooper, *The Courtauld Collection. A Catalogue and Introduction*, London 1954.

Cooper 1954b
D. Cooper, 'List of emendations to the Courtauld catalogue', *Burlington Magazine*, XCVI, 1954, pp. 120–1.

Copenhagen 1994
R. Kendall, H. Finsen and M. Wivel, *Degas intime*, exh. cat., Copenhagen, Ordrupgaard, 1994. Copenhagen 1994.

Couëssin 1988
G. de Couëssin, 'Technique, transformations dans les toiles de Degas des collections du musée d'Orsay', in *Degas inédit. Actes du Colloque Degas, Musée d'Orsay, 18–21 avril 1988*, Paris 1989, pp. 144–58.

Davies 1970
M. Davies, *National Gallery Catalogues: French School – Early Nineteenth Century, Impressionists, Post-Impressionists, etc.*, rev. C. Gould, London 1970.

Degas 1945
E. Degas, *Lettres de Degas*, ed. M. Guérin, Paris, 1945 (Eng. edn *Degas Letters*, trans. M. Kay, Oxford 1947).

Degas 1987
E. Degas, *Degas by Himself*, ed. by Richard Kendall, London, 1987.

Delbourgo and Rioux 1974
S. Delbourgo and J.-P. Rioux, 'Contribution à l'étude de la matière picturale', *Manière et matière des Impressionnistes: Laboratoire de Recherche des Musées de France – Annales*, 1974, pp. 34–42.

Detroit and Philadelphia 2002–3
J. DeVonyar and R. Kendall, *Degas and the Dance*, exh. cat., Detroit Institute of Arts; and Philadelphia Museum of Art, 2002–3. New York 2002.

Distel 1990
A. Distel, *Impressionism: The First Collectors*, trans. B. Perroud Benson, New York 1990.

Edinburgh 1979
R. Pickvance, *Degas 1879. Paintings, Pastels, Drawings, Prints and Sculpture from around 100 years ago in the Context of his Earlier and Later Works*, exh. cat., Edinburgh, National Gallery of Scotland, 1979. Edinburgh 1979.

Emberton 1996
A. Emberton, 'Keynes and the Degas sale', *History Today*, 46, no.1, January 1996, pp. 22–8.

Failing 1995
P. Failing, 'Authorship and physical evidence. The creative process', *Apollo*, CXLII, August 1995, pp. 55–9.

Fénéon 1970
F. Fénéon, 'L'Impressionisme', in J.U. Halperin (ed.) *Oeuvres plus que completes*, Vol. 1, pp. 65–6, Geneva, 1970 (first published in *L'Emancipation sociale*, Narbonne, 3 April 1887).

Fenton 1998
J. Fenton, 'Degas in the Evening', in *Leonardo's Nephew. Essays on Art and Artists*, New York, 1998, pp. 117–34.

Fletcher and DeSantis 1989
S. Fletcher and P. DeSantis, 'Degas: the search for his technique continues', *Burlington Magazine*, CXXXI, 1989, pp. 256–65.

Flint 1984
K. Flint (ed.), *Impressionists in England. The Critical Reception*, London 1984.

Fry 1918
R. Fry, 'The sale of Degas's collection' in 'A monthly chronicle', *Burlington Magazine*, XXXII, 1918, p. 118.

Fry 1972
R. Fry, *Letters of Roger Fry*, ed. D. Sutton, 2 vols, London 1972.

Gordon and Forge 1988
R. Gordon and A. Forge, *Degas*, New York 1988.

Gregory 1921
I.A.P Gregory (Lady), *Hugh Lane's Life and Achievement, with some Account of the Dublin Galleries*, Dublin 1921.

Guérin 1928
M. Guérin, 'Remarques sur des portraits de famille peints par Degas à propos d'une vérité récente', *Gazette des Beaux-Arts*, 5th period, 17, 1928, pp. 371–9.

Halévy 1960
D. Halévy, *Degas parle*, Paris 1960.

Havemeyer 1961
L.W. Havemeyer, *Sixteen to Sixty, Memoirs of a Collector*, New York 1961.

Herbert 1988
R.L. Herbert, *Impressionism: Art, Leisure and Parisian Society*, New Haven and London 1988.

Holmes 1936
C.J. Holmes, *Self and Partners (Mostly Self), Being the Reminiscences of C.J. Holmes*, London 1936.

Ittman 1966
W.M. Ittmann, 'A drawing by Edgar Degas for the Petite filles spartiates provoquant des garçons', *The Register of the Museum of Art*, The University of Kansas, III, 7, Winter 1966, pp. 38–45.

Jamot 1924
P. Jamot, *Degas*, Paris 1924.

Jeanniot 1933
G. Jeanniot, 'Souvenirs sur Degas', *Revue Universelle*,
15 October and 1 November 1933.

Kendall 1985
R. Kendall, 'Degas's colour', in R. Kendall (ed.) *Degas
1834–1984*, Manchester 1985, pp. 19–31.

Kendall 2002
R. Kendall, 'Materials, methods and meaning in Degas's
late pastels', in H. Stratis and B. Salvesen (eds) *The
Broad Spectrum*, London 2002, pp. 23–8.

Kirby et al. 2003
J. Kirby, K. Stonor, A. Roy, A. Burnstock, R. Grout
and R. White, 'Seurat's painting practice: theory,
development and technology', *National Gallery
Technical Bulletin*, 24, 2003, pp. 4–37.

Lafond 1918
P. Lafond, *Degas*, Paris 1918.

Lemoisne 1946-9
P.A. Lemoisne, *Degas et son oeuvre*, 4 vols, Paris,
1946–9. (See also Brame and Reff 1984.)

Liverpool and Glasgow 1989
R. Kendall, *Degas – Images of Women*, exh. cat.,
Liverpool, Tate Gallery, 1989. London 1989.

London 1981
A. Smith, *Second Sight: Mantegna: Samson and Delilah;
Degas: Beach Scene (Bains de Mer. Petite Fille peignée
par sa Bonne)*, exh. cat., London, The National Gallery,
1981. London 1981.

London 1984
D. Gordon, *Acquisition in Focus. Edgar Degas: Hélène
Rouart in her Father's Study*, exh. cat., London, The
National Gallery, 1984. London 1984.

London 1994
J. House, *Impressionism for England. Samuel Courtauld
as Patron and Collector*, exh. cat., London, Courtauld
Institute Galleries, 1994. London 1984.

London 1996
A. Dumas, *Degas as a Collector*, exh. cat., London, The
National Gallery, 1996 (also published in *Apollo*, CXLIV,
no. 415, September 1996, pp. 3–72). London 1996.

London and Chicago 1996
R. Kendall, *Degas – Beyond Impressionism*, exh. cat.,
London, The National Gallery; and Chicago, Art
Institute of Chicago, 1996. New Haven and London
1996.

Louisville, Pittsburgh (etc.) 2002-4
F. Fowle, 'West of Scotland collectors of nineteenth-
century French art', in V. Hamilton, *Millet to Matisse.
Nineteenth- and Twentieth-Century French Painting
from Kelvingrove Art Gallery, Glasgow*, exh. cat.
Louisville, Speed Art Museum; Pittsburgh, Frick Art
and Historical Center (etc.). Glasgow 2002, pp. 31–50.

Loyrette 1991
H. Loyrette, *Degas*, Paris 1991.

Loyrette 1993
H. Loyrette, *Degas. Passion and Intellect*, trans. I. Mark
Paris (French edn *Degas. 'Je voudrais être illustre et
inconnu'*, Paris 1988) London 1993.

MacColl 1898
D.S. MacColl, 'Degas drawings', *Saturday Review*, 85, 26
March 1898, p. 426 (reprinted in Flint 1984, pp. 302–3).

Maheux 1988
A.F. Maheux, *Degas Pastels*, Ottawa 1988.

Maheux et al. 1988
A.F. Maheux, J. Miller and I.N.M. Wainwright,
'Appendix: technical analysis of the Degas pastels at the
National Gallery of Canada', in A.F. Maheux, *Degas
Pastels*, Ottawa, 1988, pp. 85–9.

Manet 1979
J. Manet, *Journal (1893–1899) Sa jeunesse parmi les pein-
tres impressionnistes et les hommes de letters*, Paris 1979
(Eng. edn *Growing up with the Impressionists: The
Diary of Julie Manet*, trans. and ed. R. de B. Roberts
and J. Roberts, London, 1987).

Michel 1919
A. Michel, 'Degas et son modèle, *Le Mercure de France*,
1 February 1919, pp. 457–78 and 16 February 1919,
pp. 623–39.

Mills and White 1981
J.S. Mills and R. White, 'Analyses of paint media',
National Gallery Technical Bulletin, 5, 1981, pp. 66–7.

Moore 1893
G. Moore, 'The new art criticism', in *Modern Painting*,
London, 1893, pp. 232–45. (The substance of this article
first appeared in *The Spectator*, 25 March, 1 and 8 April
1893; reprinted in Flint 1984, pp. 288–96).

Moore 1918
G. Moore, 'Memories of Degas', *Burlington Magazine*,
XXXII, January 1918, pp. 22–9 and February 1918,
pp. 63–5 (incorporating article 'Degas: The Painter of
Modern Life', first published in the *Magazine of Art*,
13, 1890, pp. 416–25).

Moreau-Nelaton 1931
E. Moreau-Nelaton, 'Deux heures avec Degas', *L'Amour
de l'Art*, 12, July 1931, pp. 267–70 (reprinted in
Lemoisne, 1946–9, Vol. 1, note 218, pp. 257–61).

Munich 1970
J.A. Schmoll gen. Eisenwerth, *Malereinach Fotografie
von der Camera Obscura bis zur Pop Art*, exh. cat.,
Munich, Stadtmuseum, 1970. Munich 1970.

New York 1997-8
A. Dumas, C. Ives, S.A. Stein and G. Tinterow, *The
Private Collection of Edgar Degas*, exh. cat., New York,
Metropolitan Museum of Art, 1997. New York 1997.

New York and Houston 1994
R. Kendall, *Degas Landscapes*, exh. cat., New York, Metropolitan Museum of Art; and Houston, Museum of Fine Arts, 1994. New Haven and London 1993.

New York, Los Angeles and Paris 1998–9
M.R. Daniel, *Edgar Degas, Photographer*, with essays by E. Parry and T. Reff, exh. cat. New York, Metropolitan Museum of Art; Los Angeles, J. Paul Getty Museum, and Paris, Bibliothèque Nationale, 1998–9. New York 1998.

Nochlin 1986
L. Nochlin, 'Degas' *Young Spartans Exercising*', *Art Bulletin*, 68, 1986, pp. 486–88.

Norville-Day, Townsend and Green 1993
H. Norville-Day, J.H. Townsend and T. Green, 'Degas pastels: problems with transport and examination and analysis of materials', *The Conservator*, 17, 1993, pp. 46–55.

Omaha, Williamstown and Baltimore 1998–9
R. Kendall, *Degas and the Little Dancer*, with contributions by D.W. Druick and A. Beale, exh. cat., Omaha, Joslyn Art Museum; Williamstown, Sterling and Francine Clark Institute; and Baltimore Museum of Art, 1998–9. New Haven and London 1998.

Oxford, Manchester and Glasgow 1986
C. Lloyd and R. Thomson, *Impressionist Drawings from British Public and Private Collections*, exh. cat., Oxford, Ashmolean Museum; Manchester City Art Gallery; and Glasgow, the Burrell Collection, 1986. Oxford and London 1986.

Paris 1955
D. Cooper, *Les Impressionnistes de la Collection Courtauld*, exh. cat., Paris, Musée de l'Orangerie, 1955. Paris 1955.

Paris, Ottawa and New York 1988–9
J.S. Boggs, D.W. Druick, H. Loyrette, M. Pantazzi and G. Tinterow, *Degas*, exh. cat., Paris, Galeries Nationales du Grand Palais; Ottawa, National Gallery of Canada; and New York, Metropolitan Museum of Art, 1988–9. New York and Ottawa 1988.

Pickvance 1963
R. Pickvance, '"L'Absinthe" in England', *Apollo*, LXXVII, 1963, pp. 395–8.

Pingeot 1995
A. Pingeot, 'The casting of Degas' sculptures: completing the story', *Apollo*, CXLII, August 1995, pp. 60–3.

Pissarro 1980
C. Pissarro, *Correspondence de Camille Pissarro, tome 1, 1865–1885*, ed. J. Bailly-Herzberg, Paris 1980.

Pool 1964
P. Pool, 'The history pictures of Edgar Degas and their background', *Apollo*, LXXX, 1964, pp. 306–11.

Reff 1968
T. Reff, 'The pictures within Degas's pictures', *Metropolitan Museum Journal*, 1, 1968, pp. 125–66.

Reff 1976a
T. Reff, *Degas: The Artist's Mind*, London, 1976.

Reff 1976b
T. Reff, *The Notebooks of Edgar Degas*, 2 vols (Vol. 1, text, Vol. 2, plates), Oxford, 1976.

Reff 1995
T. Reff, 'The morbid content of Degas's sculpture', *Apollo*, CXLII, August 1995, pp. 64–71.

Rewald 1937
J. Rewald, 'Un portrait de la Princesse de Metternich par Edgar Degas', *L'Amour de l'Art*, March 1937, p. 89.

Riopelle et al. 2003
C. Riopelle and X. Bray, *A Brush with Nature. The Gere Collection of Landscape oil Studies*, with an essay by C. Gere, rev. edn, London, 2003 (first published to accompany an exhibition in 1999).

Roquebert 2001
A. Roquebert, 'Quelques observations sur la technique de Degas à La Nouvelle-Orléans', *Techné*, 13–14, 2001, pp. 89–99.

Rouart 1945
D. Rouart, *Degas: à la recherche de sa technique*, Paris, 1945 (reprinted Geneva, 1988; Eng. edn, *Degas: In Search of his Technique*, New York 1988).

Rouart 2001
J.-M. Rouart, *Une famille dans l'impressionnisme*, Paris 2001.

Ruhemann 1968
H. Ruhemann, *The Cleaning of Paintings*, London 1968.

Rutter 1922
F. Rutter, *Some Contemporary Artists*, London 1922.

Rutter 1927
F. Rutter, *Since I was Twenty-Five*, London 1927.

Salus 1985
C. Salus, 'Degas' *Young Spartans Exercising*', *Art Bulletin*, LXVII, 1985, pp. 501–6.

Scharf 1968
A. Scharf, *Art and Photography*, London 1968.

Sickert 1917
W. Sickert, 'Degas', *Burlington Magazine*, XXXI, November 1917, pp. 183–91.

Sickert 1923
W. Sickert, 'Monthly Chronicle: Degas', *Burlington Magazine*, XLIII, 1923, p. 308.

Singapore, Canberra (etc.) 1999–2000
R.R. Brettell, with N.H. Lee, *Monet to Moore.*
The Millennium Gift of Sara Lee Corporation, exh. cat.
Singapore Museum of Art; Canberra, National Gallery
of Australia (etc), 1999–2000. New Haven and
London, 1999.

Spalding 1998
F. Spalding, *The Tate: A History*, London 1998.

Stelzer 1966
O. Stelzer, *Kunst und Photographie: Kontakte, Einflüsse,
Wirkungen*, Munich, 1966.

Sturman and Barbour 1995
S. Sturman and D. Barbour, 'The materials of the
sculptor: Degas' techniques', *Apollo*, CXLII, August 1995,
pp. 49–54.

Sutton 1976
D. Sutton, *Walter Sickert: A Biography*, London 1976.

Sutton 1986
D. Sutton, *Edgar Degas: Life and Work*, New York 1986.

Sutton 1989a
D. Sutton, 'The Degas sales and England', *Burlington
Magazine*, CXXXI, 1989, pp. 266–72.

Sutton 1989b
D. Sutton, 'Degas et l'Angleterre', in *Degas inédit. Actes
du Colloque Degas, Musée d'Orsay*, 18–21 avril 1988,
Paris, 1989, pp. 277–88.

Terrasse 1983
A. Terrasse, *Degas et la photographie*, Paris 1983.

Thomson 1988
R. Thomson, *Degas: The Nudes*, London 1988.

Tinterow 1997
G. Tinterow, 'Degas's Degas', in A. Dumas, C. Ives,
S.A. Stein and G. Tinterow, *The Private Collection
of Edgar Degas*, exh. cat., New York, Metropolitan
Museum of Art, 1997, pp. 75–7.

Valéry 1938
P. Valéry, *Degas, danse, dessin*, Paris, 1938. (Eng. edn
reprinted in *Degas, Manet, Morisot. The Collected
Works of Paul Valéry*, Vol. 12, ed. J. Mathews, trans.
D. Paul, New York 1960.

Vollard 1937
A. Vollard, *Degas, an Intimate Portrait*, trans.
R.T. Weaver, New York 1937.

Washington 1984–5
G.T.M. Shackelford, *Degas: The Dancers*, exh. cat.,
Washington DC, National Gallery of Art, 1984–5.
Washington DC 1984.

Washington, Montreal, Yokohama and London 1990–1
C. Bührle et al., *The Passionate Eye – Impressionist and
Other Master Paintings from the Collection of Emil G.
Bührle, Zürich*, exh. cat., Washington DC, National
Gallery of Art; Montreal Museum of Fine Arts;
Yokohama Museum of Art; and London, Royal
Academy of Arts, 1990–1. Geneva 1990.

Washington 1998
J.S. Boggs, *Degas at the Races*, with contributions by
S.G. Sturman, D.S. Barbour and K. Jones, exh. cat.,
Washington DC, National Gallery of Art, 1998.
Washington DC 1998.

Washington and San Francisco 1986
C.S. Moffett, *The New Painting: Impressionism
1874–1886*, with contributions by R.R. Brettell, exh. cat.
Washington DC, National Gallery of Art; and San
Francisco, Fine Art Memorial Museums, M.H. de
Young Memorial Museum. Oxford 1986.

White et al. 1998
R. White, J. Pilc and J. Kirby, 'Analyses of paint media',
National Gallery Technical Bulletin, 19, 1998, pp. 74–95.

Zürich and Tübingen 1994–5
F. Baumann and M. Karabelnik (eds), *Degas Portraits*,
exh. cat., Zürich, Kunsthaus; and Tübingen, Kunsthalle,
1994–5. Zürich 1994.

Glossary

Aquatint a printmaking technique related to *etching* in which the copper plate is coated with a porous resin, giving a granulated effect when bitten by the acid; the printed image resembles a wash.

Casein a binder made from milk protein, occasionally used as a paint medium.

Distemper a water-based paint with a glue medium, sometimes extended with chalk.

Drypoint a printmaking method in which the design is scratched directly on the copper plate with a sharp needle; a burr of metal is thrown up by the process, which gives a soft richness to the printed lines.

Ébauche the preliminary laying-in of rough outlines and tones in a painted composition, in a more or less monochrome fashion: the final colouring layers would be painted on top.

Electric crayon / *crayon voltaique* an instrument made from the carbon filament of an electric light, used by Degas for incising lines in printmaking.

Essence oil paint from which most of the oil has been soaked out on blotting paper, and then diluted with turpentine to give an effect similar to watercolour; used almost always on a paper support.

Etching the most common printmaking technique: the design is scratched through an acid-resistant wax or varnish layer on a copper plate, which is then immersed in acid and the lines are bitten into the metal. The ink is held in the indented lines – the so-called *intaglio* method of printing.

FTIR Fourier Transform Infrared Spectroscopy and Microscopy: an analytical technique that characterises the molecular structure of compounds by examining their infrared spectra – and can be carried out on a microscopic scale. Organic and inorganic pigments, binders, varnishes and mixtures of these materials may be analysed by this method.

Glaze a transparent colour layer, generally over a lighter underpaint.

Gouache a watercolour rendered opaque by the addition of white pigment.

Ground a uniform coating applied to a canvas or panel to prepare it for painting; for nineteenth-century canvases, this would usually be a layer of light-coloured oil paint.

Infrared Reflectography (IRR) an imaging technique that can show the layers immediately below the visible surface of a painting; the artist's preliminary drawing and alterations to the painted composition may be revealed. Infrared radiation, which is able to penetrate the upper paint layers, is used in conjunction with an infrared-sensitive television camera, and the image is assembled with the aid of a computer.

Lining/strip-lining the reinforcement of a canvas painting by gluing an additional layer of fabric to the reverse; in strip-lining, only the edges where the canvas is tacked to the stretcher are strengthened.

Lithography printmaking technique in which the design is drawn on wetted smooth limestone with a greasy material: lithographic ink sticks only to those areas already drawn. Dampened paper is pressed on to the surface to make the print.

Medium the fluid binder in which coloured pigments are suspended to make paint.

Macro and micro photographs magnified and highly magnified details of a painting or paint sample.

Millboard manufactured painting support made of compressed fibres bound with glue or oil and sometimes faced with paper.

Monotype a print made from a design drawn, brushed or wiped directly on a metal plate in ink or oil paint; an impression is taken by pressing a sheet of paper against it. The image may be unique, or there may be enough ink or paint for one strong and one faint impression to be made.

Pentimento/i a change of composition in a painting, which may become visible with time – or may be detected using *infrared* or *X-ray* examination.

Sanguine red chalk or crayon, with a brownish tinge.

Scumble a semi-opaque light colour layer over a darker underpaint.

Tempera traditionally, a paint using a medium of egg yolk or whole egg.

Wove/laid paper laid paper is made on a wire mesh which leaves regular 'chain lines' on the surface; wove paper is made on a tray with a mesh so finely constructed that it leaves no marks on the surface.

X-ray/radiograph an X-ray of a painting can show all the layers superimposed, including the structure of the support and the paint layers; an X-radiograph is the image produced by the X-ray.

Photographic Credits

All photographs are © The National Gallery, London, unless otherwise indicated.

Every effort has been made to contact copyright holders of photographs and we apologise for any omissions.

Basel
Kunstmuseum
© Oeffentliche Kunstsammlung Basel
Photo: Martin Bühler fig. **50**

Berwick-upon-Tweed, Northumberland
© Berwick-upon-Tweed Borough
Museum & Art Gallery fig. 141

Birmingham
© The Barber Institute of Fine Arts, The
University of Birmingham figs 86, 93

Cambridge, Massachusetts
© 2004 President and Fellows of Harvard
College figs 66, 68, 81, 132

Chicago, Illinois
© The Art Institute of Chicago figs 6,
34, 61

Copenhagen
© Ny Carlsberg Glyptotek, Copenhagen
Fig. 11

© Ordupgaard, Copenhagen
Photo: Fotograf Pernille Klemp,
Copenhagen fig. 30

Detroit, Michigan
© The Detroit Institute of Arts
Photograph 1964 figs 63, 87

Dublin
© Dublin City Gallery The Hugh Lane
fig. 40

Edinburgh
© National Galleries of Scotland
Photo: Antonia Reeve, Edinburgh fig. 7

Glasgow
Glasgow Museums: The Burrell
Collection
© Glasgow Museums fig. 44

Hartford, Connecticut
© Wadsworth Atheneum Museum of
Art, Hartford fig. 126

Houston, Texas
© Houston Museum of Fine Arts fig. 140

Kansas City, Missouri
© The Nelson-Atkins Museum of Art,
Kansas City
Photo: E.G. Schempf fig. 24

Lawrence, Kansas
© Spencer Museum of Art, Kansas
University Museum, Lawrence fig. 67

London
E & R Cyzer Gallery
© Courtesy of E & R Cyzer Gallery,
London fig. 88

Hulton Archive/ 2004 Getty Images
© Hulton Archive/ 2004 Getty Images,
London fig. 106

National Portrait Gallery
© Courtesy of the National Portrait
Gallery, London fig. 128

Tate
© Tate, London 2004 figs 8, 42, 89
Photo: The National Gallery, London
figs 43, 129

The British Museum
© Copyright The British Museum,
London figs 19, 33, 35, 36

The Gere Collection, on long term loan
to the National Gallery
© Courtesy of the owner
Photo: The National Gallery, London
fig. 47

The Samuel Courtauld Trust, Courtauld
Institute of Art Gallery
© The Samuel Courtauld Trust,
Courtauld Institute of Art Gallery,
London figs 122, 124

The Victoria and Albert Museum
© The Board of Trustees of the Victoria
and Albert Museum, London fig. 4

Los Angeles, California
© The J. Paul Getty Museum,
Los Angeles fig. 9

Los Angeles County Museum of Art
© 2004 Museum Associates, Los Angeles
County Museum of Art. All Rights
Reserved fig. 111

Louisville, Kentucky
© The Speed Art Museum, Louisville
fig. 85

Munich
Neue Pinakothek
© Bayerische Staatsgemäldesammlungen,
Munich fig. 16

New York
© Brooklyn Museum of Art, Brooklyn,
New York figs 13, 45, 134

© The Metropolitan Museum of Art,
New York figs 27, 28, 31, 32, 64, 69
Photograph 1994 fig. 14

Collection Andrea Woodner and
Dian Woodner
© Copyright untraced fig. 29

Oslo
© Nasjonalgalleriet, Oslo
Photo: J. Lathion fig. 156

Paris
© Bibliothèque Nationale de France,
Paris figs 38, 48, 49, 51, 92, 98, 99, 112
Photograph 1953 fig. 82

Courtesy of *Catalogue des tableaux,
pastels et dessins par Edgar Degas et
provenant de son Atelier*, Paris, Galerie
Georges Petit 6–8 mai 1918
© Copyright untraced fig. 159

Musée d'Orsay
© RMN, Paris
Photo: Arnaudet fig. 25
Photo: Gérard Blot fig. 2
Photo: H. Lewandowski figs 17, 20, 21, 41

Musée du Louvre
© RMN, Paris figs 62, 65
Photo: J.G. Berizzi fig. 15

Pasadena, California
© The Norton Simon Foundation,
Pasadena fig. 26

Pau
© Musée National des Beaux Arts de Pau
fig. 5

Philadelphia, Pennsylvania
© Philadelphia Museum of Art fig. 148
Photo: Eric Mitchell, 1987 fig. 3
Photo: Graydon Wood, 1994 figs 10, 157

Private Collection
© Copyright untraced figs 22, 91, 123, 155

© Courtesy Barford Sculptures Ltd,
London
Photo: John Riddy fig. 152

© Courtesy of the owner figs 113, 149

© Courtesy of the owner
Photo: The Art Institute of Chicago,
Illinois fig. 118

Lewyt Collection
© Copyright untraced fig. 142

Photo: Christie's Images Ltd, London
figs 60, 75

Photo: Prudence Cuming Associates Ltd,
London fig. 114

© The Samuel Courtauld Trust,
Courtauld Institute of Art Gallery,
London
Photo: Witt Library fig. 115

Richmond, Virginia
© Virginia Museum of Fine Arts,
Richmond
Photo: Katherine Wetzel fig. 102

Tacoma, Washington
© Tacoma Art Museum, Washington
fig. 46

Toledo, Ohio
© Toledo Museum of Art, Toledo fig. 70

Washington, DC
© Dumbarton Oaks, House Collection,
Washington, DC fig. 12

© National Gallery of Art, Washington,
DC. Board of Trustees
Photograph 2003 figs 23, 37
Photograph 2004 fig. 18

Williamstown, Massachusetts
Sterling and Francine Clark Art Institute
© 1999 Clark Art Institute,
Williamstown, Massachusetts fig. 1

Infrared reflectograms
Infrared reflectography was carried out
by Rachel Billinge using a Hamamatsu
C2400 camera with an N2606 series
infrared vidicon tube. The camera is
fitted with a 36mm lens to which a Kodak
87A Wratten filter has been attached
to exclude visible light. The infrared
reflectogram mosaics were assembled
on a computer using an updated version
of the software described in R. Billinge,
J Cupitt, N. Dessipris and D. Saunders,
'A note on an improved procedure for the
rapid assembly of infrared reflectogram
mosaics', *Studies in Conservation*, vol. 38,
II, 1993, pp. 92–8.

X-radiographs
The X-radiographs of paintings on
pp. 76–7, fig. 71, p. 80, fig. 77 and p. 148,
fig. 165, have been produced by
digitising the original X-ray negatives
and assembling the individual images
into a seamless mosaic covering the
whole painting. To improve the legibility
of the images, the shadows cast by
the stretcher and crossbars have been
removed by using an image-processing
technique known as histogram matching
to balance the differing tonal ranges; this
process is described in more detail in
J. Padfield, D. Saunders, J. Cupitt and
R. Atkinson, 'Recent improvements in
the acquisition and processing of X-ray
images of paintings', *National Gallery
Technical Bulletin*, 23, 2002, pp. 62–75.